ROME
SECRETS

Dedicated to my mother and (late) father.

ROME
SECRETS
Susan Wright

CUISINE • CULTURE • VISTAS • PIAZZAS

images
Publishing

Published in Australia in 2013 by

The Images Publishing Group Pty Ltd

ABN 89 059 734 431

6 Bastow Place, Mulgrave, Victoria 3170, Australia

Tel: +61 3 9561 5544 Fax: +61 3 9561 4860

books@imagespublishing.com

www.imagespublishing.com

Copyright © The Images Publishing Group Pty Ltd. 2013

The Images Publishing Group Reference Number: 1089

National Library of Australia Cataloguing-in-Publication entry

Author: Wright, Susan, author, photographer

Title: Rome secrets / text and photography by Susan Wright

ISBN: 978 1 86470 522 5 (hardback)

Subjects: Rome (Italy) – Description and travel

 Rome (Italy) – Guidebooks

 Rome (Italy) – Pictorial works

Dewey Number: 914.563204

Edited by Mandy Herbet

Designed by The Graphic Image Studio Pty Ltd, Mulgrave, Australia
www.tgis.com.au

Pre-publishing services by United Graphic Pte Ltd., Singapore

Printed on 150gsm Quatro Silk Matt by Everbest Printing Co. Ltd., in Hong Kong/China

IMAGES has included on its website a page for special notices in relation to this and our other
publications. Please visit www.imagespublishing.com.

PHOTO CREDITS

All photography by Susan Wright unless otherwise mentioned, with permission and thanks to
the following:

The French Embassy in Italy and photographer Zeno Colantoni for the supply of images of
Palazzo Farnese on pages 45, 162, 163

The Galleria Colonna for the supply of image on page 45

Acqua Madre for the supply of image on page 125

Aaron Borchardt for the supply of image on pages 172–173

TABLE OF CONTENTS

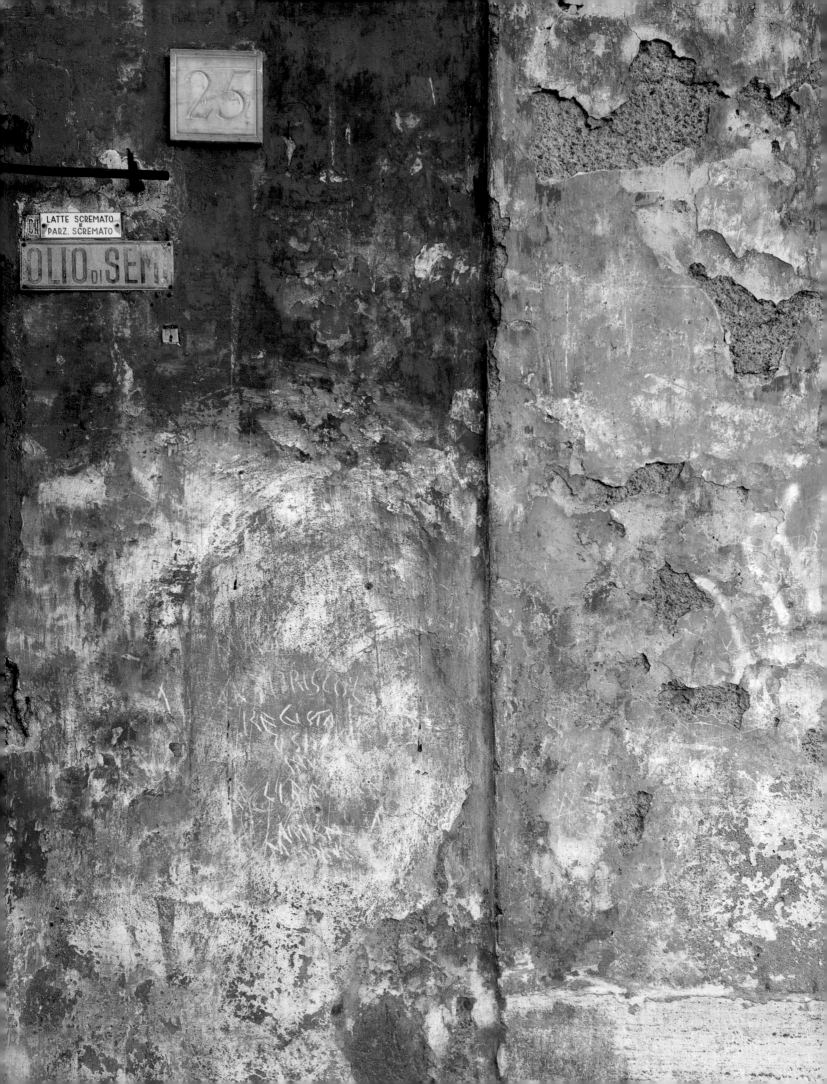

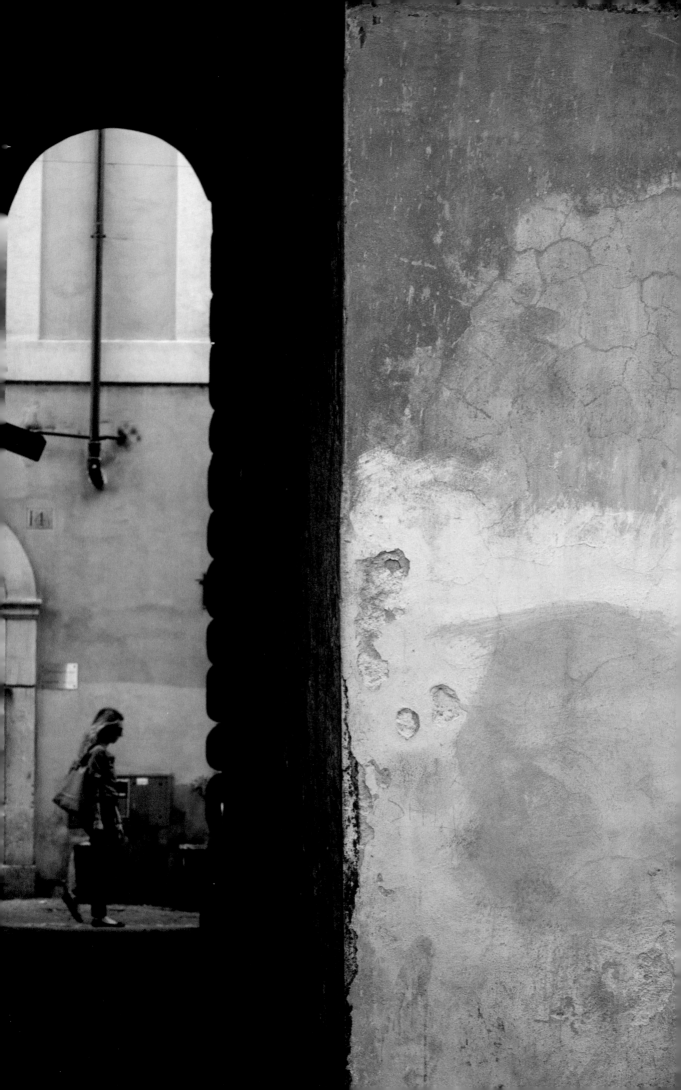

INTRODUCTION

For someone who has never seen Rome, it is hard to believe how beautiful life can be!

— ITALIAN PROVERB

Falling in love with Rome came very naturally and easily to me.

As an artist, photographer and a dreamer at heart, my imagination was captivated and inspired by the timeless grandeur, compelling beauty and irresistible ambience and spirit of this great city.

As I walked the ancient cobblestone streets, I felt as though I was immersed in a dynamic, electric movie set, unfolding around me as I went about my day.

Alleyways and piazzas were poised like perfectly composed stages. Vintage Vespas, with a cast of immaculately dressed men and women, zipped by me on noisy, bustling streets as vivacious characters spoke a language that sounded more like an opera, filling the streets with *allegro* tones.

My days were filled with wonder, like a child experiencing everything anew.

Via del Colosseo 16a was where I called home. A buttercup yellow, Renaissance palazzo, with vivid fuchsia bougainvillea draped over the entrance and weeping lilac wisteria filling the hidden courtyard with its delicate fragrance. It seemed more like a dream than reality to me. So picture-perfect, it was popular with tourists and passers-by who would stop, admire, linger and take photos. The graceful Madonna gazed lovingly and serenely down from the front façade to all who passed beneath. As the name suggests, it was a few steps from the magnificent Colosseum. I would gaze from my bedroom window at the full moon rising over its warmly lit decaying façade, mesmerised by the magical vision before me. So ancient, so present and yet so timeless.

I thanked my lucky stars for the opportunity and the experience. Here I was, a country girl from rural Australia who grew up amongst the sugarcane fields of tropical north Queensland, now living her dream, half way around the world, in the iconic, Eternal City.

My favourite pastime was strolling the city streets and exploring the different *rioni* (districts) and the clusters of tiny alleyways that intertwine with hidden *piazze*, main thoroughfares, ancient ruins, temples, cathedrals and concealed treasures.

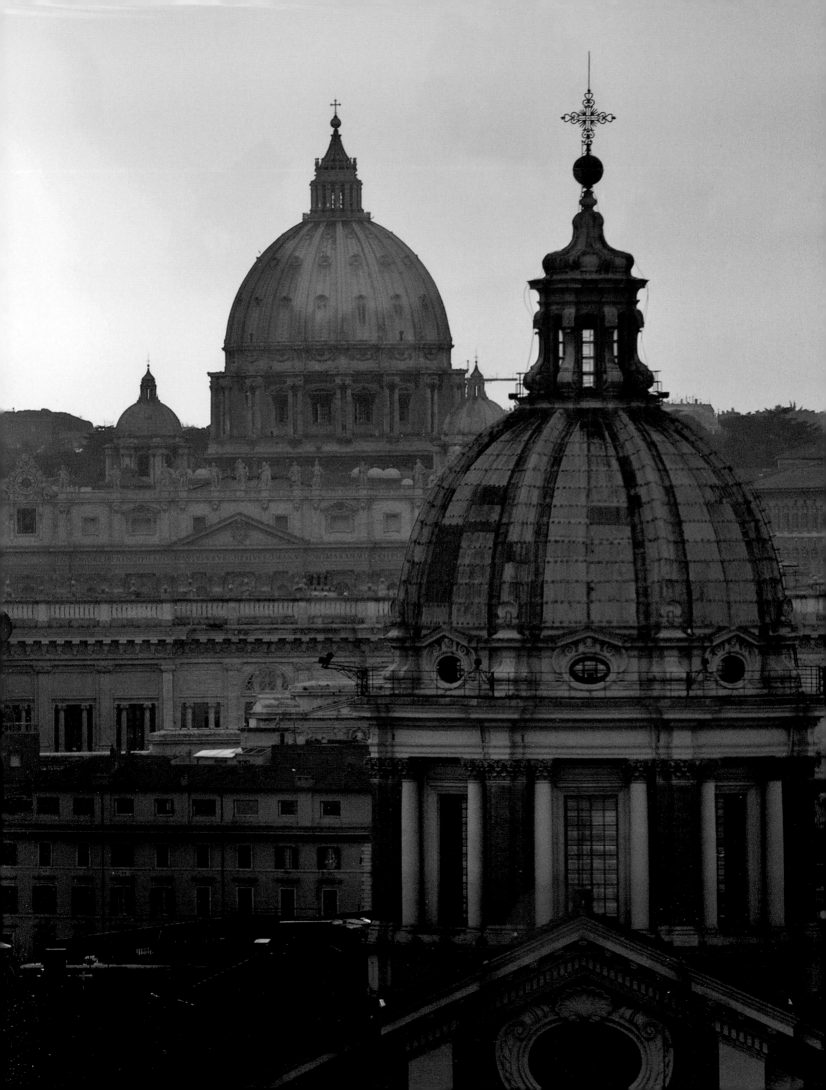

I was Alice in her Roman Wonderland – rich and vivid, beautiful and surreal, peopled with exotic, theatrical characters.

In the 10 years since first moving to Rome, I have discovered a remarkable city that continues to fascinate and surprise me. There are countless layers to the city, which slowly reveal themselves to you over time.

'Roma non basta una vita' is a popular Roman saying, meaning that one lifetime is simply not enough to see and to appreciate the wealth of artistic, cultural, archaeological and sacred patrimony that personifies this great city. I hope to inspire and intrigue you as you walk with me across the aged cobblestones, down the curious alleyways to hidden *piazze*, fairytale palaces and lost gardens into the heart of secret Rome.

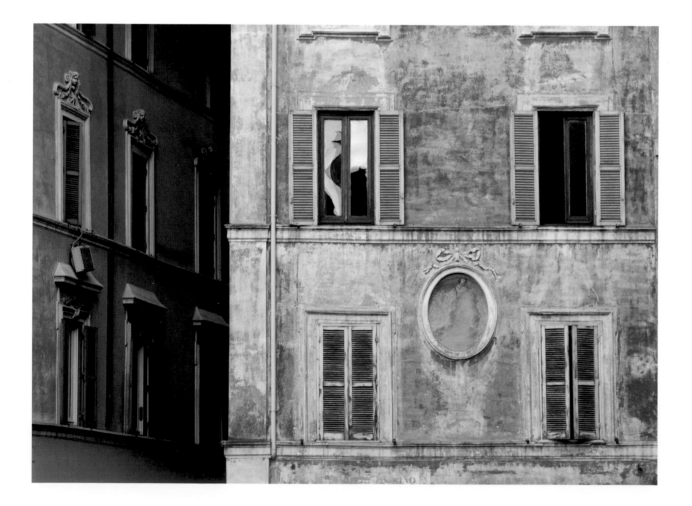

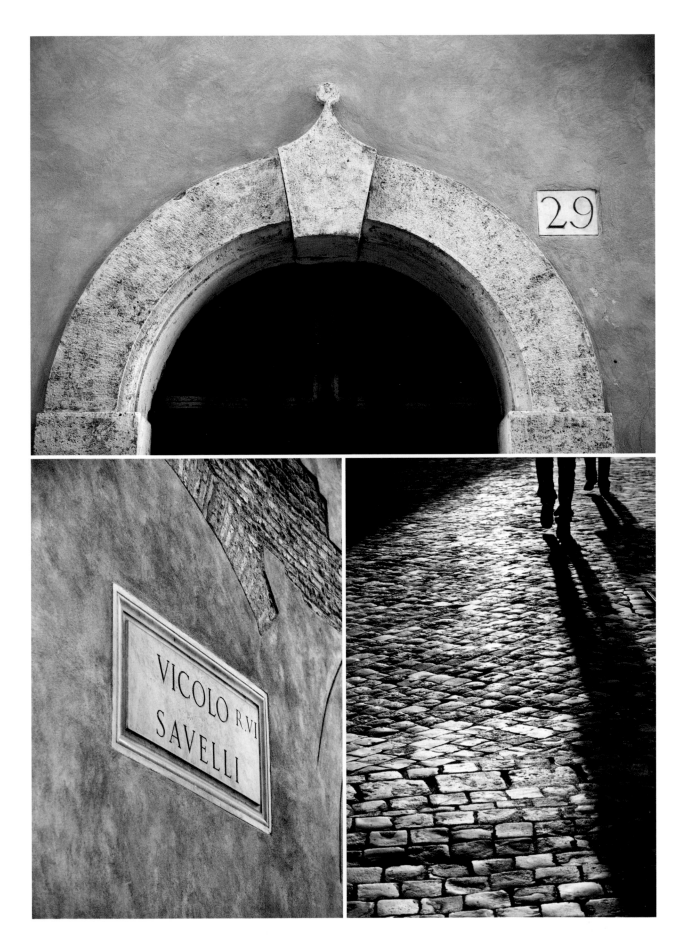

DISCOVER *Scoprire*

Roma è un museo a cielo aperto! (Rome is an open-air museum!)

— ROMAN PROVERB

Romans will proudly tell you; *'Roma è un museo a cielo aperto'* – 'Rome is an open-air museum' for all to see and admire. No need to buy an entry ticket, it is enough to wander the main thoroughfares and grand *piazze* to be enthralled by the grandeur and magnetism of this iconic city.

Follow the well-worn tourist path to some of the star exhibits – the Colosseum, Imperial Forum, Piazza Navona, Trevi Fountain and the Vatican City – and admire the city's quintessential attractions.

Journey away from the long queues and crowds, through the different *rioni* to hidden backstreets, tucked-away *piazze*, quiet alleyways and forgotten gardens, and encounter a more intimate portrait of Rome, revealing the city's authentic spirit.

Il centro storico (the historic centre) is an intricate web of *vie* and *vicoli* (streets and alleyways), weaving through a maze of rich warm ochre and yellow façades of regal palaces, ancient ruins and Renaissance and Baroque cathedrals.

Suspended gardens of lush green vines and cheerful blossoms cascade from textured, stained walls and decorated windowsills. Whimsical angels, mythical Gods and serene Madonnas adorn many street corners, doorways and façades, peering down upon centuries of souls who have wandered by.

The smoothly worn *sanpietrini*, cobblestones named after the workers at San Pietro, Saint Peter's Basilica, entice you through intricate passageways that open out onto magnificent marbled piazzas, embellished with architectural masterpieces and sensual sculptured fountains.

Lose yourself in any one of the historic districts of Campo Marzio, Monti, Trastevere, Parione or Testaccio and be delightfully surprised at what you may find.

Opposite: Winding cobblestone alleyways in the bohemian district of Trastevere, on the west bank of the Tiber River.

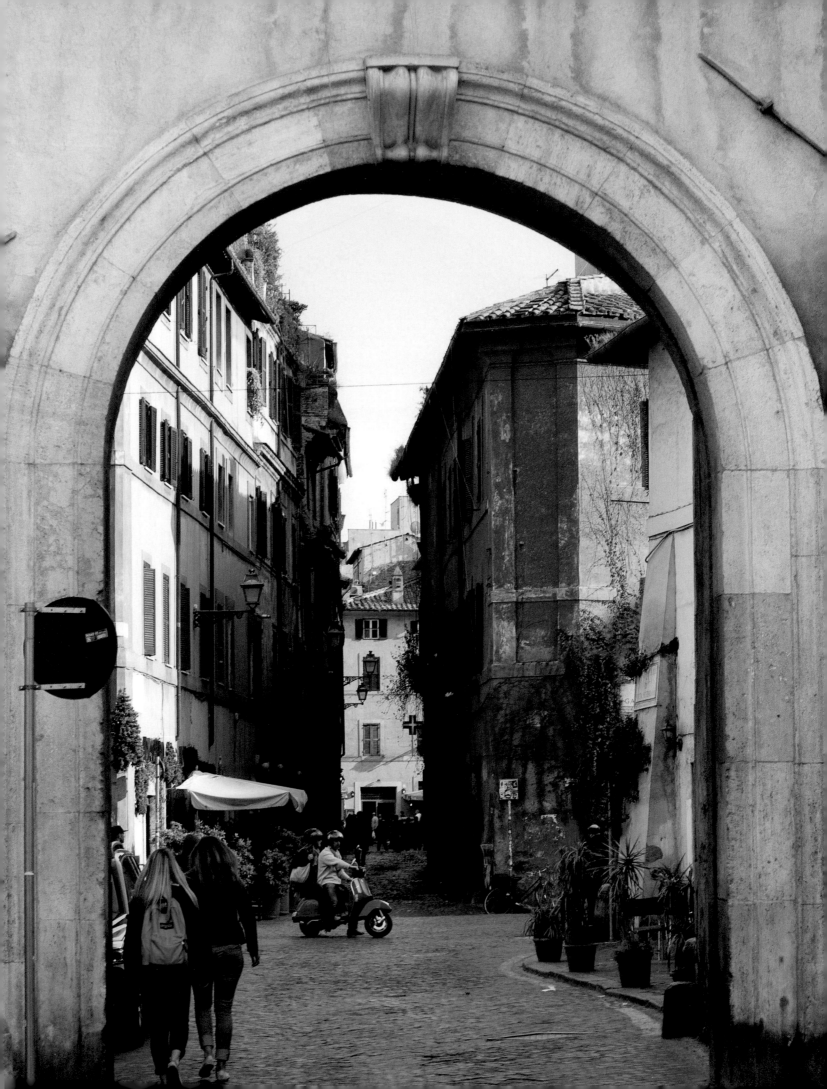

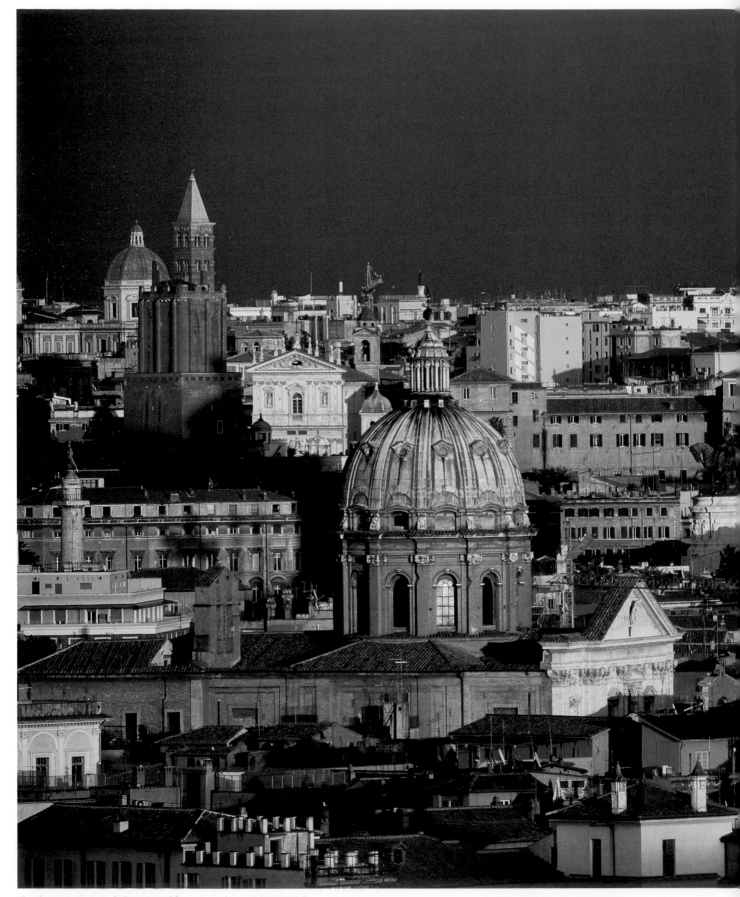

The dramatic Roman skyline viewed from Janiculum Hill (Gianicolo).

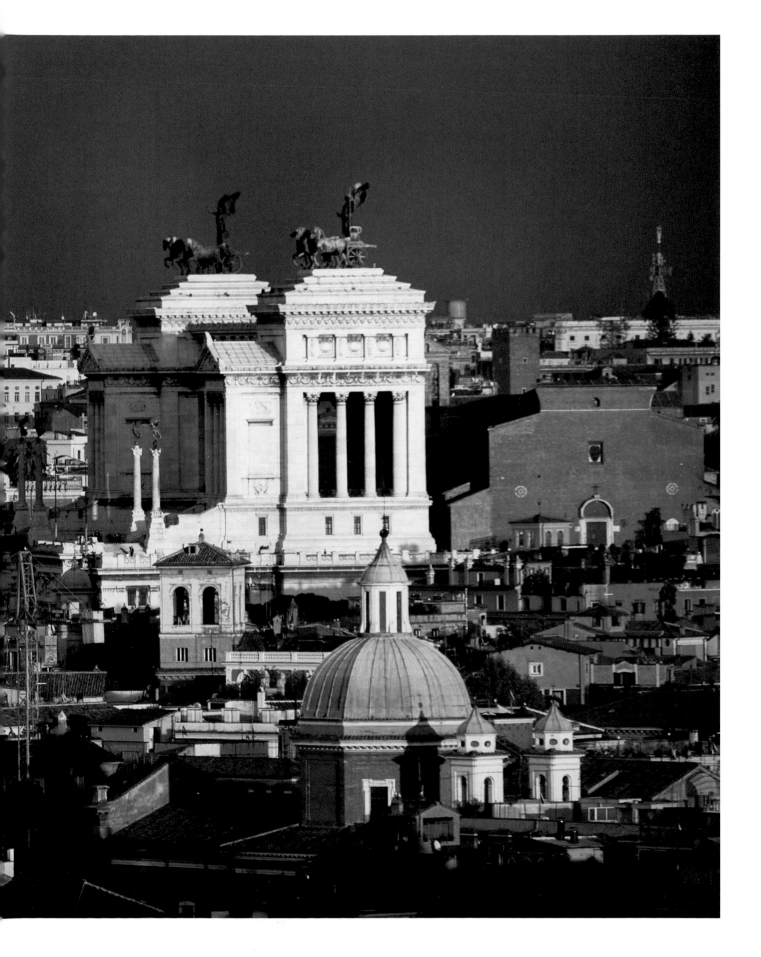

Rome is like a book of fables, on every page you meet up with a prodigy. And at the same time we live in dream and reality.

– HANS CHRISTIAN ANDERSEN

DISTRICTS *RIONI*

Rome's districts are called *rioni*, derived from the Latin word *regio* (region), identifying the different zones in the *centro storico* (historic centre). There are a total of 22 *rioni*, like tiny individual villages with their own distinct personality and style, all pieced together making up the compact city centre.

Rione Monti is *numero uno* (district number 1), bordering the Colosseum and including the Forum of Augustus, Markets of Trajan and the church of Santa Maria Maggiore.

In ancient times, the area known as the *Suburra* (suburbs) was densely populated with slums and brothels. Monti's gentrification has transformed the tiny backstreets between the major thoroughfares of Via Cavour and Via Nazionale. This lively district is now popular for its diversity of traditional and contemporary artisan shops and boutiques, vintage clothing, hip bars, restaurants and trattorias.

Rione Testaccio, affectionately named after the mountain of discarded ancient clay amphoras from centuries past, is a foodie's heaven, with some of the best authentic local cuisine available in the historic centre. Rome's original meatpacking district, the old *mattatoio* (slaughterhouse), is now home to MACRO (Museum of Contemporary Art), fresh produce markets, cultural events and the *Città dell'Altra Economia*, specialising in bio-dynamic and organic food supplies.

Across the river, the popular Trastevere district, meaning to traverse the *Tevere* (Tiber River), is characterised by narrow winding streets and small dwellings. The original inhabitants during the Middle Ages were sailors and fishermen and immigrants from the East. The bohemian neighbourhood's modern-day transformation sees the cobblestone lane-ways overflowing with popular restaurants, bars, quirky shops and fashionable B&Bs. With several large foreign educational institutions incorporated in the district, the piazzas, bars, restaurants and shops are patronised by many young students, filling the streets with a lively upbeat vibe, both day and night.

Encompassing much of the historic centre is the *rione* of Campo Marzio (Campus Martius), considered by many Romans to be the true heart of the city. This charming district incorporates many important monuments, opulent villas and palaces of Renaissance nobility, as well as some of the city's most notable squares, Piazza di Spagna (the Spanish Steps) and Piazza del Popolo.

Retaining much of its classical and historic charm, the neighbourhood's beautiful buildings and manicured streets are now home to chic residences for affluent Romans, luxury tourist accommodation, exclusive designer boutiques, art galleries and exquisite antique shops.

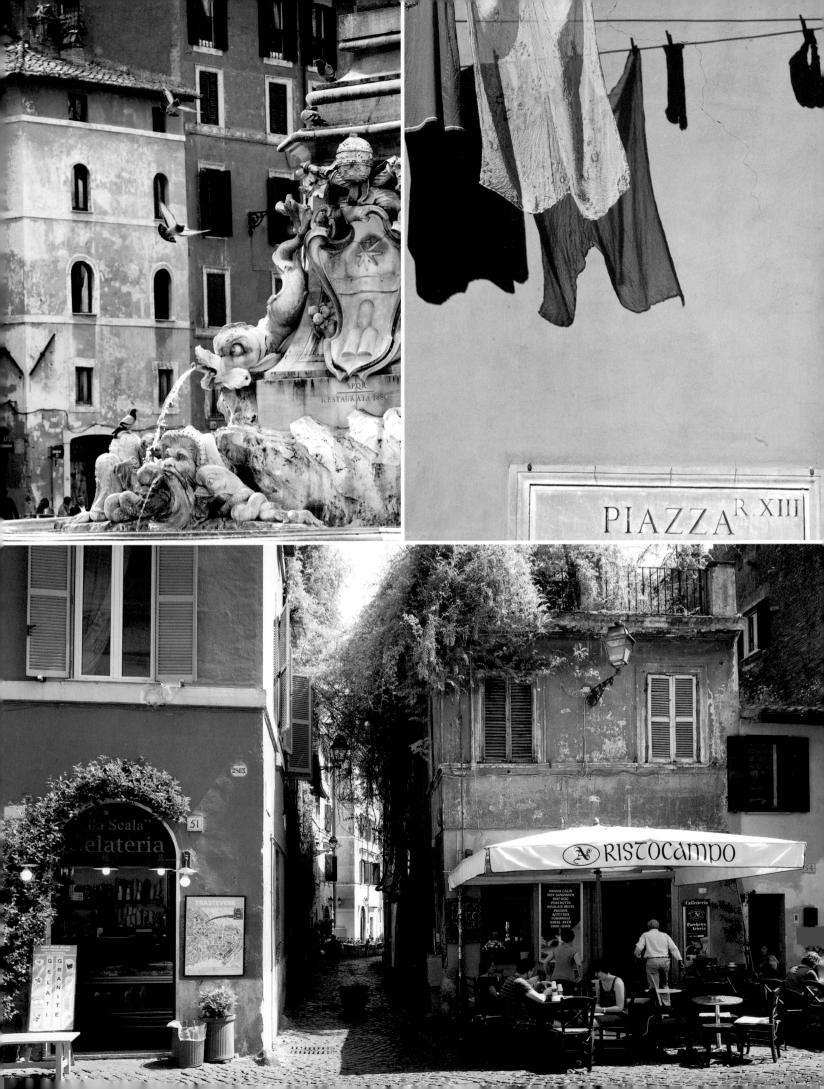

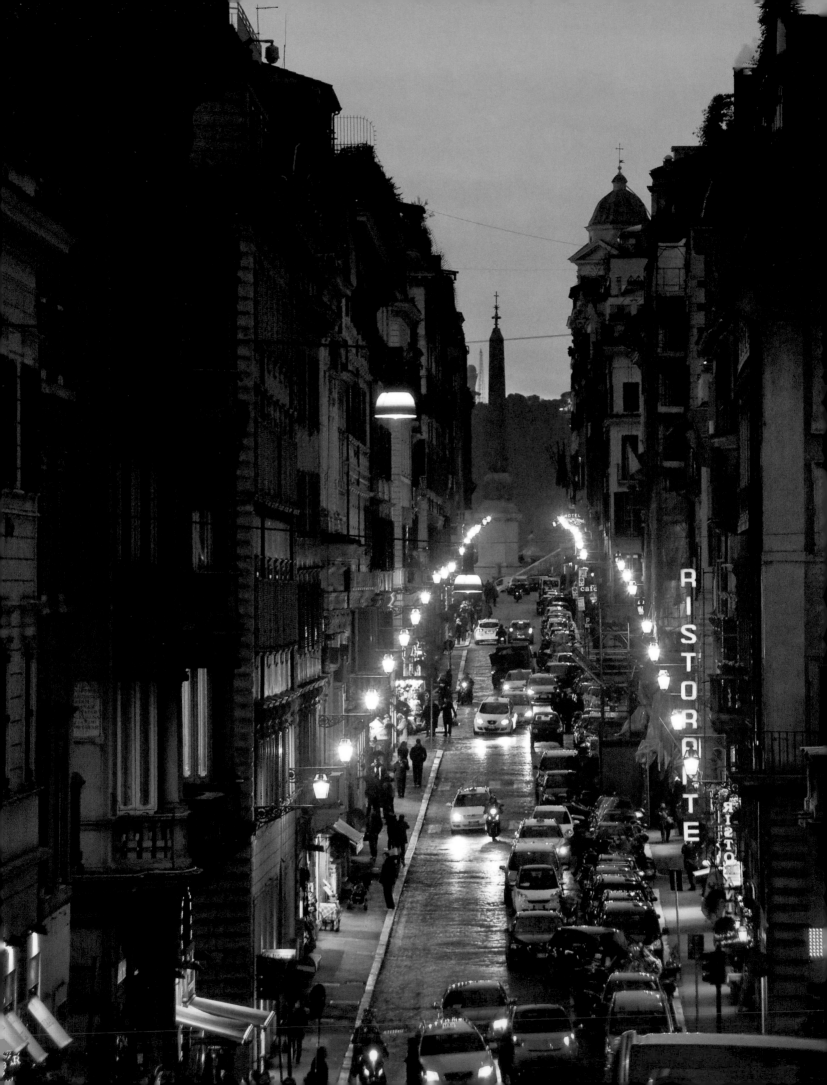

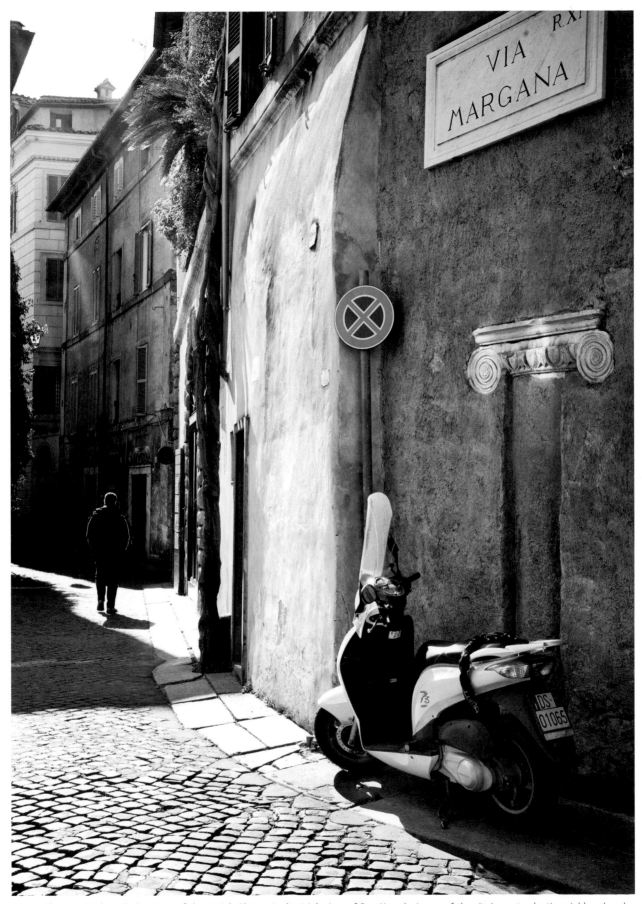

Above: The previously walled quarter of the Jewish Ghetto, in the 11th *rione* of Sant'Angelo, is one of the city's most eclectic neighbourhoods.
Opposite: Via Sistina, above the Spanish Steps in the elegant *rione* of Campo Marzio, is lined with luxury hotels and exclusive boutiques.

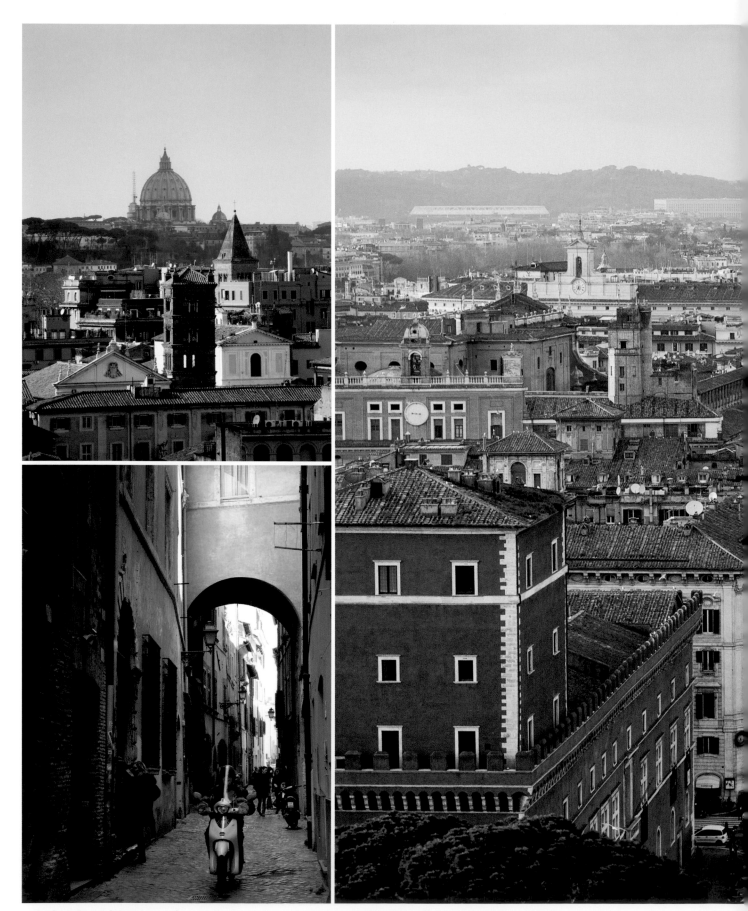

Main photo: Rome's historic centre from Piazza Venezia down Via del Corso and beyond to Villa Borghese and Monte Mario.
Top left: View of the imposing form of Saint Peter's Basilica, over the medieval rooftops of the Trastevere district.
Bottom left: Near Campo dei Fiori, tiny alleyways wind through the picturesque *rione* of Parione.

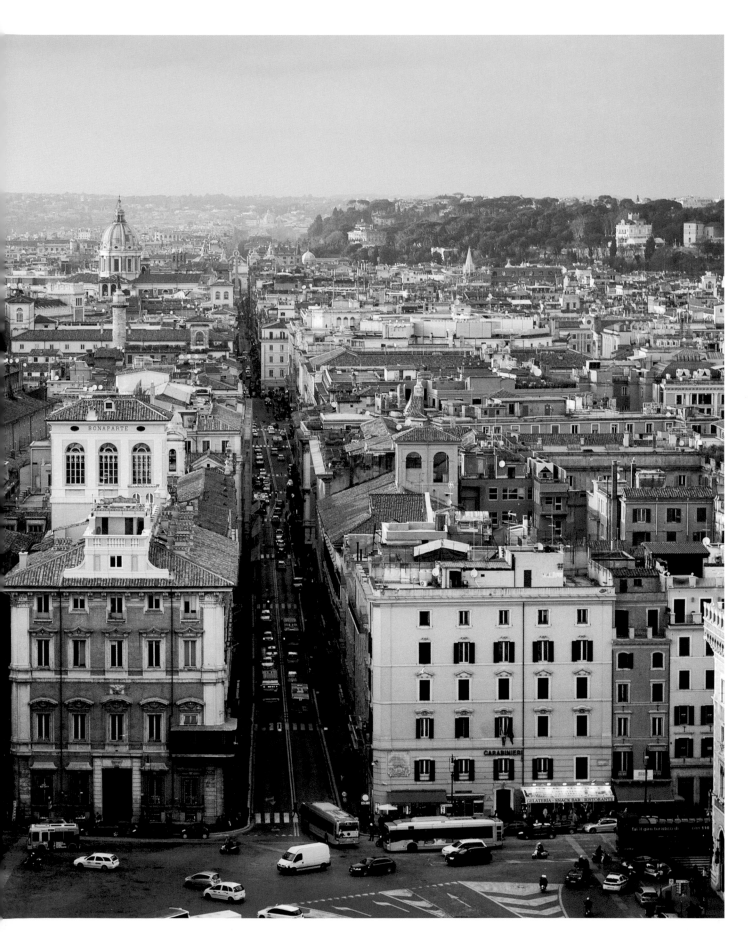

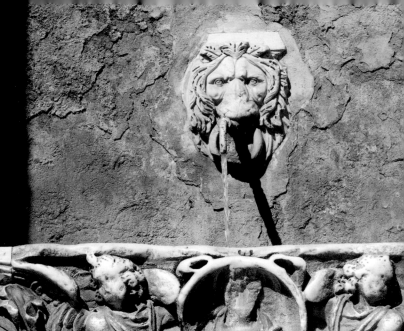

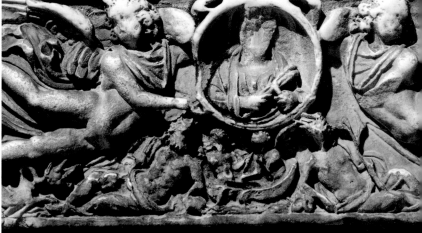

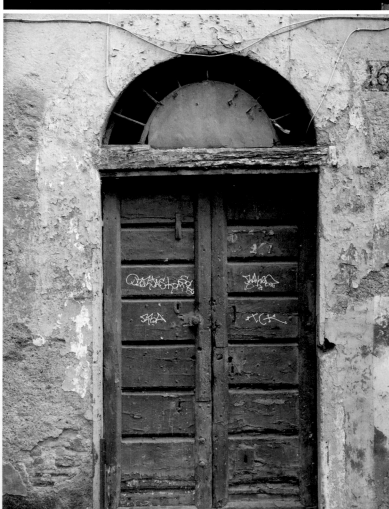

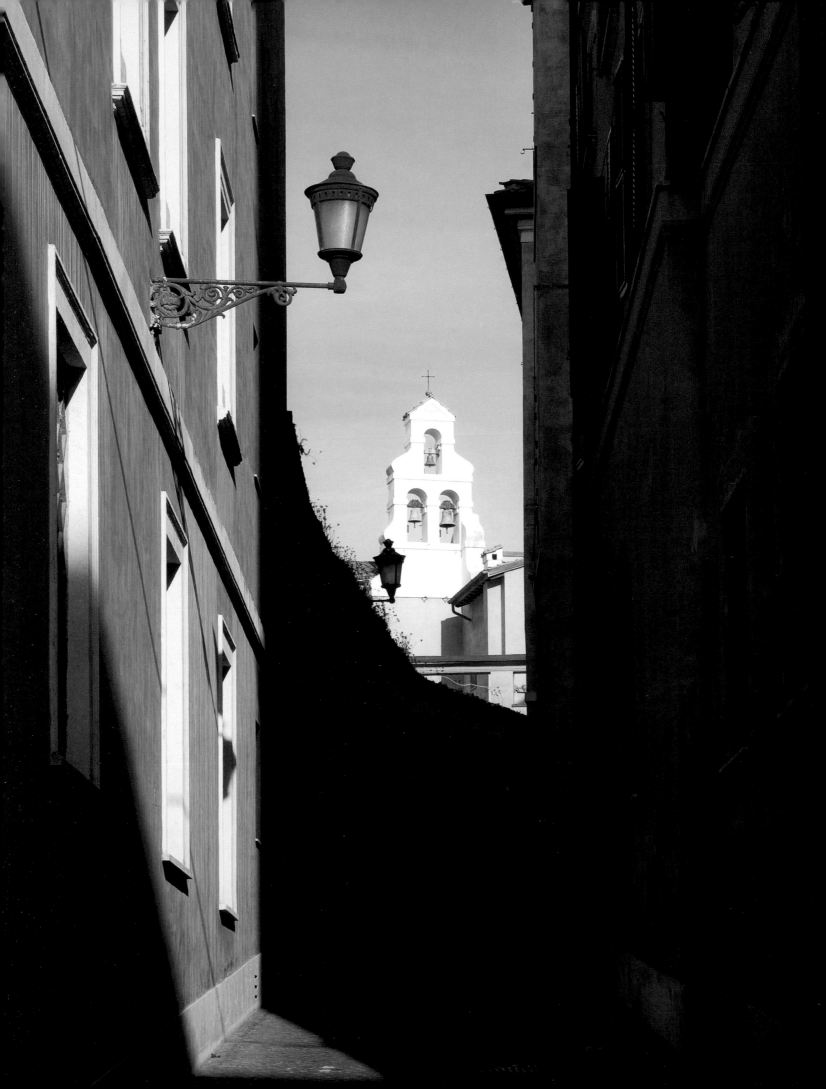

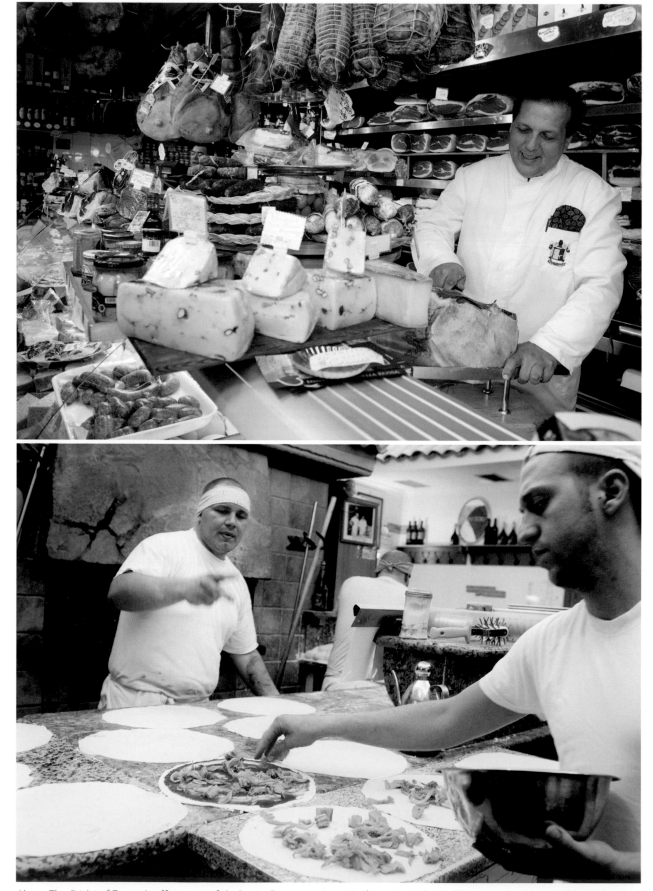

Above: The district of Testaccio offers some of the best culinary experiences in the centre. Volpetti delicatessen (top) has the finest Italian food and wine. Popular with the locals, Pizzeria da Remo (bottom) serves tasty, authentic wood-fired pizzas.
Opposite: The Hotel Hassler Roma's Michelin-starred restaurant, Imàgo, headed by chef Francesco Apreda (pictured), offers contemporary Italian cuisine, with one of the most breathtaking views over the Eternal City.

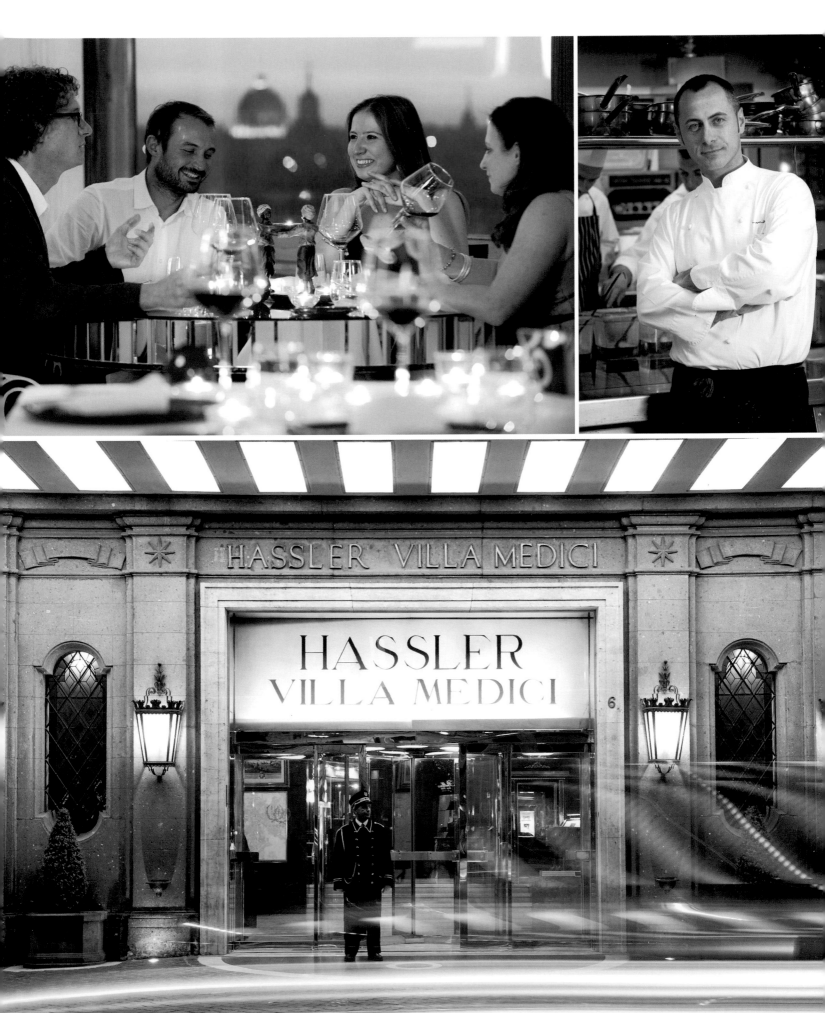

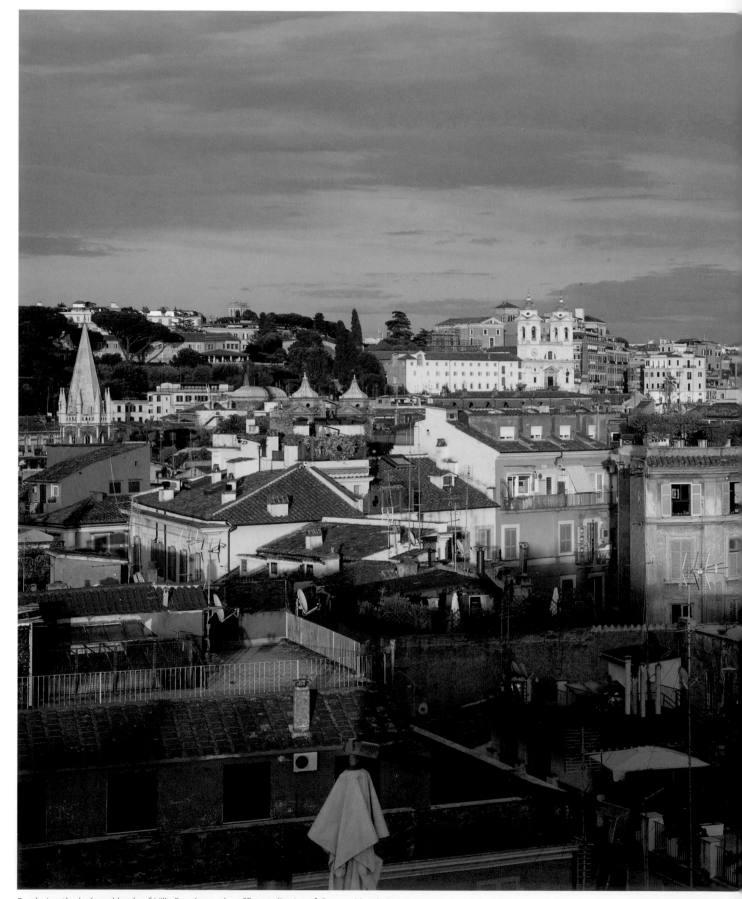

Bordering the lush parklands of Villa Borghese, the affluent district of Campo Marzio incorporates
the Spanish Steps, Villa Medici and the Church of the Santissima Trinità dei Monti.

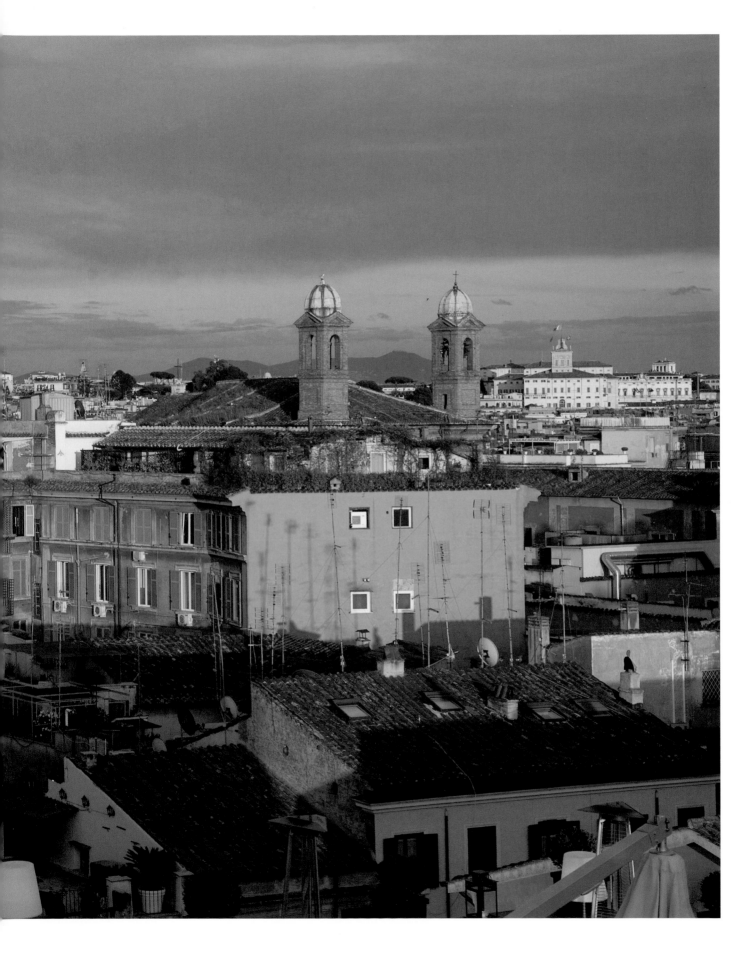

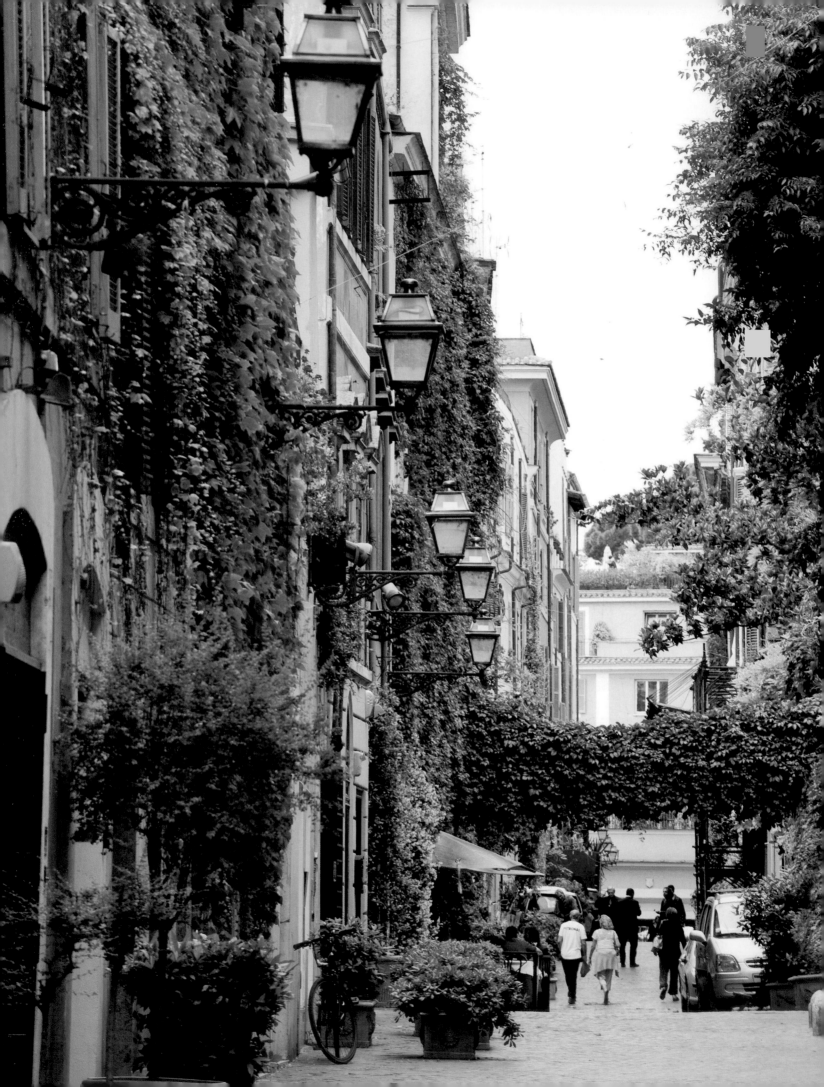

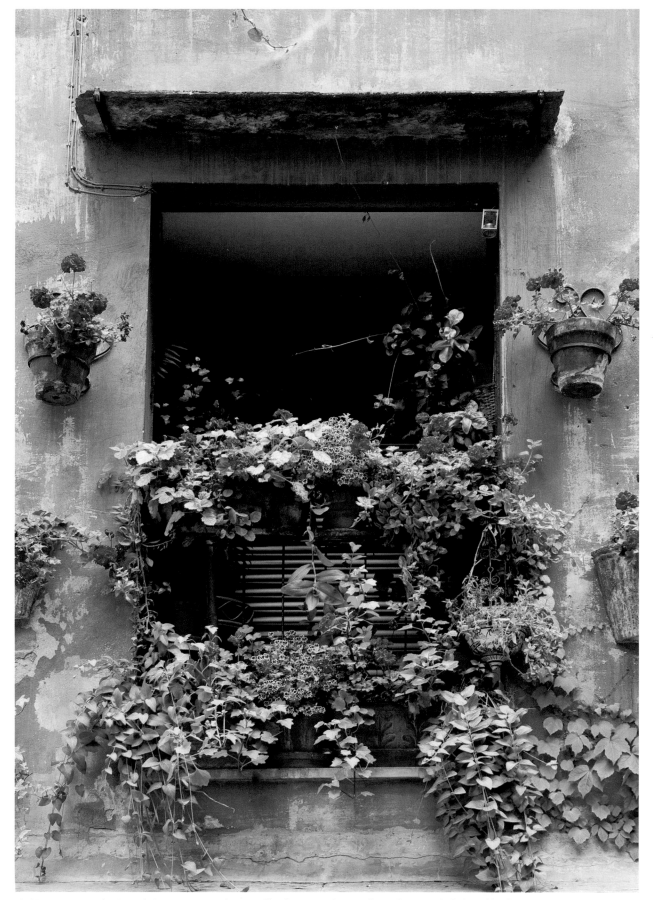

Via Margutta, near the Spanish Steps, was once home to film director Federico Fellini and was made fashionable after its appearance in the movie *Roman Holiday*. Art galleries, antique dealers and restaurants are now found along this charming street.

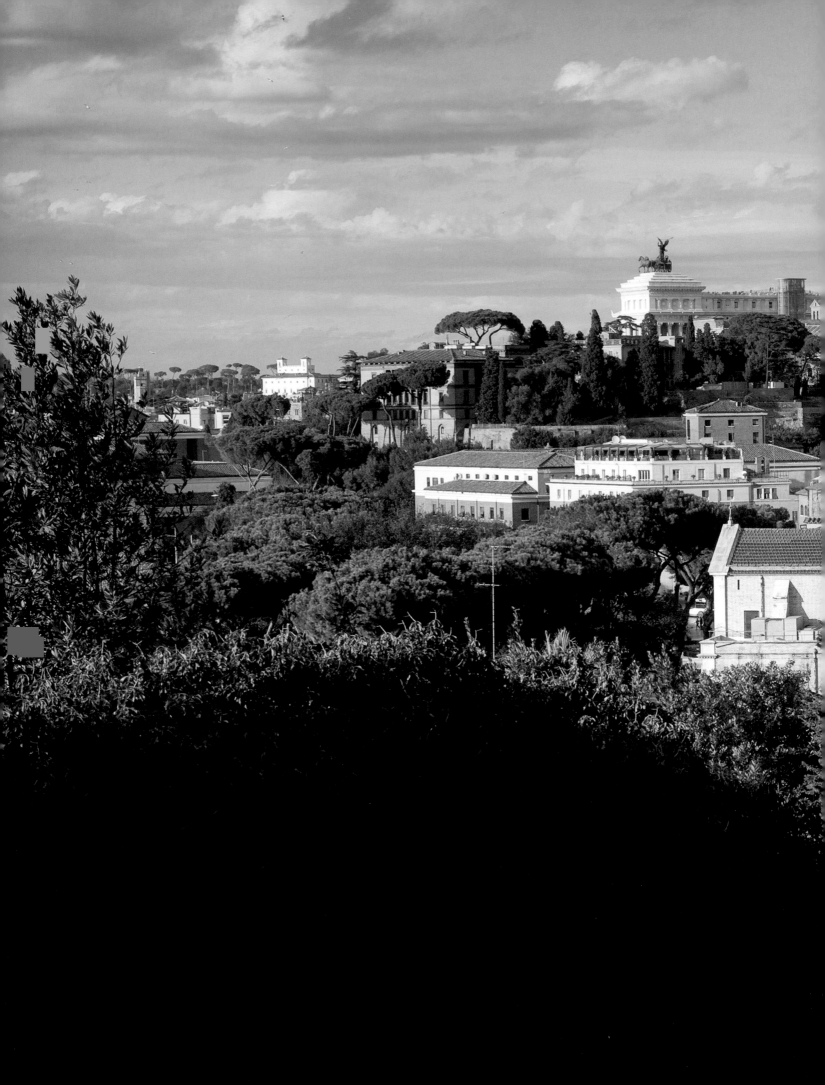

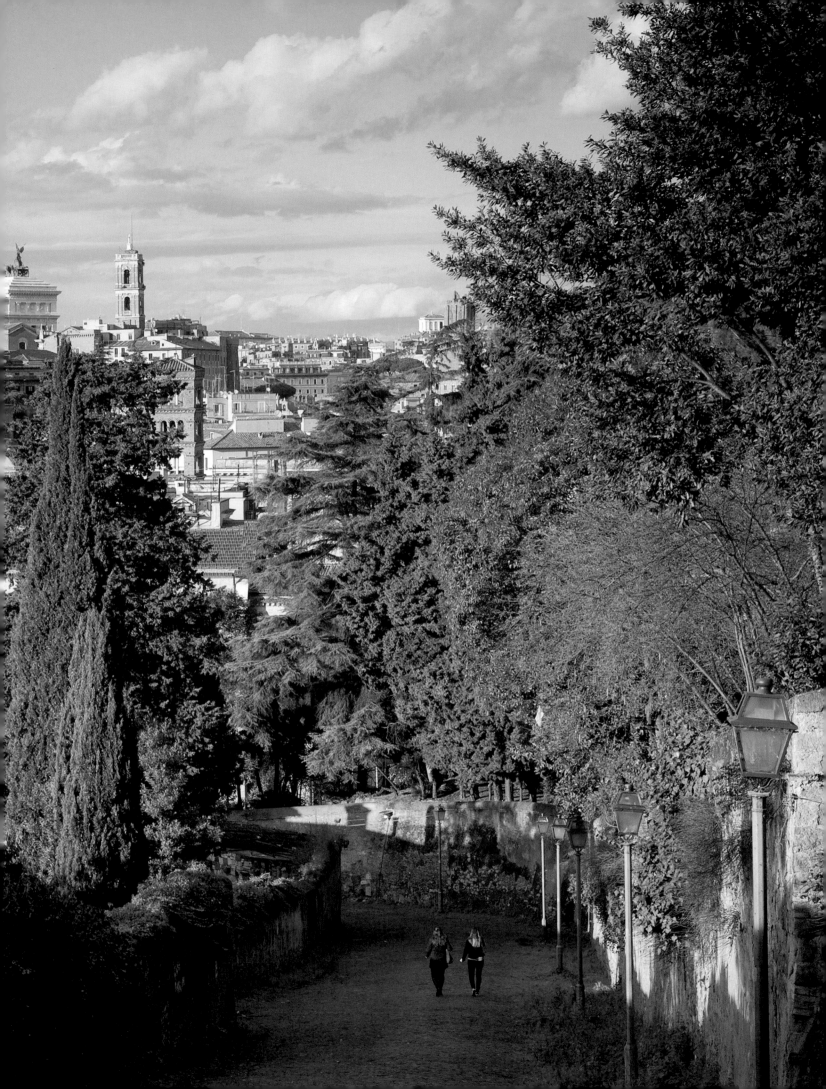

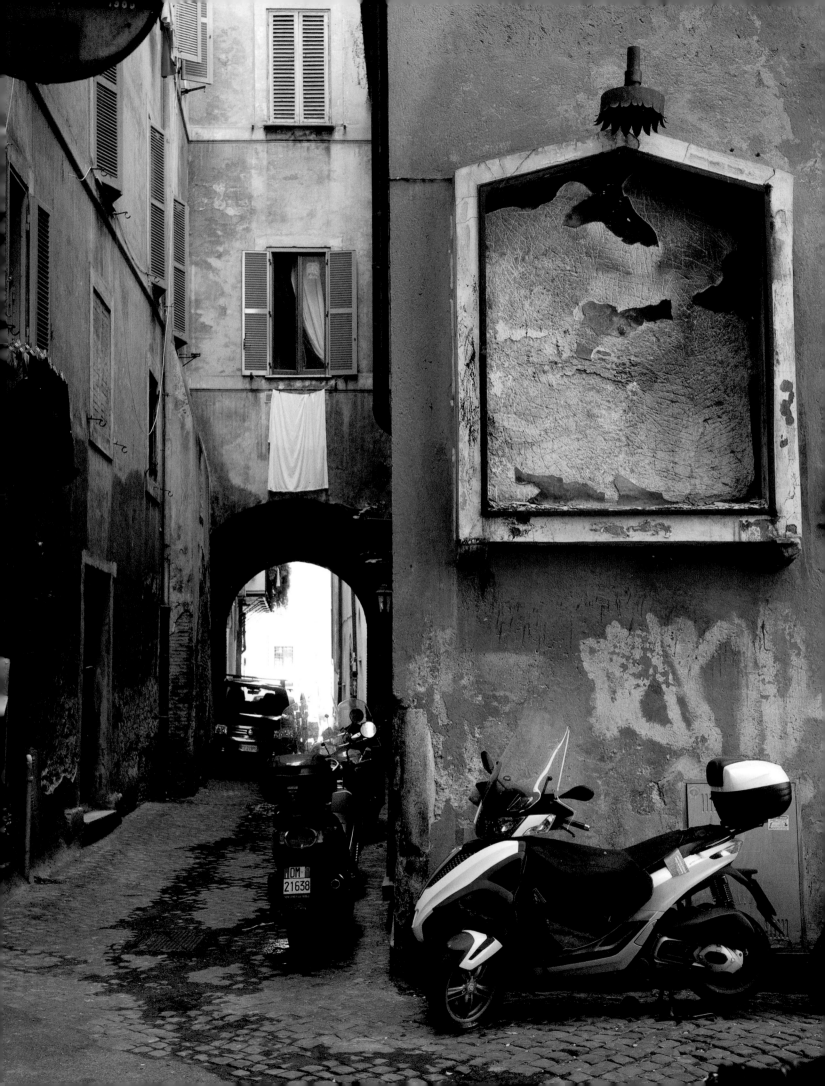

CLEMENTE · X · P · M ·
ANNVENTE
ORATORY CONGREGATIO
PVBLICAE COMMODITATI
ET FACILIORI
AD ECCLESIAM ACCESSVI
VIAM APERVIT STRAVITQVE
AN · IVBILEI · M · DC · LXXV

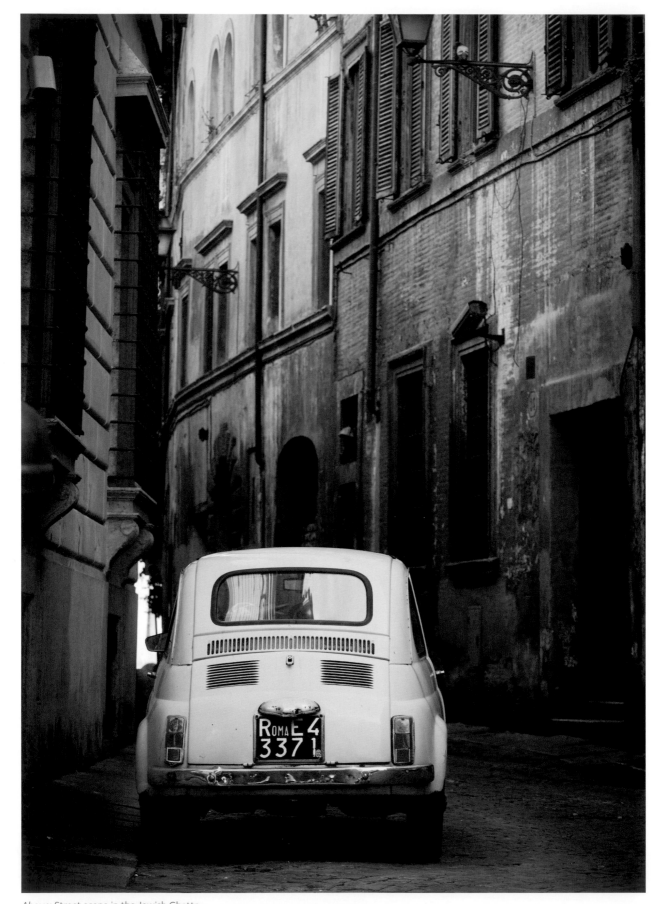

Above: Street scene in the Jewish Ghetto.
Opposite: In ancient times, the *Suburra* (suburbs) was a densely populated area
of slums. It is now home to the recently gentrified, fashionable district of Monti.

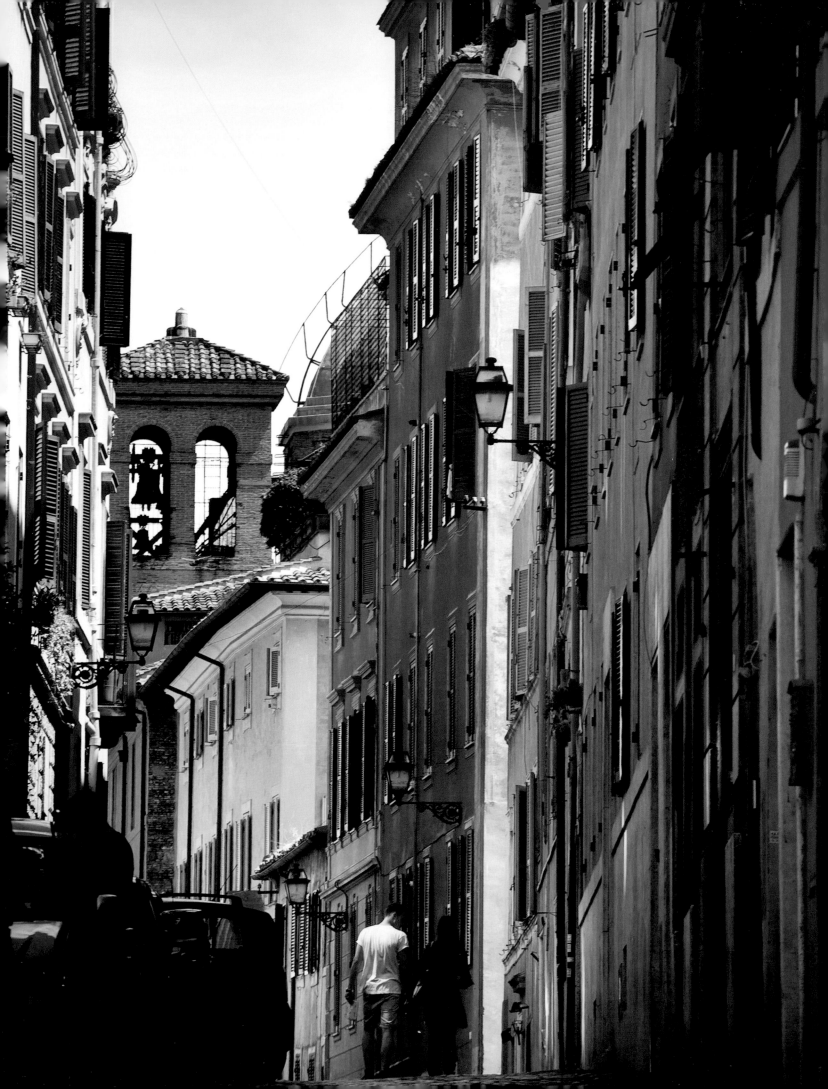

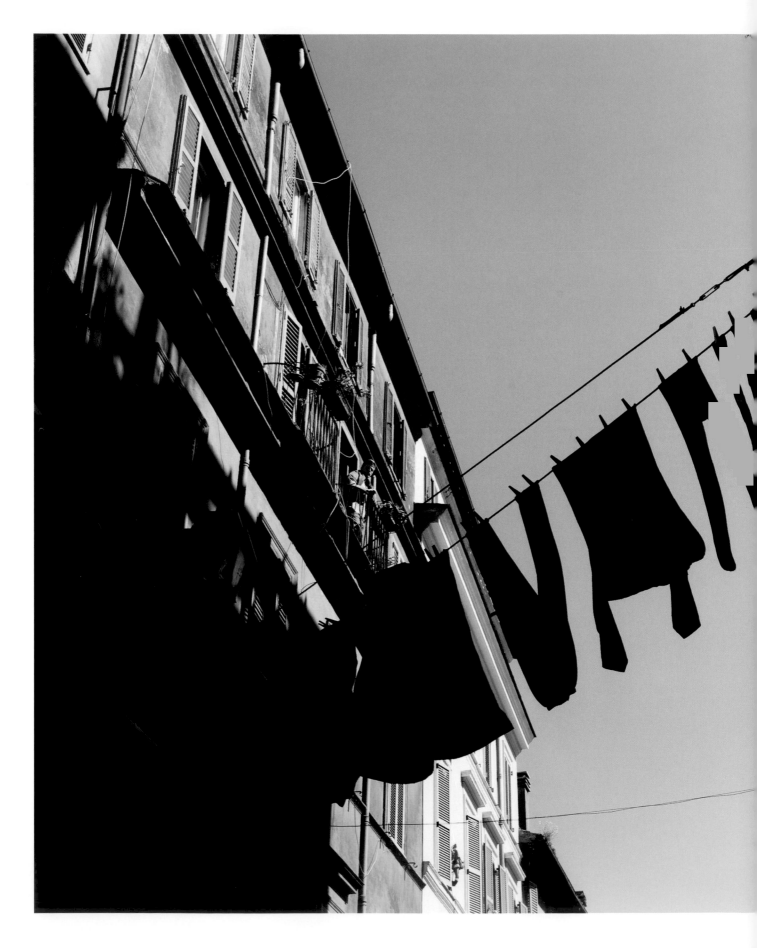

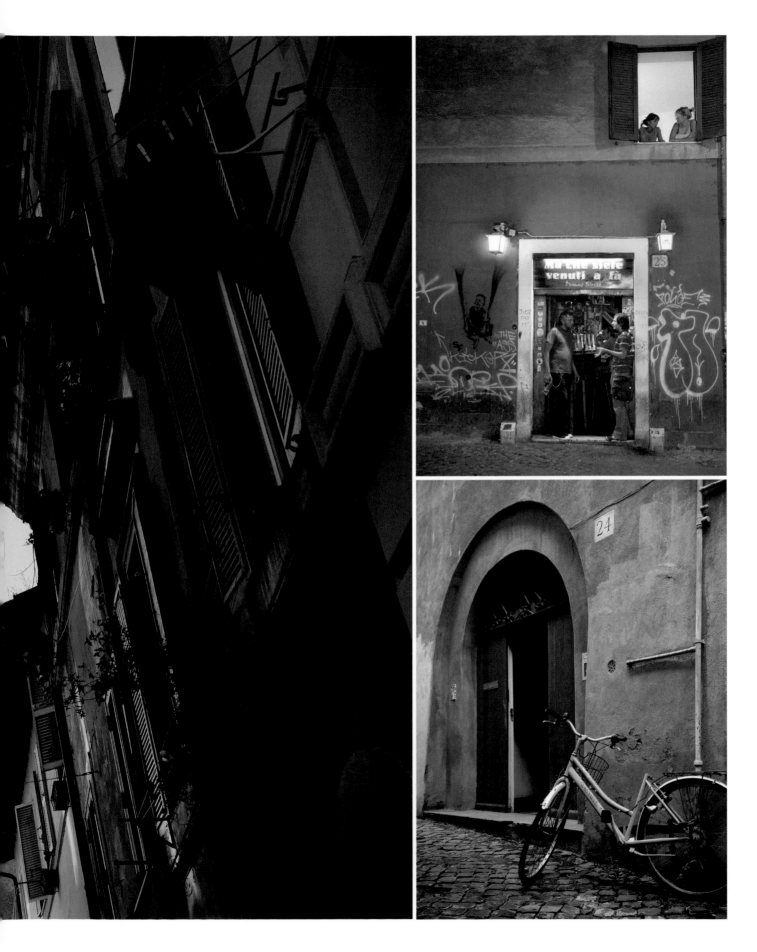

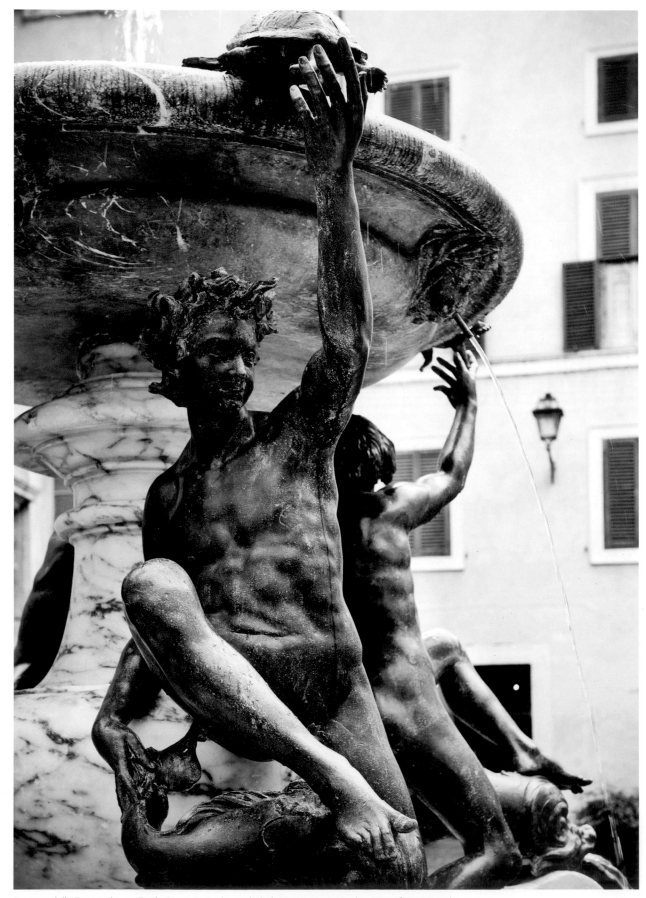

Fontana delle Tartarughe, or Turtle Fountain, in the secluded, Piazza Mattei in the *rione* of Sant'Angelo.

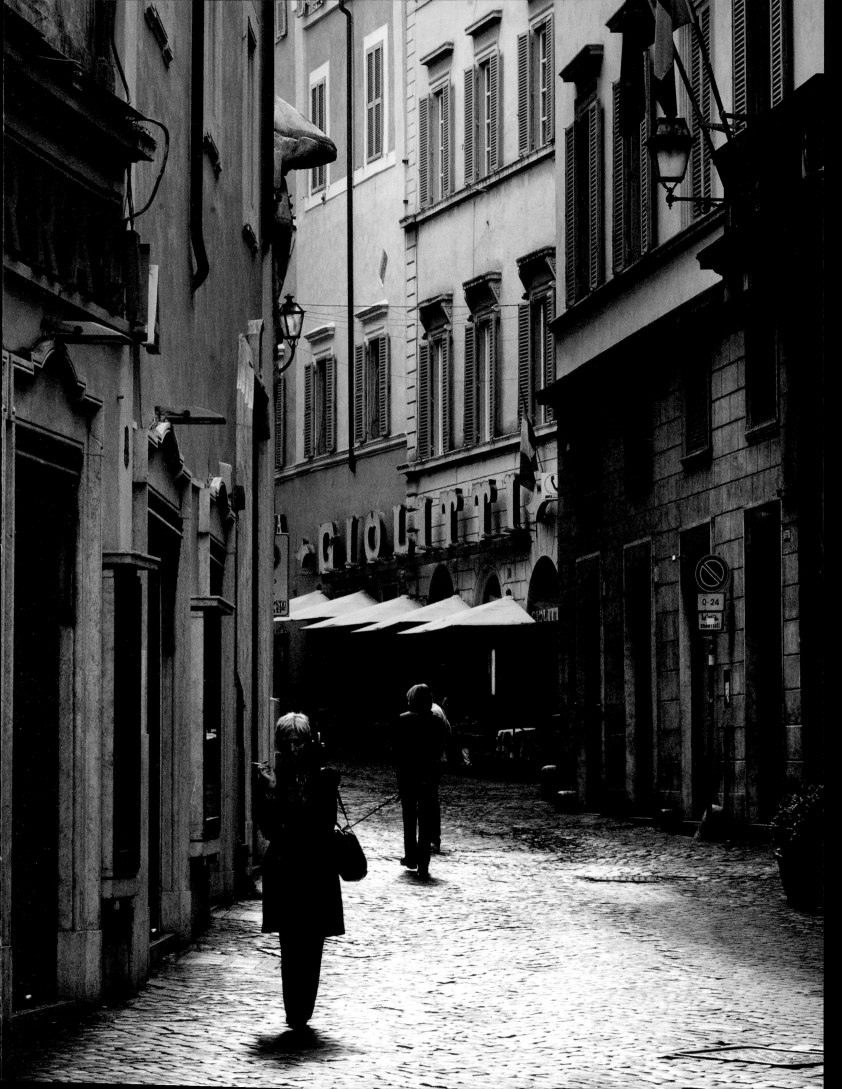

SECRET DOORWAYS *PORTE SEGRETE*

Luxurious frescoed palaces, mysterious cloisters, fairytale gardens and Renaissance masterpieces are just a few of the treasures you can find hidden behind many secret doorways throughout the city centre.

Stumble across the entrance to the Order of Malta's Magistral Villa and peer through the keyhole to the secret, enchanted garden, symmetrically framing the dome of Saint Peter's Basilica in the distance.

Enter a silent, dark church, a few steps from Piazza Navona and find Caravaggio masterpieces, humbly decorating the walls.

Slip through a doorway in a concealed corner of a cathedral and discover Rome's oldest cloister, or enter a 16th-century palace designed by Michelangelo, revealing exquisite Renaissance frescoes and sculptures.

Opposite: The secret garden and fountain at Palazzo Barberini, a spectacular 17th-century palace with architectural features by Bernini and Borromini, houses the Galleria Nazionale d'Arte Antica.

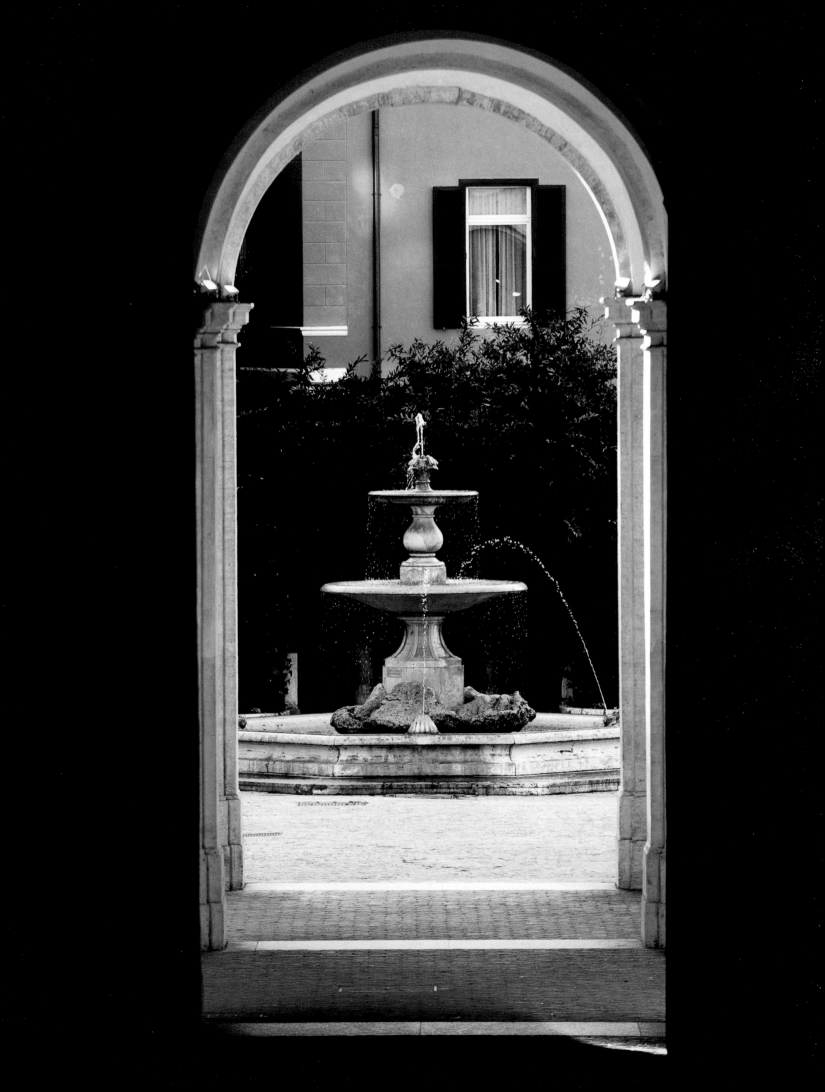

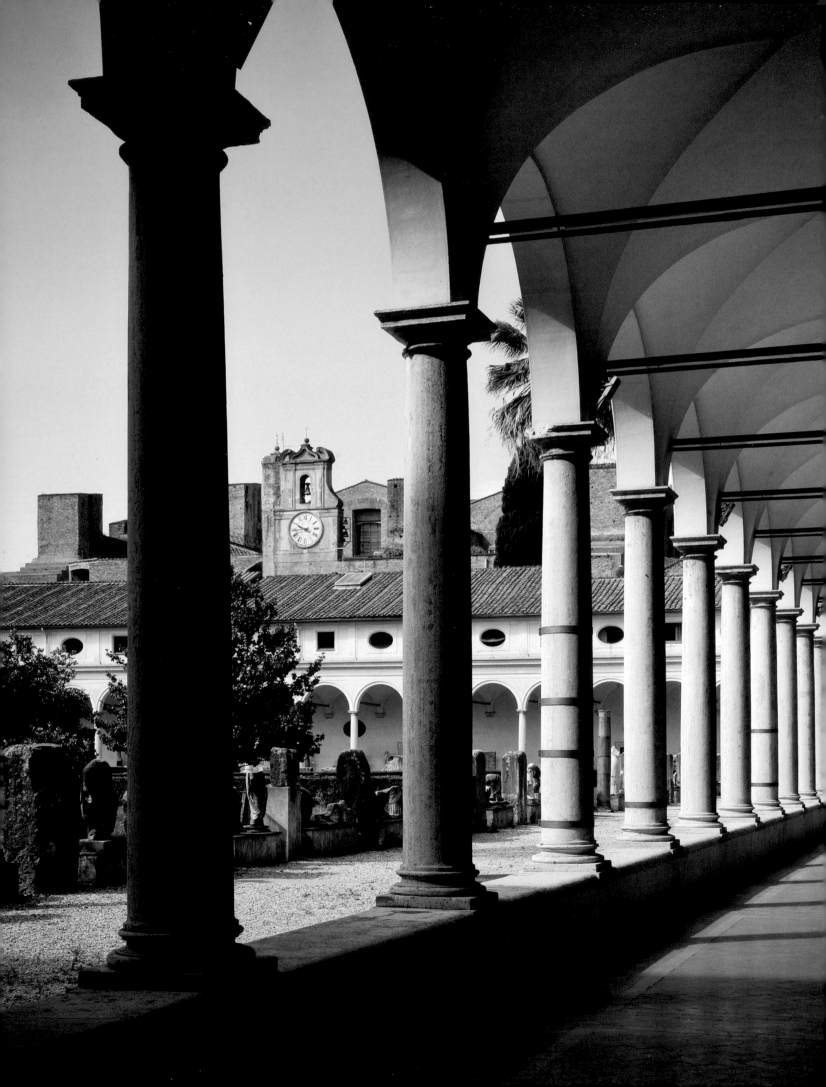

Opposite: Museo Nazionale Romano, 16th-century cloister designed by Michelangelo forming part of the baths of Diocletian, comprises 13 hectares.
Top: The opulent Palazzo Colonna, built in the 14th century by the Colonna family, is one of the largest private palaces in Rome.
Bottom: Subterranean 1st-century mosaics beneath the Palazzo Farnese.

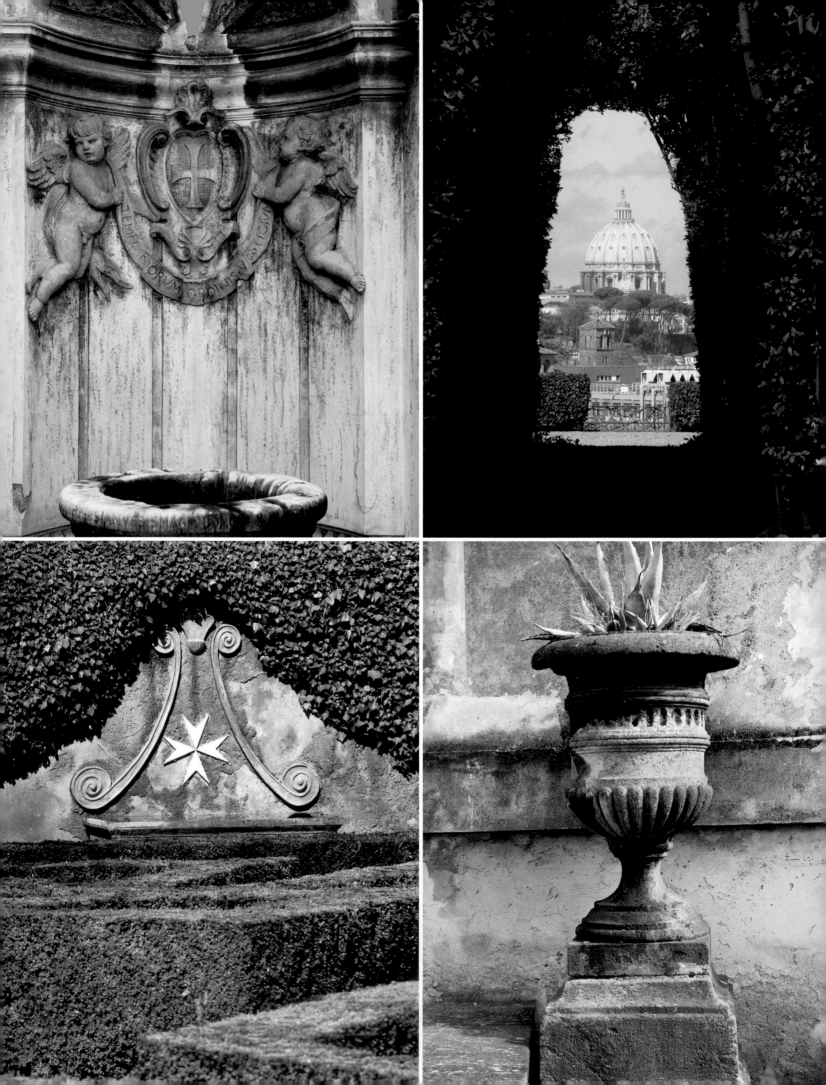

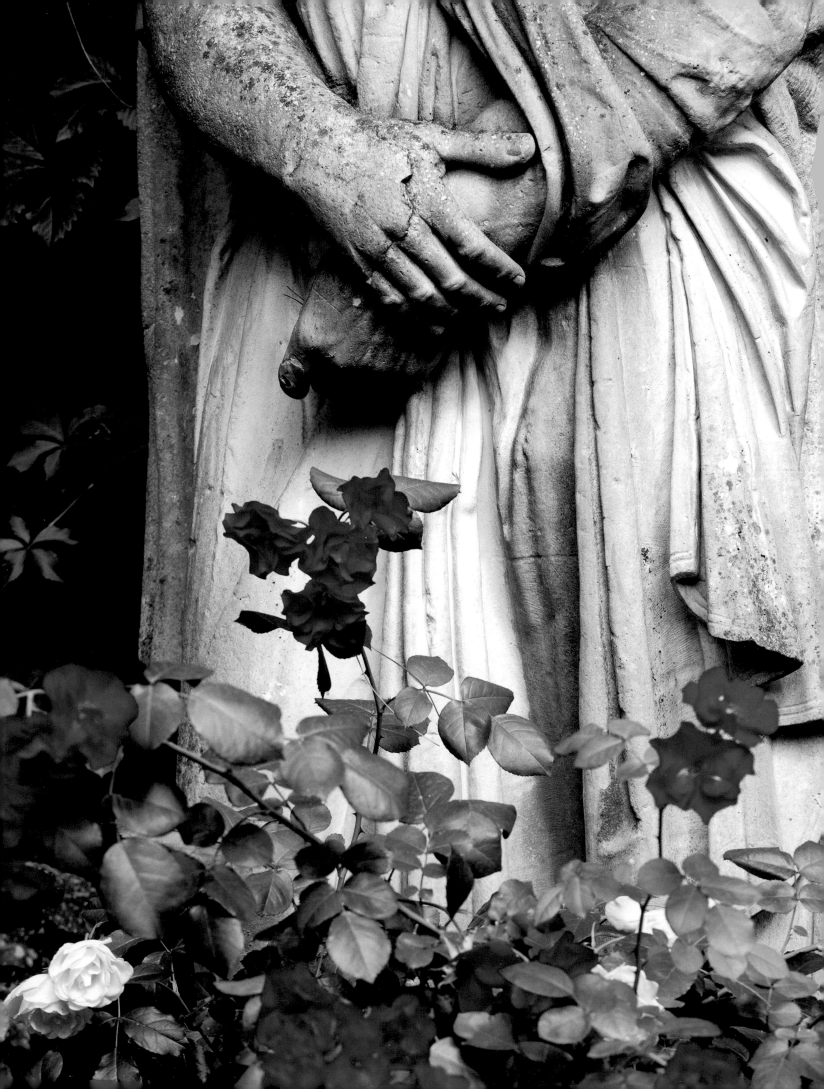

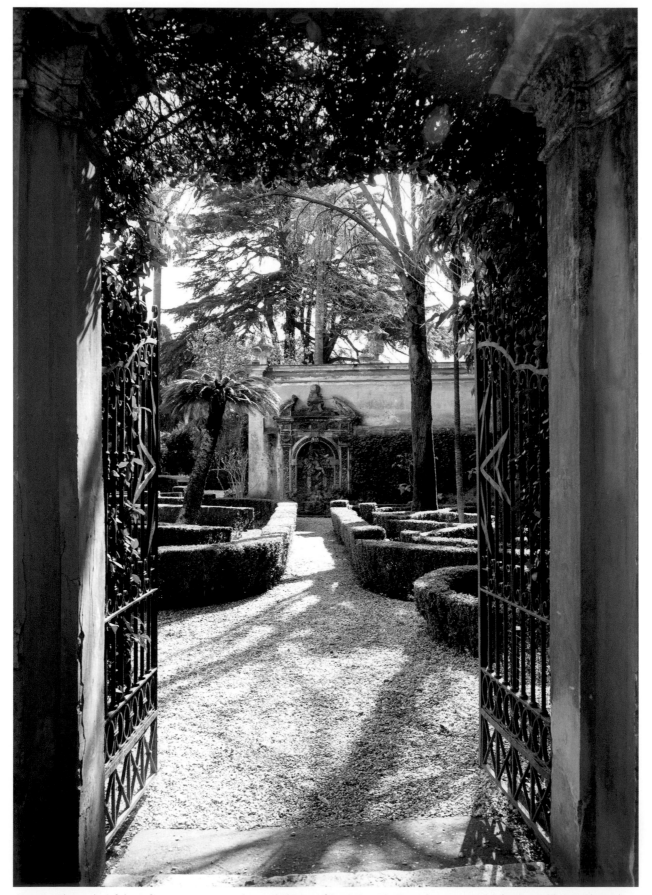

Opposite: The garden of the Anfiteatro Castrense – the amphitheatre of Santa Croce in Gerusalemme, a mini Colosseum with an enchanted garden of ornamental trees, shrubs and an organic fruit and vegetable garden, cultivated by Cistercian monks over several centuries.
Previous page and above: The secret garden of the Magistral Villa of the Sovereign Order of Malta, on Aventino Hill and the Palazzo Farnese garden.

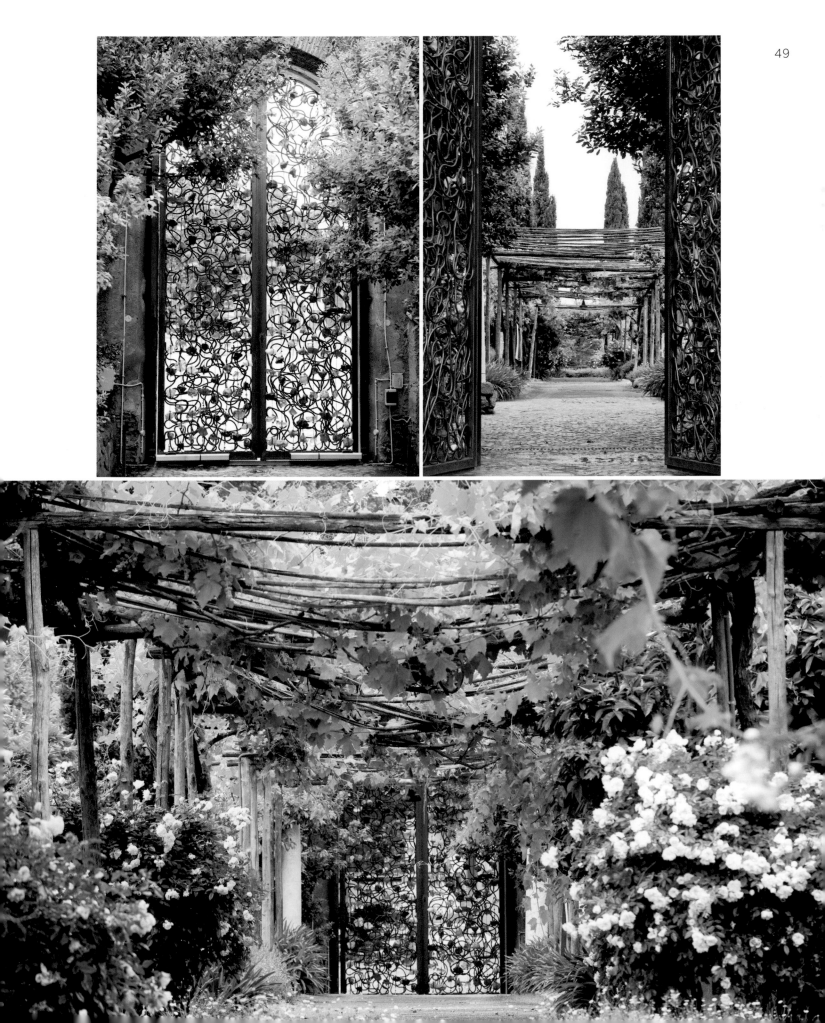

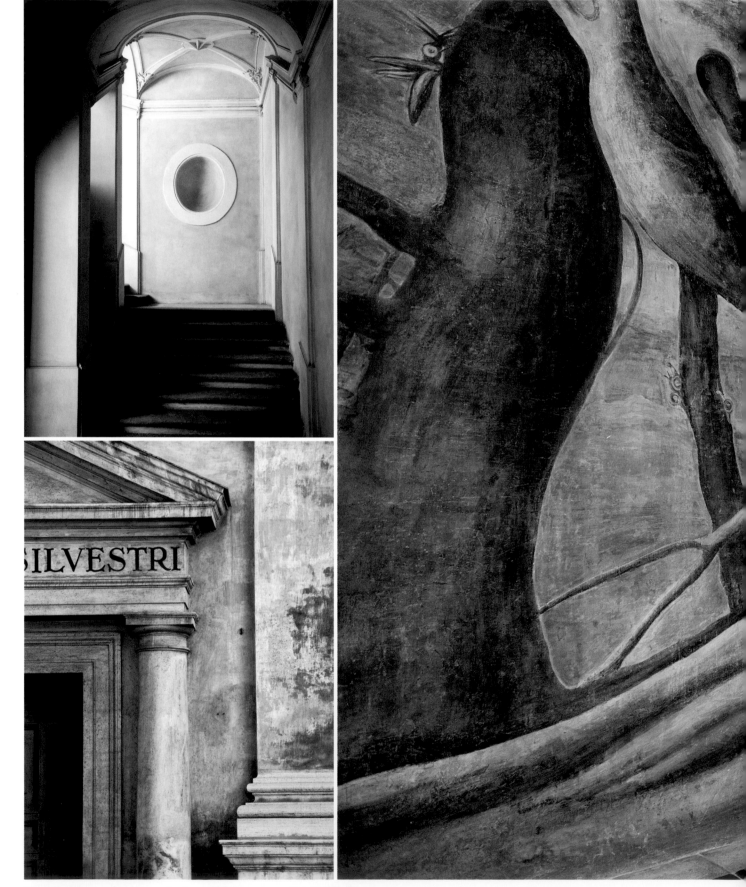

The optical illusion of an anamorphosis, a wall fresco representing the life of
Saint Francis of Paola, in the Convent of Trinità dei Monti near the Spanish Steps.

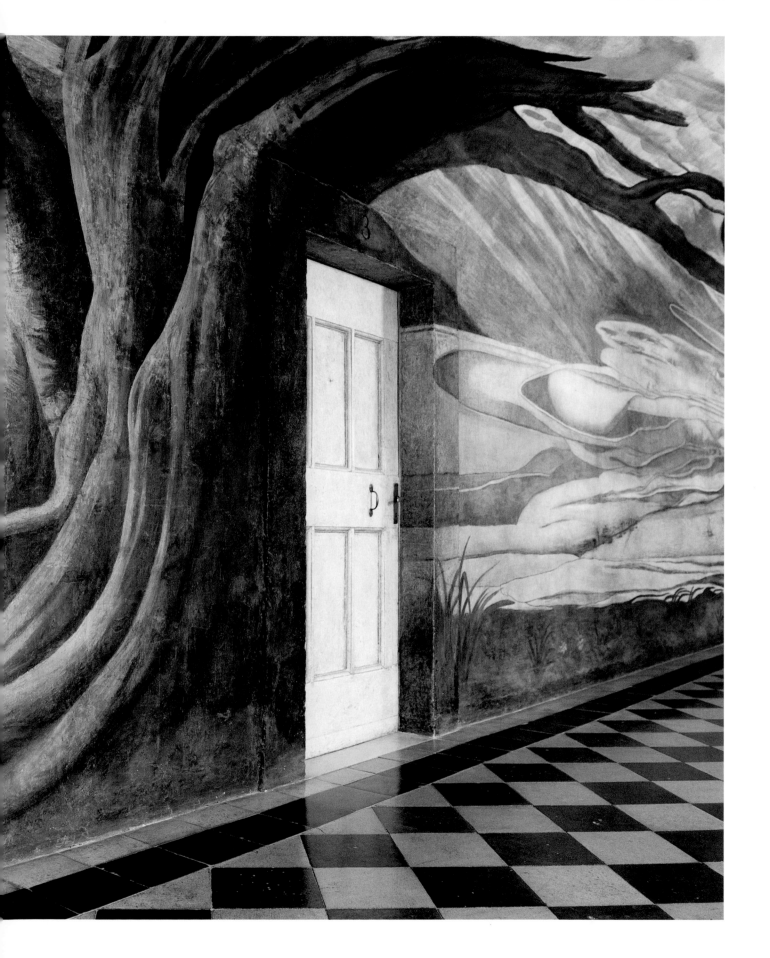

ROME WITH A VIEW *IL BELVEDERE*

From the dome of St. Peter's one can see every notable object in Rome... He can see a panorama that is varied, extensive, beautiful to the eye, and more illustrious in history than any other in Europe.

— MARK TWAIN

Experience a different dimension to Rome away from the orderly chaos and frenetic pulse of the busy city streets.

Step out onto an exclusive, stylish, sixth-floor panoramic terrace bar or restaurant with breathtaking vistas. Take a brisk hike up a flight of well worn stairs to a public lookout with expansive views or stroll through a secluded, romantic garden for a more intimate perspective.

Rome's signature skyline of marble and ochre, terracotta rooftops, jewelled domes and crucifixes will captivate you and leave a lasting impression on your senses.

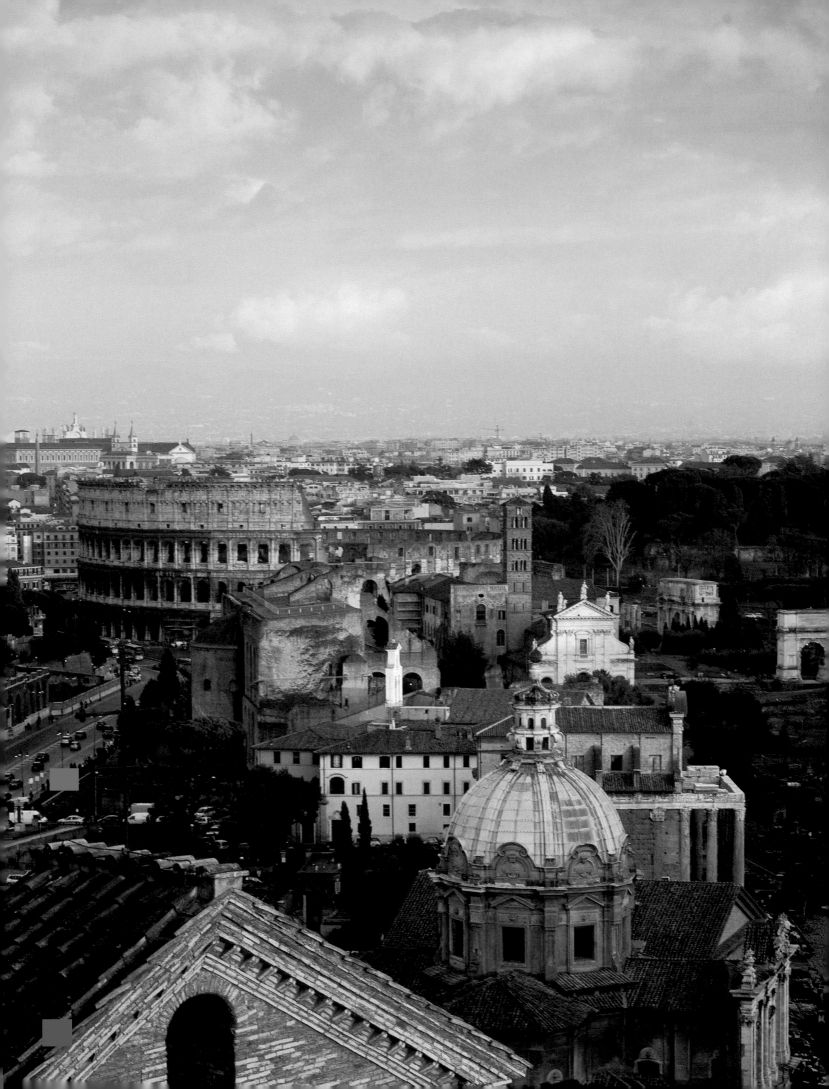

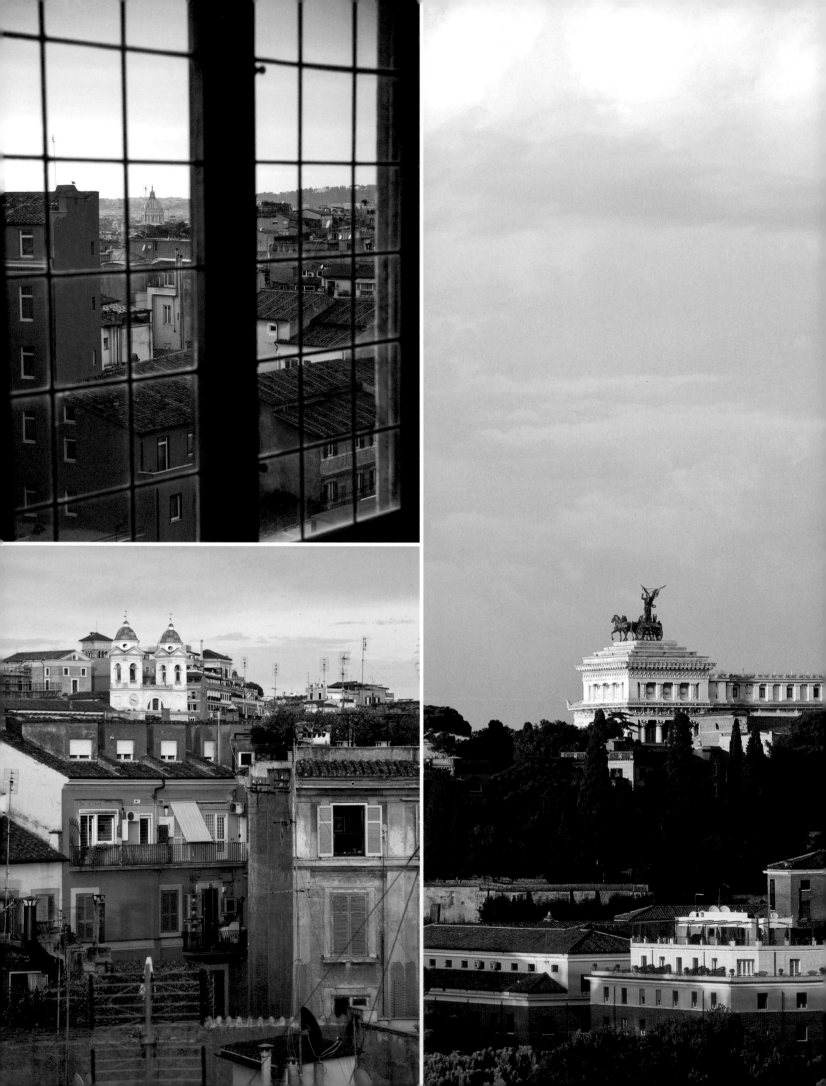

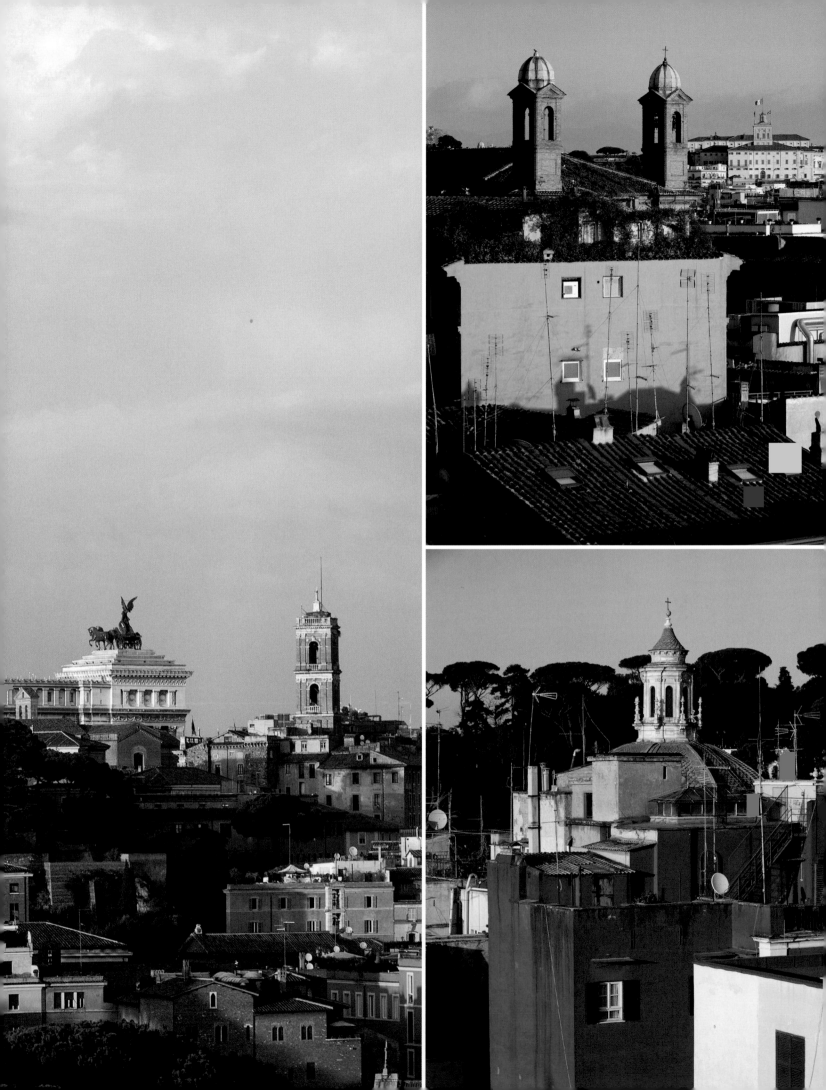

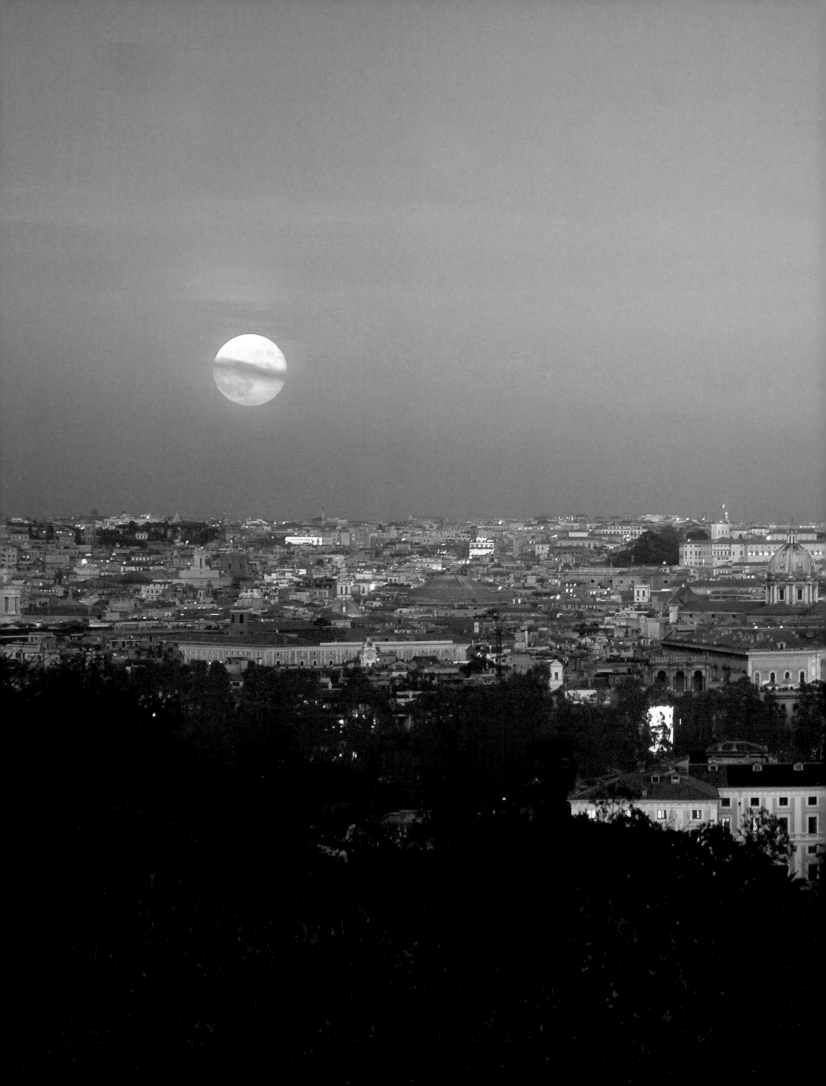

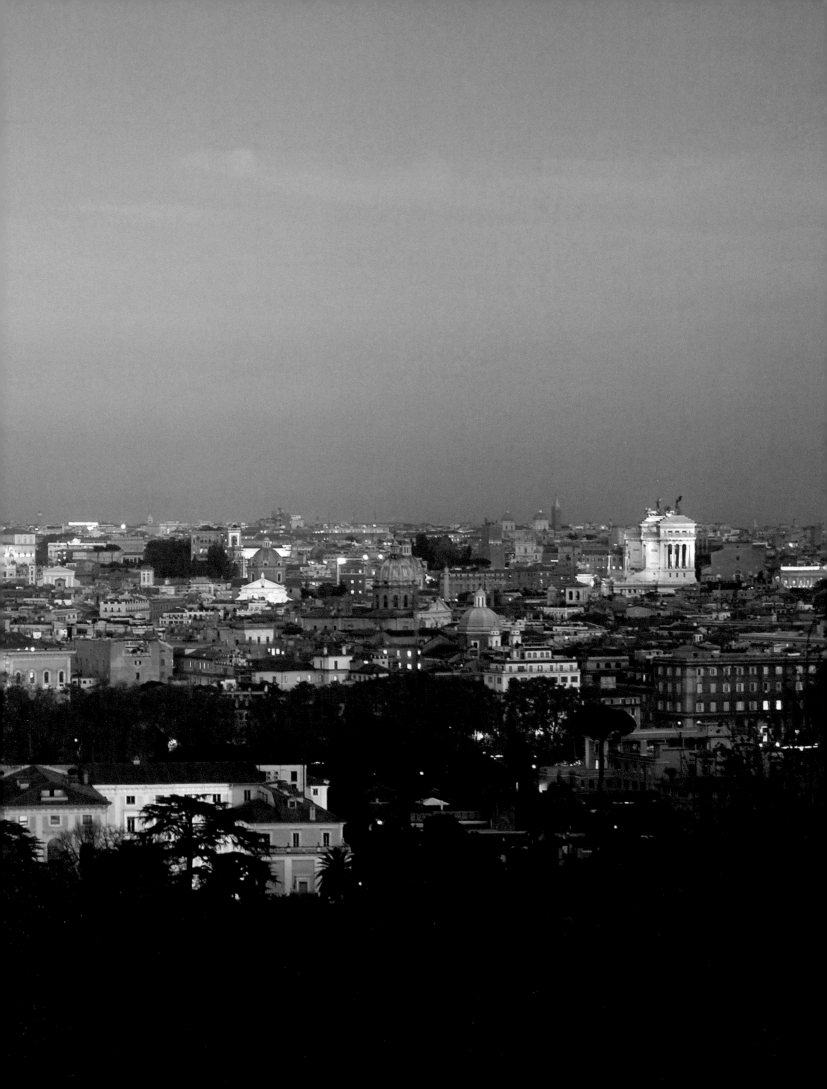

SEASONAL ROME *LE STAGIONI*

The light that reveals Rome's monuments is not that to which we are accustomed; it produces numerous optical effects plus a certain atmosphere, all impossible to put into words. The light strikes Rome in ways that I've never seen.

— MARIE–HENRI BEYLE, ALIAS STENDHAL

Rome conveys a kaleidoscope of changing moods and expressions throughout the seasons.

Spring bursts forth with new life, light and colour, melting away the late winter sleepy blues. The air is filled with a vibrant anticipation and a contagious, playful flirtation that overflows from the city sidewalks and piazzas. It is undoubtedly one of the most romantic seasons to experience in Rome.

It is also the season of freshly picked *carciofi* (artichokes), *fave* (broad beans), *asparagi salvataggi* (wild asparagus) and juicy red *fragole* (strawberries), to name a few, and you can find these ingredients flavouring the seasonal menus at many restaurants and trattorias.

The warm Mediterranean sun rises to its peak in the summer months and the heat penetrates the stone, marble and cobblestones. Summer is by far the most popular season for tourists to flock to the city. The streets are overflowing with sightseers as the sultry, humid air fills the days and nights.

Aperitivo hour in the bar-fringed piazzas are filled with stylishly dressed Romans sporting the latest summer trends while savouring a refreshing *Campari soda*, *spritz*, *prosecco* or orange-infused *Crodino*.

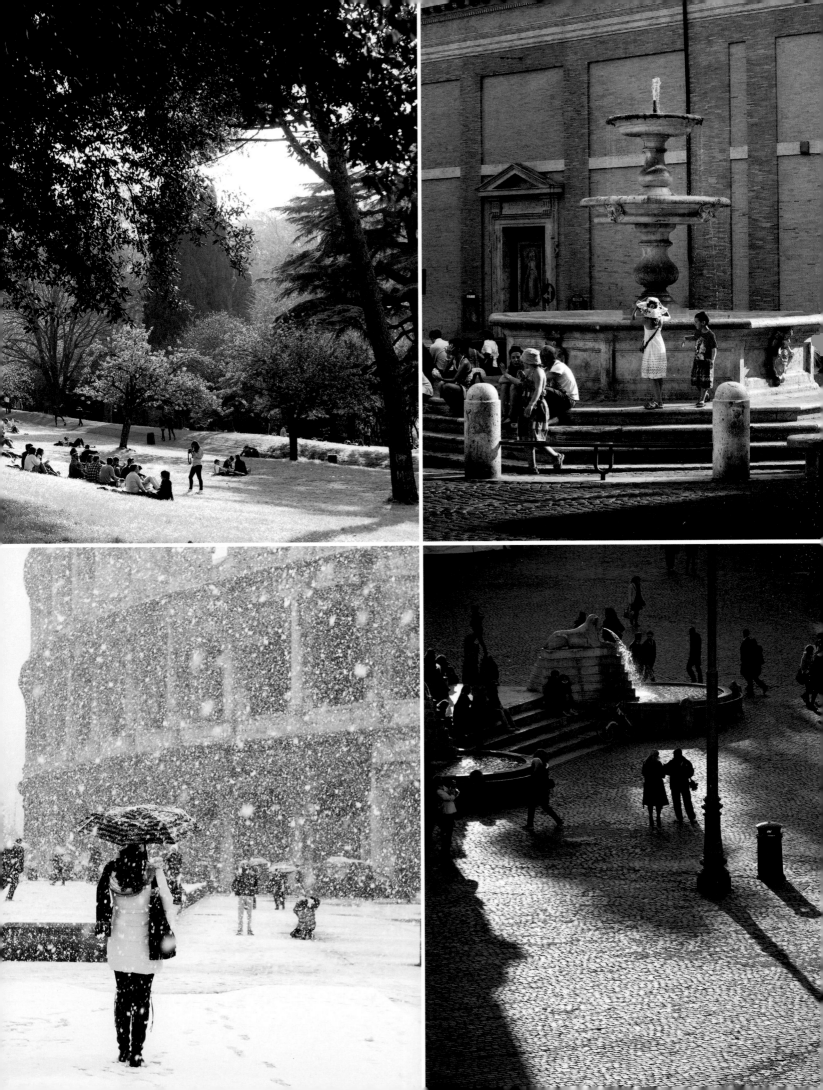

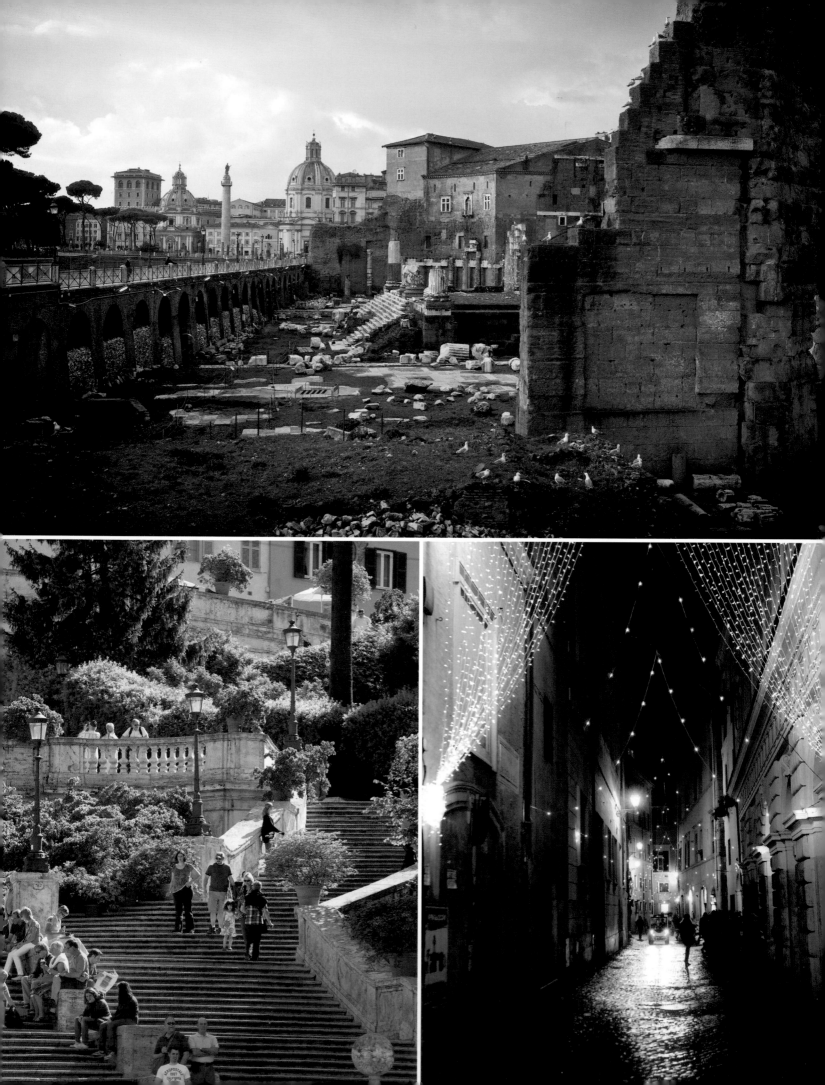

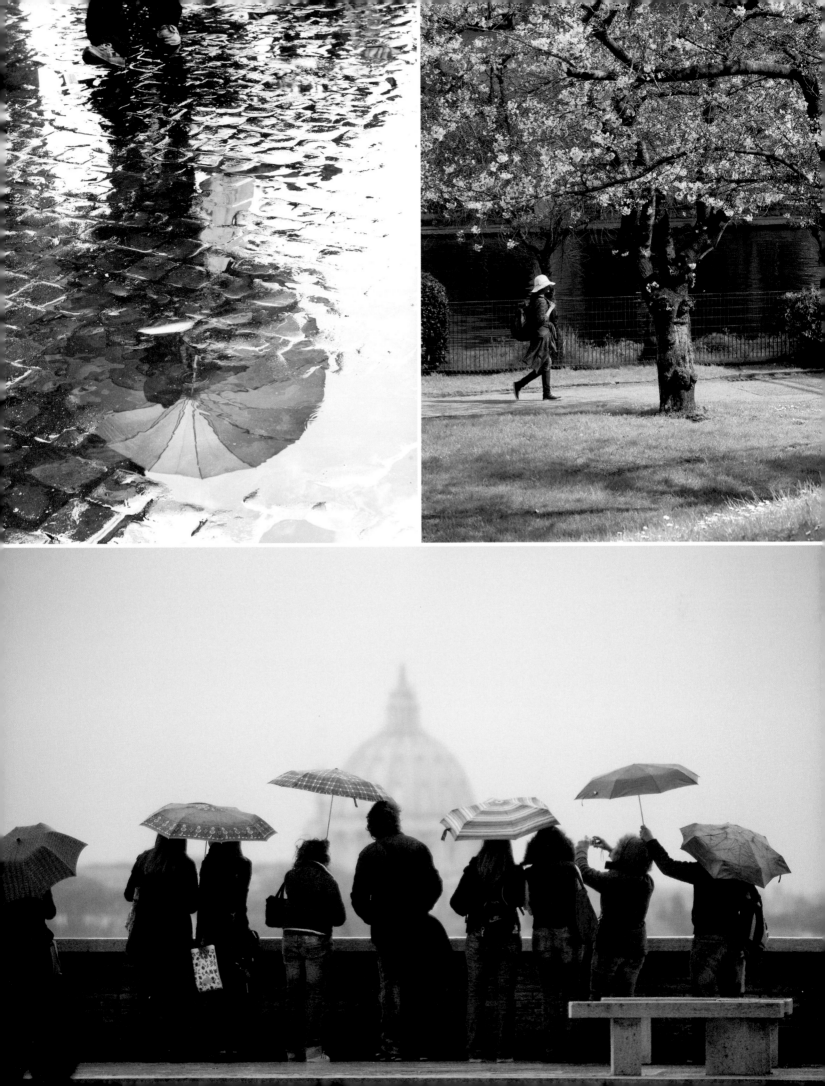

The month of August transforms the city as many Romans flee, trading dusty cobblestones for white sandy beaches on their annual summer vacation. The city streets have a slight reprieve from the daily onslaught of chaos and movement as many bars, restaurants, offices and shops close for the three-to-four-week *riposo*, or rest.

The arrival of Autumn fills the atmosphere with a magical light, painting the sky and city streets like an impressionist masterpiece, with strokes of soft pastel hues of golds, greys and blues. The city reveals her most sublime beauty during this season as the days grow shorter and the shadows stretch longer over the cobblestones. Rich golden, red sunsets celebrate the days end as swarms of migrating starlings create pirouetting whirls, dancing in the sky.

The crisp cool air of Winter heralds a season of festivities, celebrations and cheer as the year comes to a close. Religious and sacred festivals fill the calendar days. Urban street scenes transform into sparkling, jewelled showpieces as millions of Christmas lights and decorations, glisten from shop windows, street corners and grand boulevards.

The sweet aroma of roasting chestnuts drifts from street corner grills and market stalls are decorated with colourful gourds and *puntarelle* (chicory), while *tartufi* (truffles) flavours a medley of restaurant dishes. As seasonal temperatures plunge, Mother Nature performs her winter spectacle and paints the cityscape a pristine white, rendering the city a monochromatic wonderland.

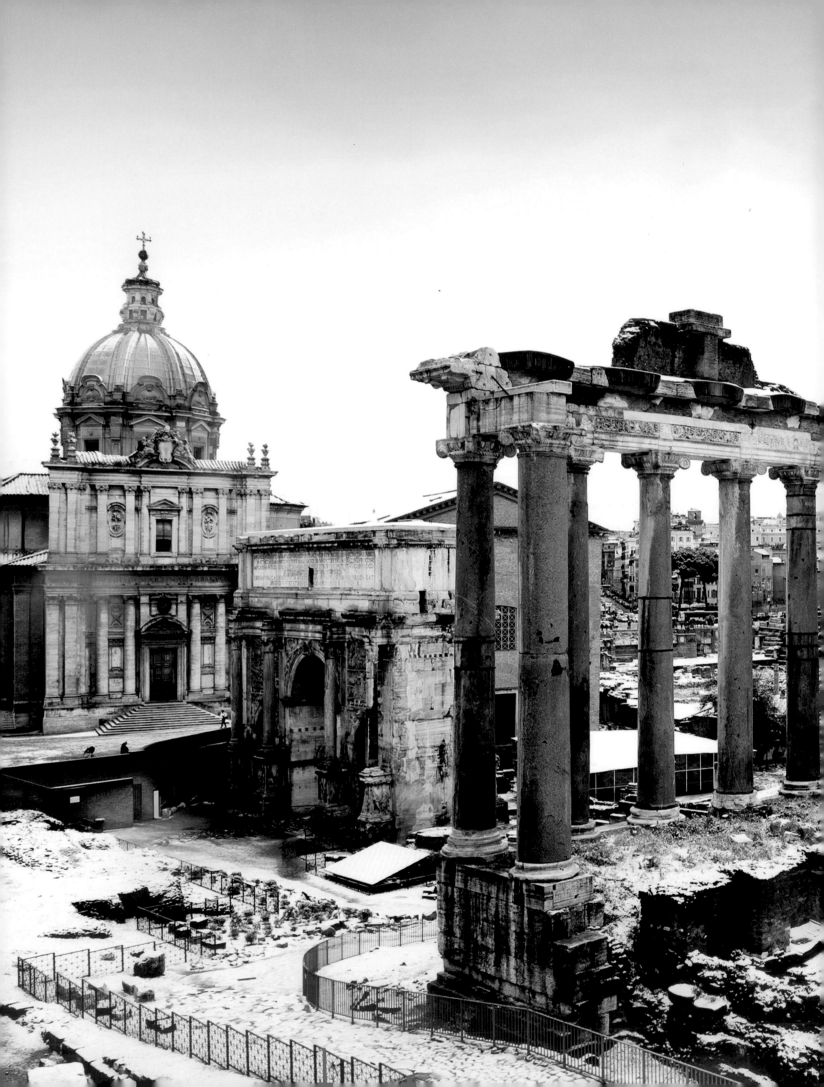

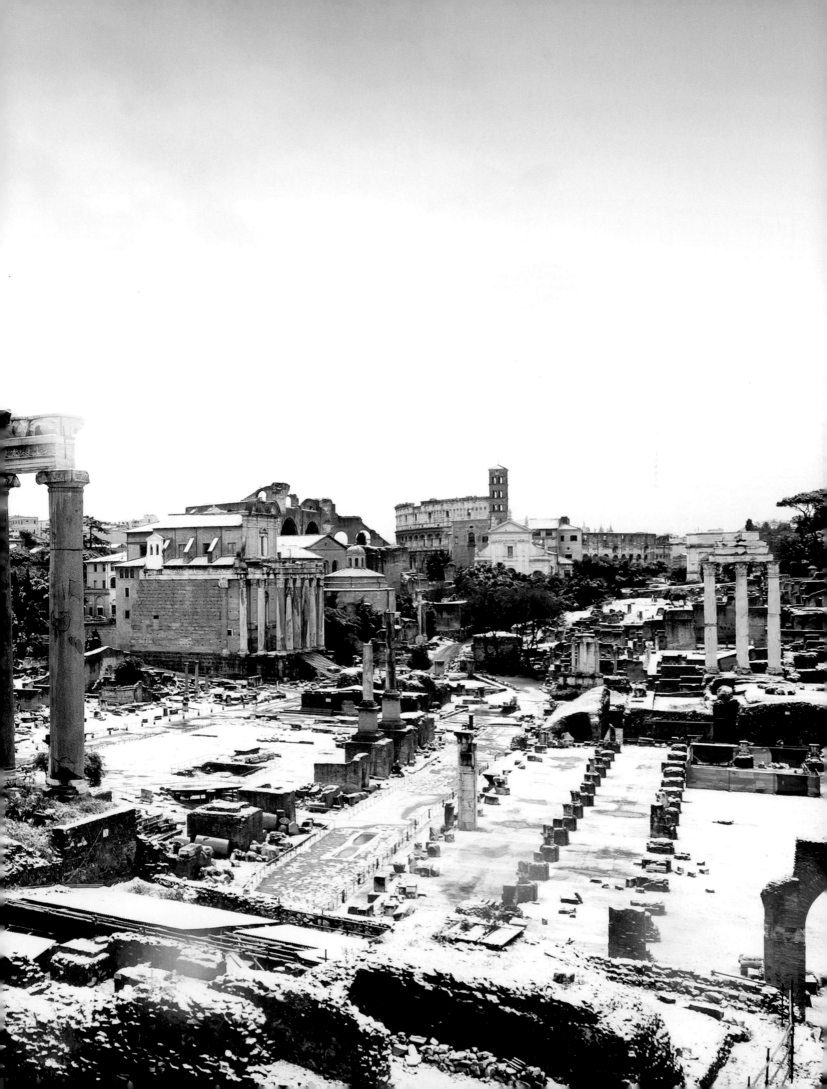

MARKET *Al Mercato*

Y ou can find them in many alleyways, piazzas and street corners scattered across the historic centre and beyond – i *mercati*, or markets.

To experience daily life like a true local, there is no better place to start than at a Roman market.

Wandering the local markets is a feast for your senses – richly coloured and textured fresh fruit and vegetables, meticulously stacked in rows creating a masterpiece out of nature's rich palette and filling the air with fresh and alluring aromas.

The warm, open and authentic hospitality and friendliness of the local farmers and producers, proud of their produce, will have you engaged and relishing in the life of the local market.

Francesco, with his freshly baked bread from bio-dynamic wheat and grains; Alfredo and his farm-fresh *carciofi* (artichokes), *limoni* (lemons), *pomodori* (tomatoes) and *melanzane* (eggplant) and Geppa with her wide, open smile, offering an assortment of hand-picked aromatic herbs from her *agriturismo*, or farm, outside of Rome. These are just a few of the faces that you may find at some of the local markets enriching your experience and enticing you back for more.

There are not only countless fresh produce markets to enjoy in Rome, you can also find an assortment of speciality markets in different *rioni* and at varying times of the week, month and year. Markets with flowers, vintage clothing, shoes, art, antiques, books, bric-a-brac, and organic fruit and vegetables picked from the *campagna romana*. There is something for everyone and every taste.

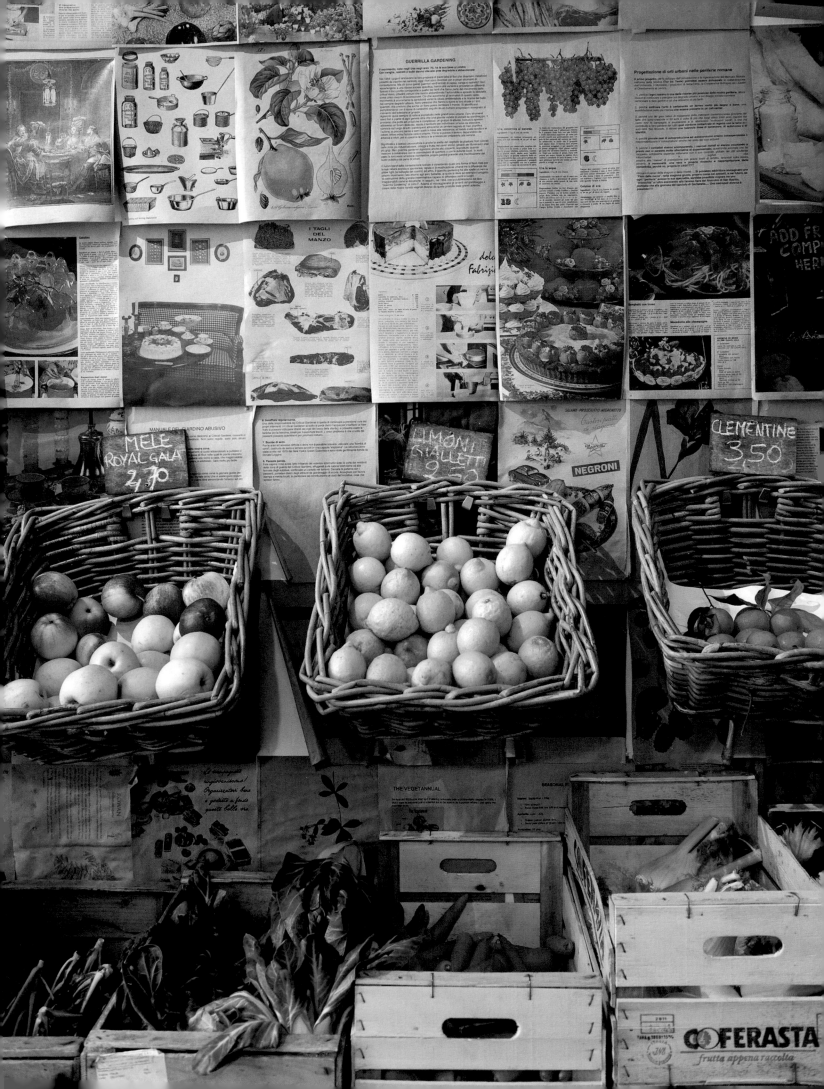

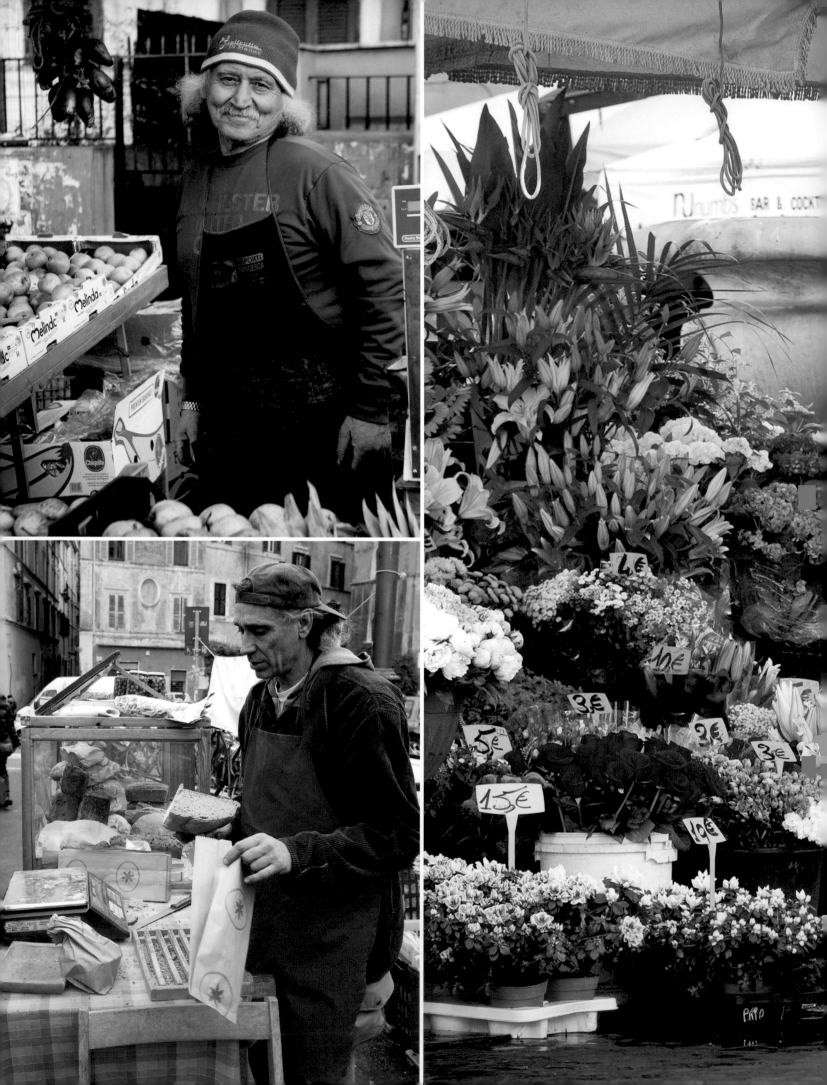

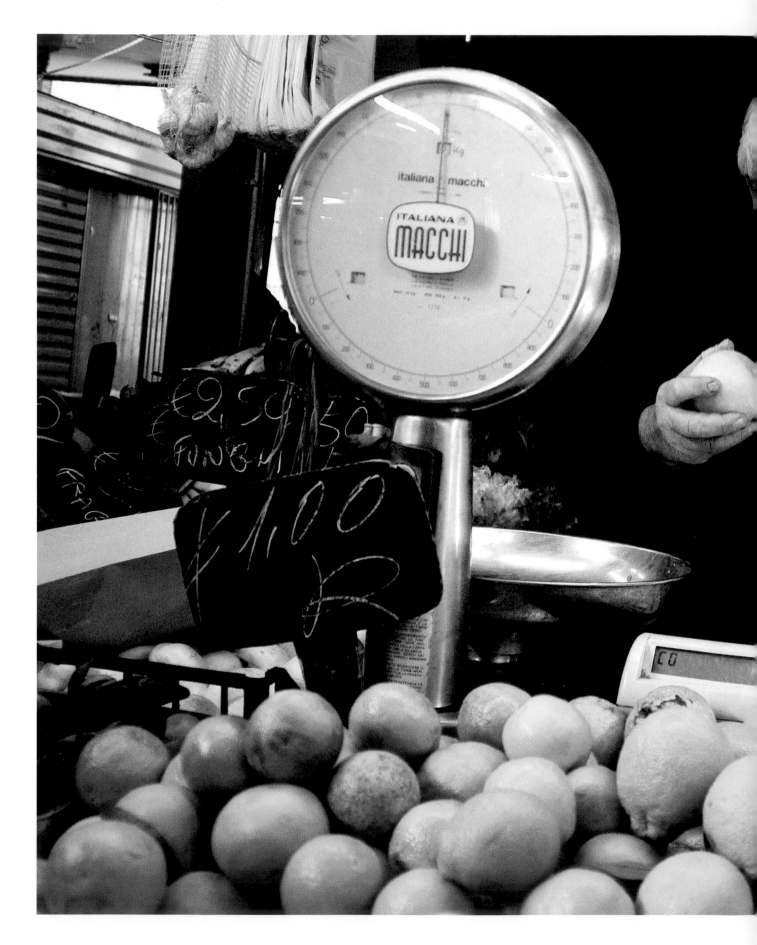

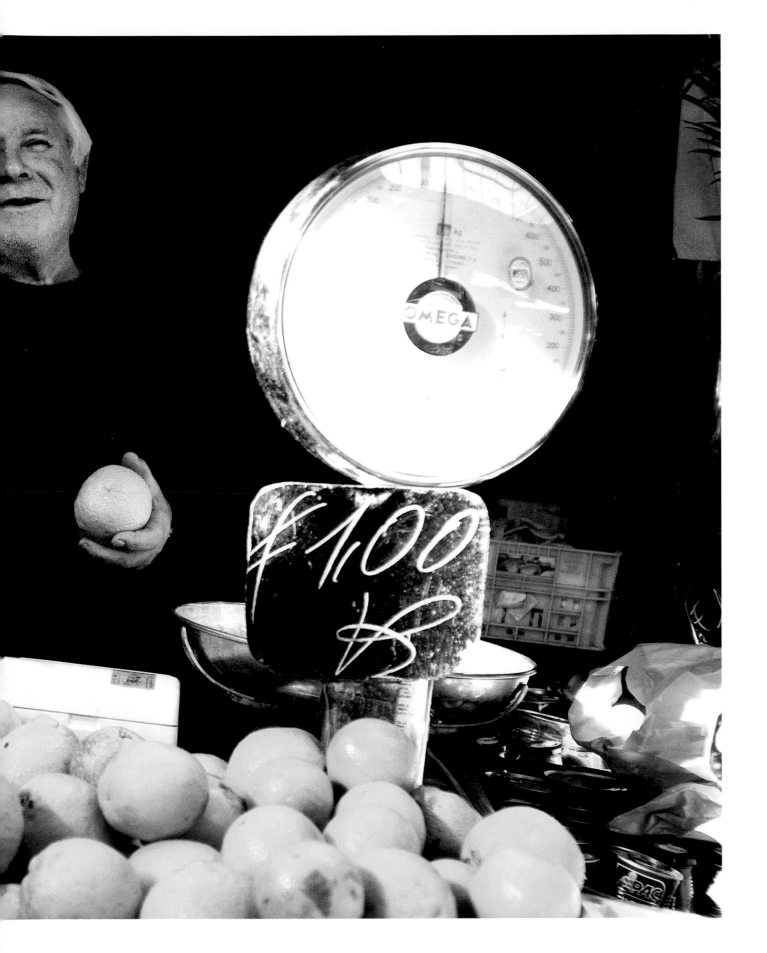

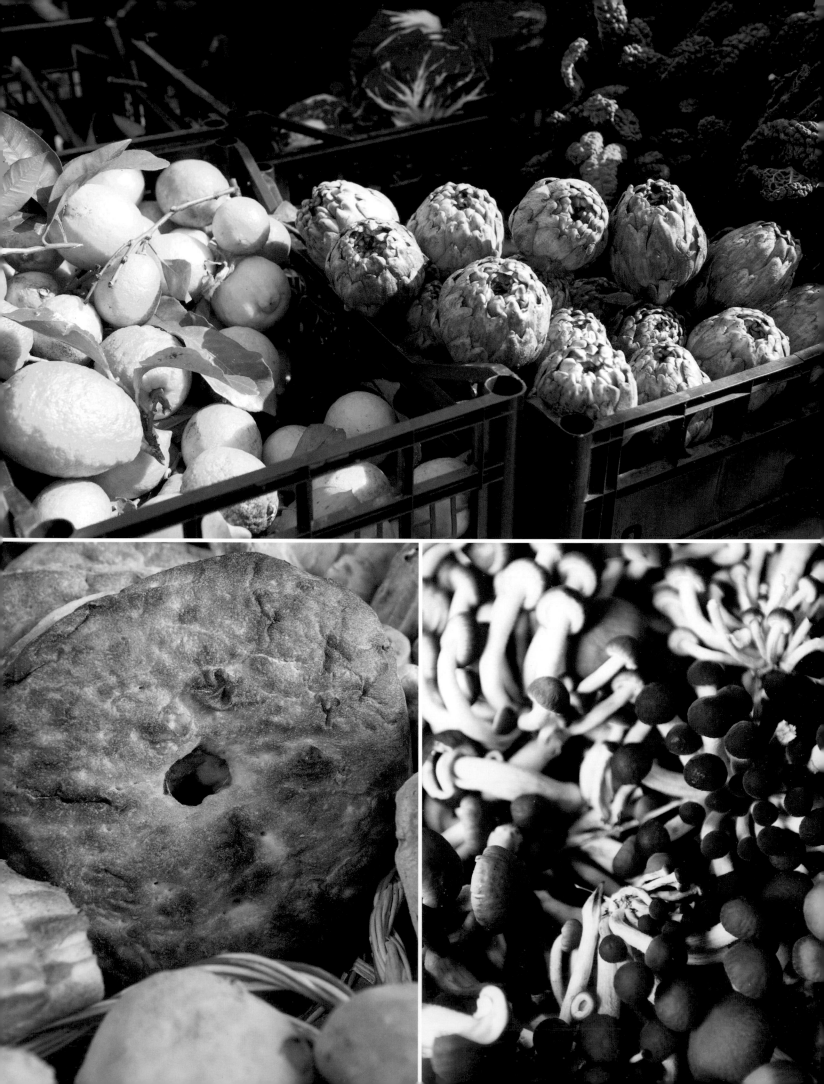

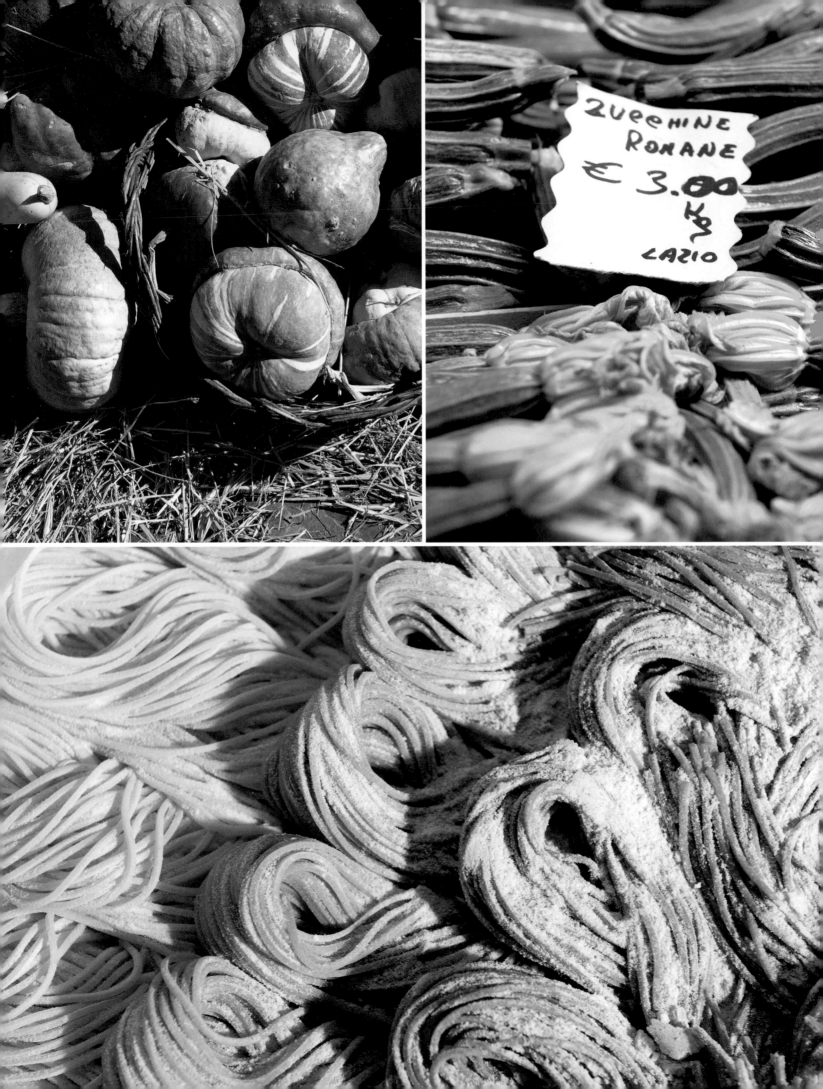

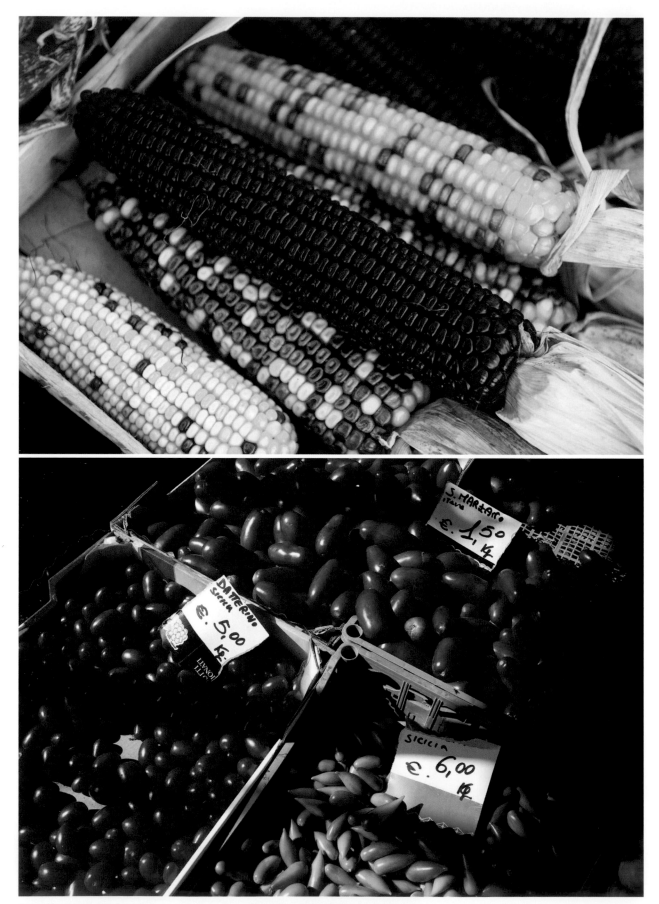

Top and opposite: Food producers and farmers from the Lazio region sell their produce at the
Mercato di Campagna Amica del Circo Massimo, or Circo Massimo Farmers Market, every weekend.
Bottom: Tomatoes for sale at the Campo dei Fiori markets, which are held daily.

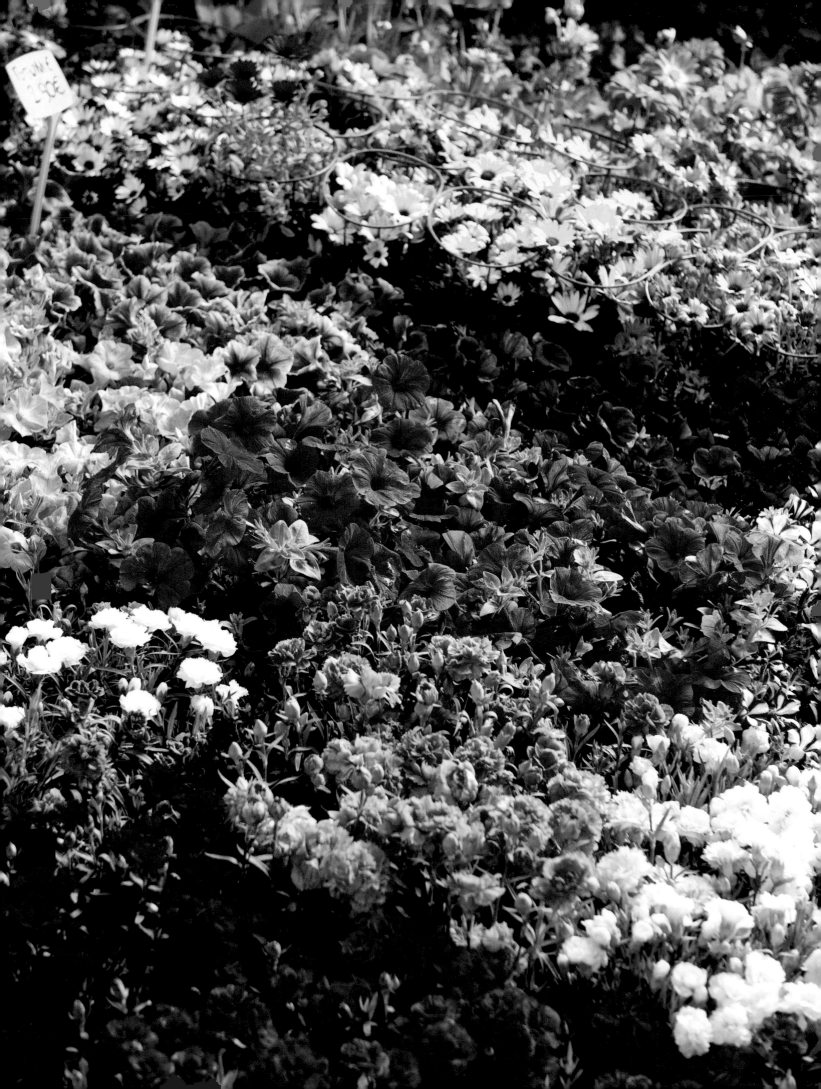

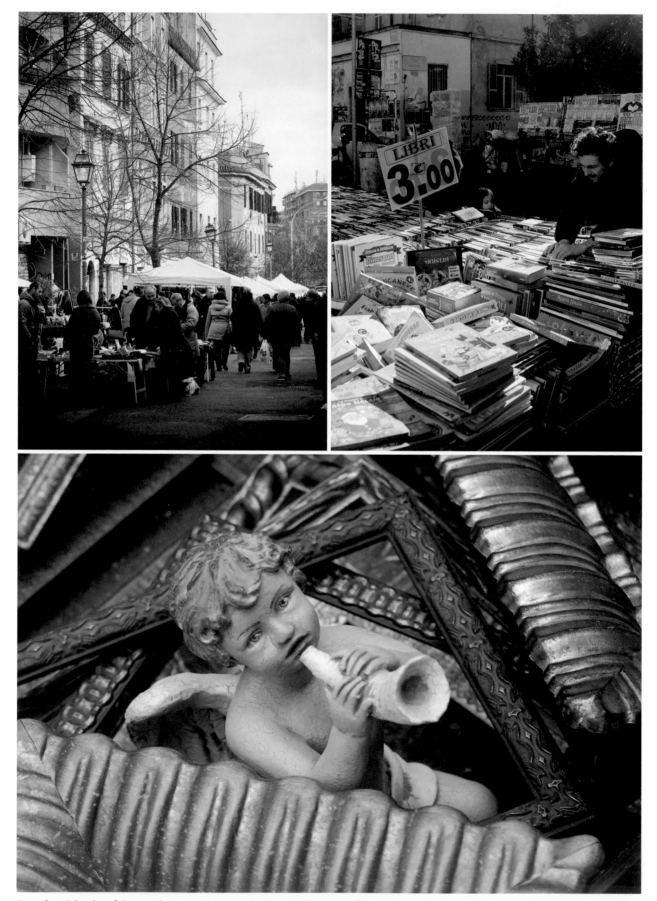

Every fourth Sunday of the month, Via del Pigneto in the Pigneto district transforms into an open-air market.
Vintage fashions, books, antiques, bric-a-brac and fresh produce are just a few of the offerings available.

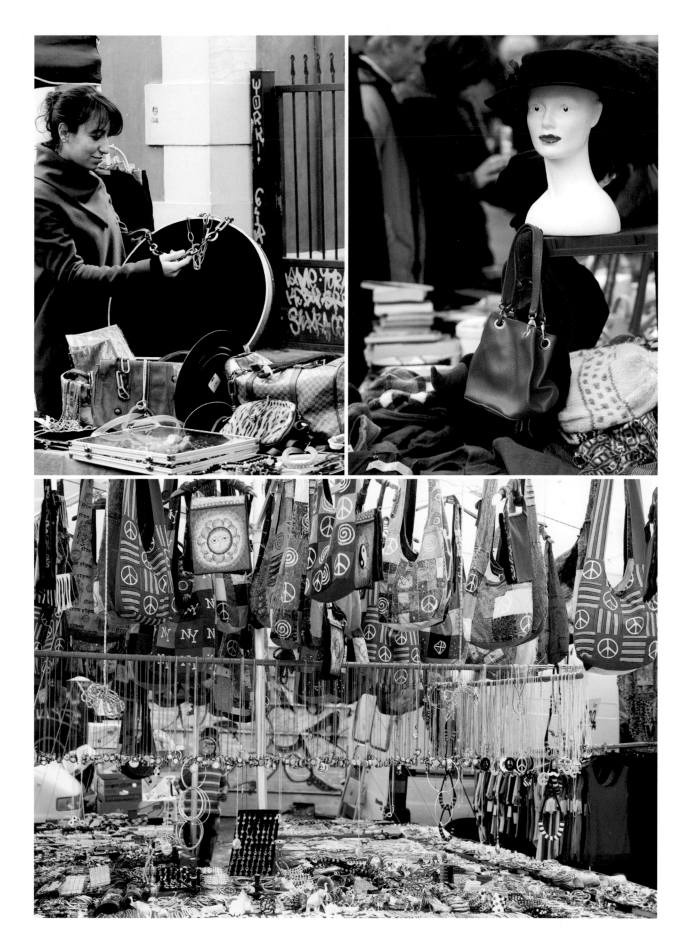

EATING *Mangiare*

A tavola non si invecchia. (One does not get old when eating at the table with good friends and family.)

– ITALIAN PROVERB

Truly one of the best things about Italy is the delicious food and fresh, mouth-watering produce. The culture of food is woven into the fabric of society and even in the capital, in the new millennium, this tradition of eating and enjoying quality cuisine is still the centrepiece of daily life.

Fresh seasonal produce from the Roman countryside is hand-picked daily, arriving at local markets and restaurants throughout the historic centre. Cooked and prepared from generations of traditional, local recipes and delivered on your plate with appetising aromas and flavours.

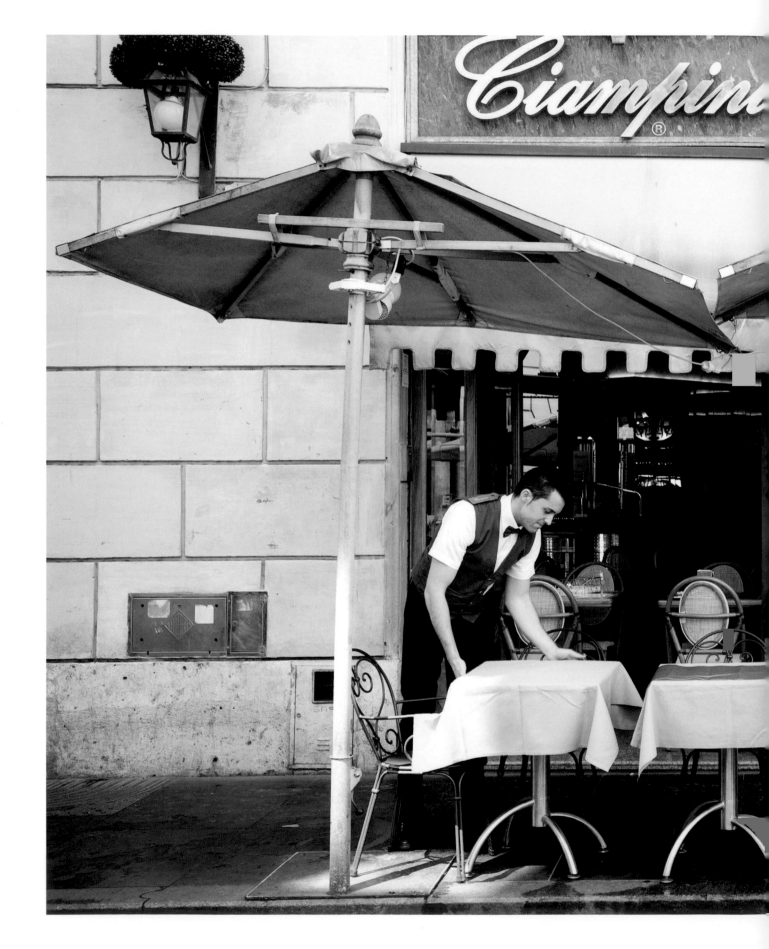

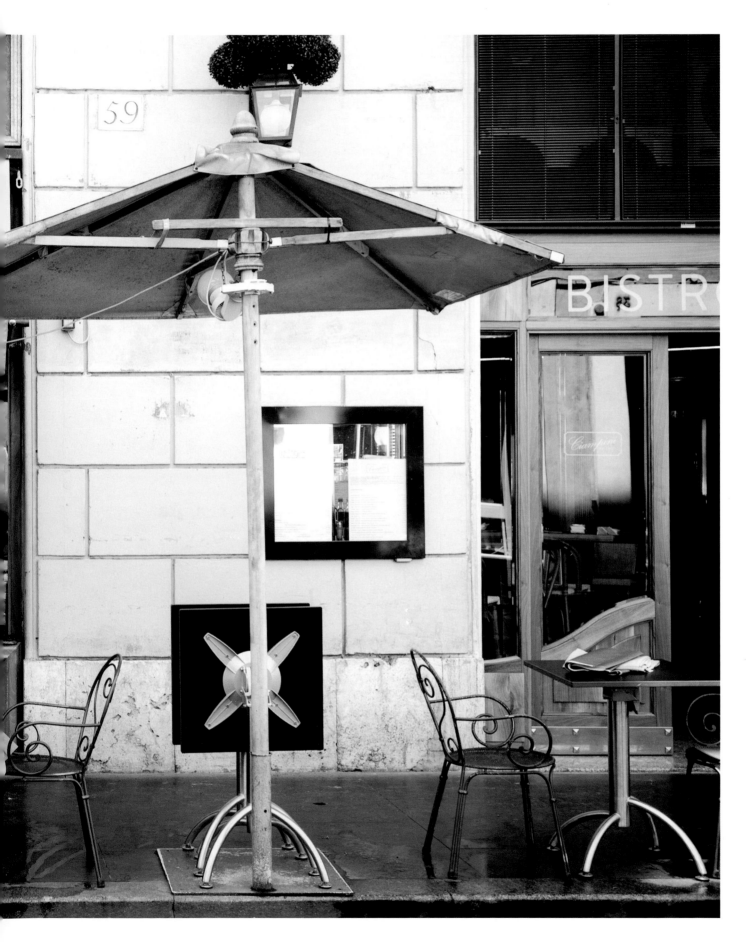

BUON APPETITO

La vita è una combinazione di magia e pasta. (Life is a combination of magic and pasta.)

– FEDERICO FELLINI

Italians are passionate about their food. Enjoying a delicious feast together with family and friends is one of the most important and simple pleasures of life in Italy.

Every meal is blessed with the words *buon appetito*, with even the humble *panino* (sandwich) eaten *al volo* (on the run) meriting a word of appreciation.

The dialogue of food colours everyday conversation. You will hear Romans discussing good food together, no matter where they may be.

To really experience the best in Roman traditional cuisine, complete with the festive, jovial ambience, it is essential to do as the Romans do and head to local *ristoranti*, *trattorie*, *pizzerie* and *tavole calde*, away from the tourist hot spots.

For the more adventurous, try the traditional *cucina povera* (poor kitchen) also known as *quinto quarto* (the fifth quarter) serving up all manner of offal and organ meats, flavoured with seasonal herbs and vegetables from ancient recipes.

For a more refined palate, there is a delicious assortment of Michelin-starred restaurants serving original artistic creations, marrying traditional Roman ingredients with innovative cooking techniques. Combined with impeccable service in stylish settings, this makes for unforgettable dining experiences.

The hero of the Roman kitchen – *carciofi*, or artichokes – tempts passers-by at a restaurant display in the Jewish Ghetto.

BUCAIINI CON
ALI Ci e POModoRi
PACHINO.
FRi

LA INVERSA
DEL GHETTO
"KOSHER"

-ABBACCHIO
ALLA GIUDIA
-POLPETTE NONNA
ESTER. etc

SCUS
CARNE
VERDURE

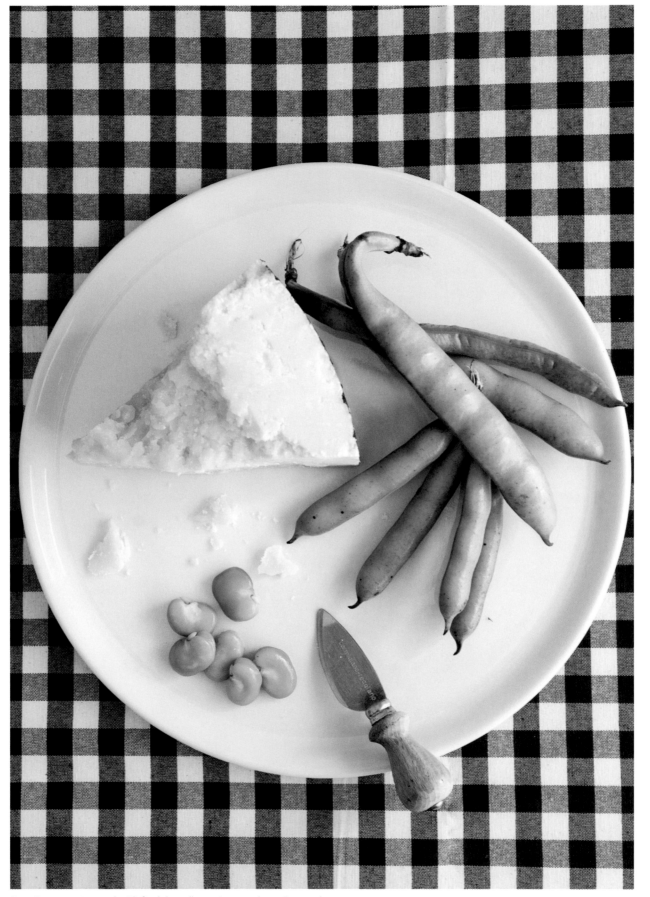

Pecorino romano served with fresh broadbeans is a popular spring snack.

You may want to try:

The quintessential Roman vegetable, *carciofi romani* (Roman artichokes), with their textured purple and green leaves, are in season from December through to late spring, eaten *alla romana*, braised with herbs and garlic or *alla giuda*, Jewish style, served deep-fried and found in many restaurants in the Jewish Ghetto.

Pecorino romano, a cheese made from sheep's milk from the Roman countryside, has been part of the Roman diet since ancient times and is still made today from a traditional recipe. It is one of Italy's oldest cheeses and is popular in Roman cuisine, mostly for grating into a variety of pasta dishes.

Classic Roman pasta dishes such as *Amatriciana* with *pancetta* (bacon) or *guanciale* (pig's cheek), *pecorino* and tomato or *Carbonara* with *pancetta*, *egg* and *pecorino* to tempt your taste buds.

For a hearty feast, *Coda alla vaccinara*, or Roman oxtail stew, is a rich stew of tender ox or veal's tail, slowly cooked with an assortment of aromatic herbs and vegetables.

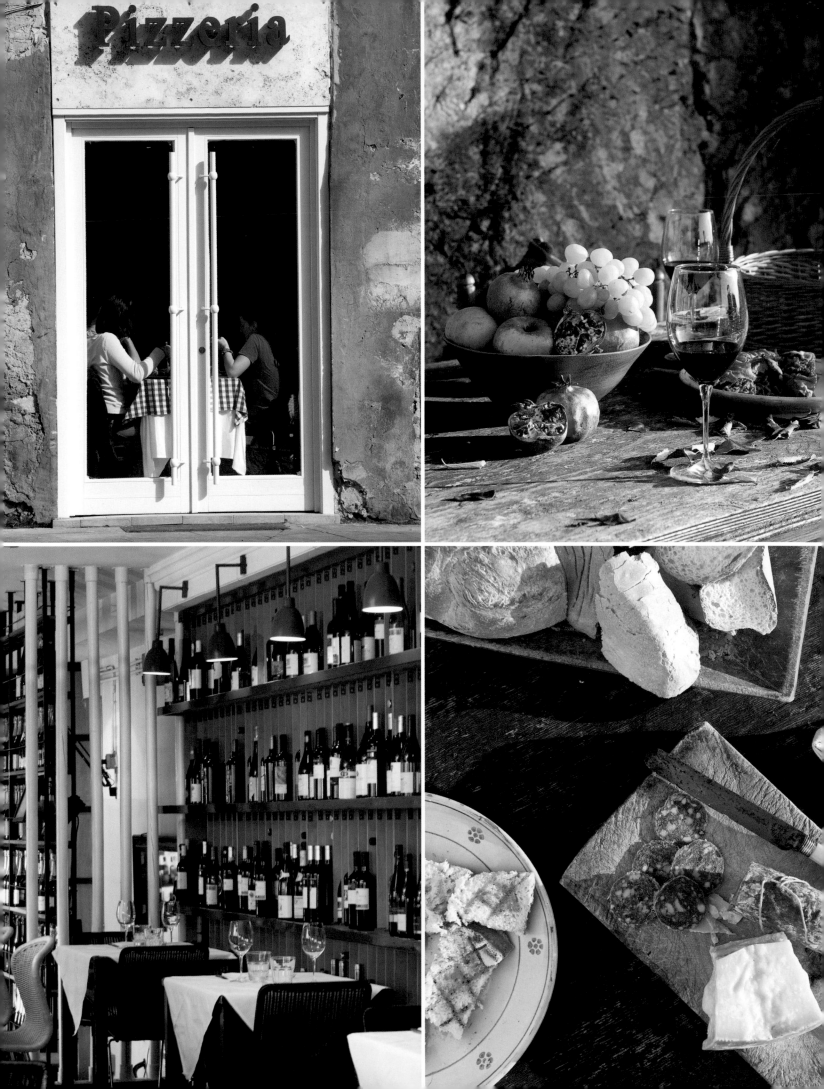

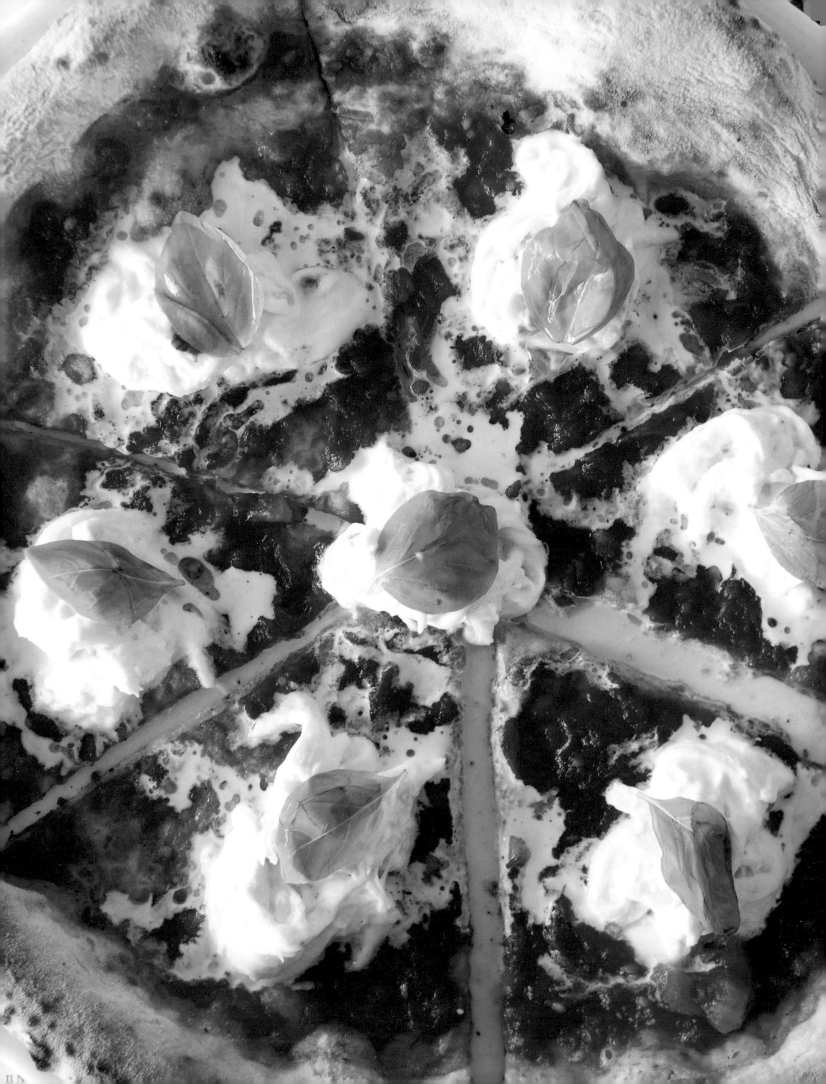

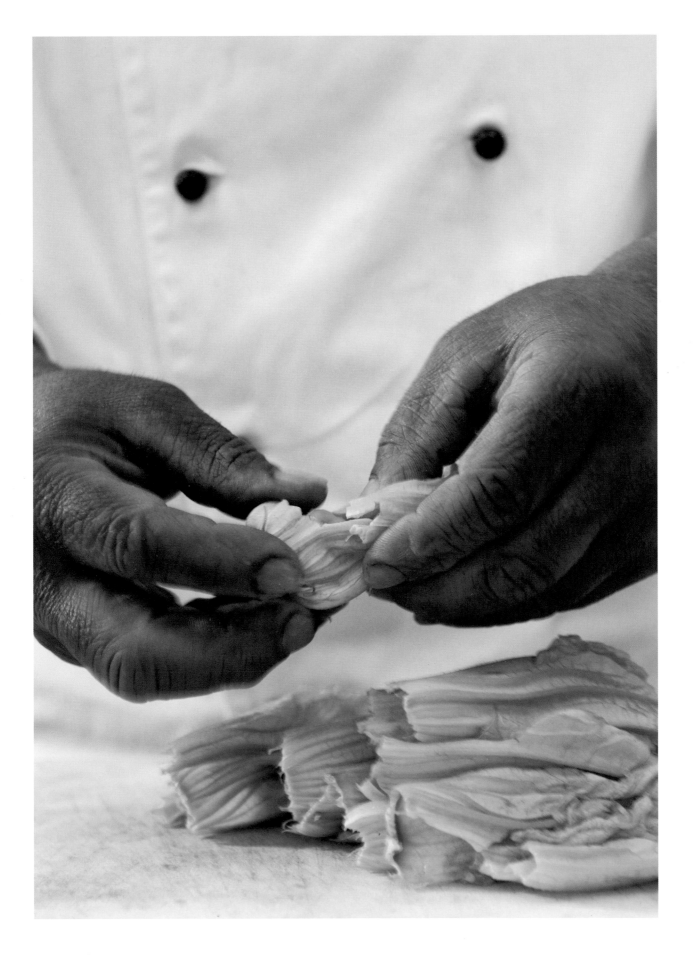

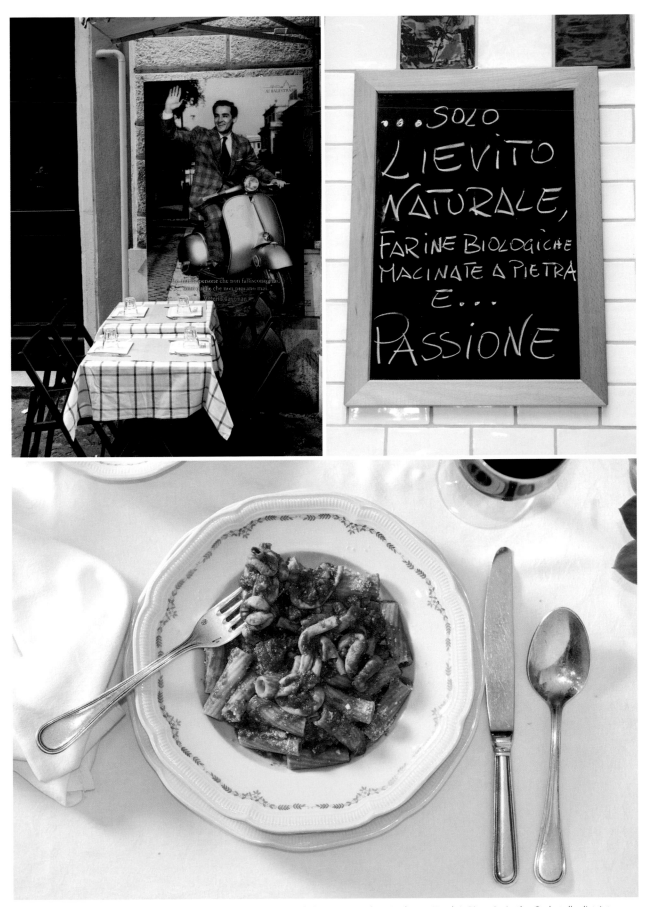

Top right: List of ingredients with the most important ingredient of all – *passione* (passion) – at Eataly's Pizzeria, in the Garbatella district.
Bottom: Rigatoni con la Pajata, a classic Roman dish of short pasta served with tomato sauce, calf small intestines and ewe's milk cheese, served at Checchino restaurant in Testaccio.

IL CAFFÈ

In the early morning, Rome awakens to the animated clatter of a million *tazze* (coffee cups), saucers and spoons being stacked in rows onto marble counters in bars and cafes in every street corner and *piazza* across the city. Here you will find Romans queuing for their ceremonial morning *espresso*, *caffè macchiato* or *cappuccino*.

Artisanal coffee blends of arabica and robusta beans are hand-roasted daily on the premises, in some of the city's best historic coffee houses.

Follow your nose and join the queue for your daily fix at Sant'Eustachio, Tazza d'Oro, Castroni or Paranà, to name a few local spots.

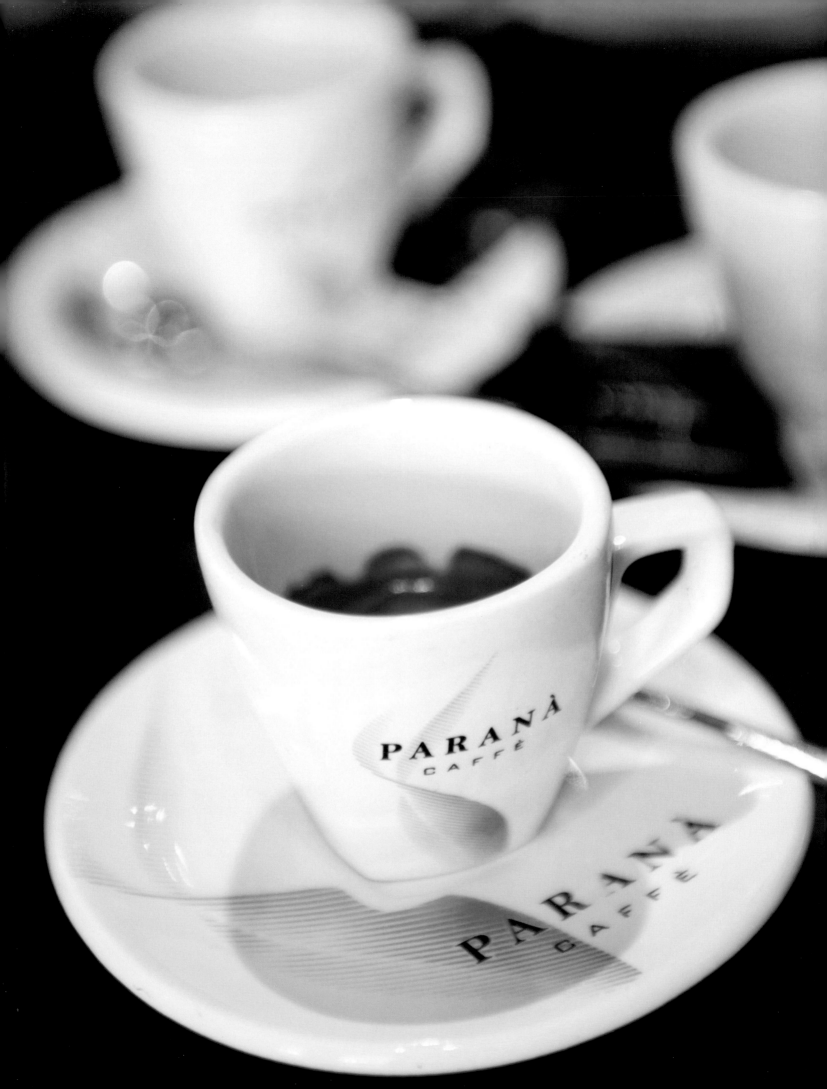

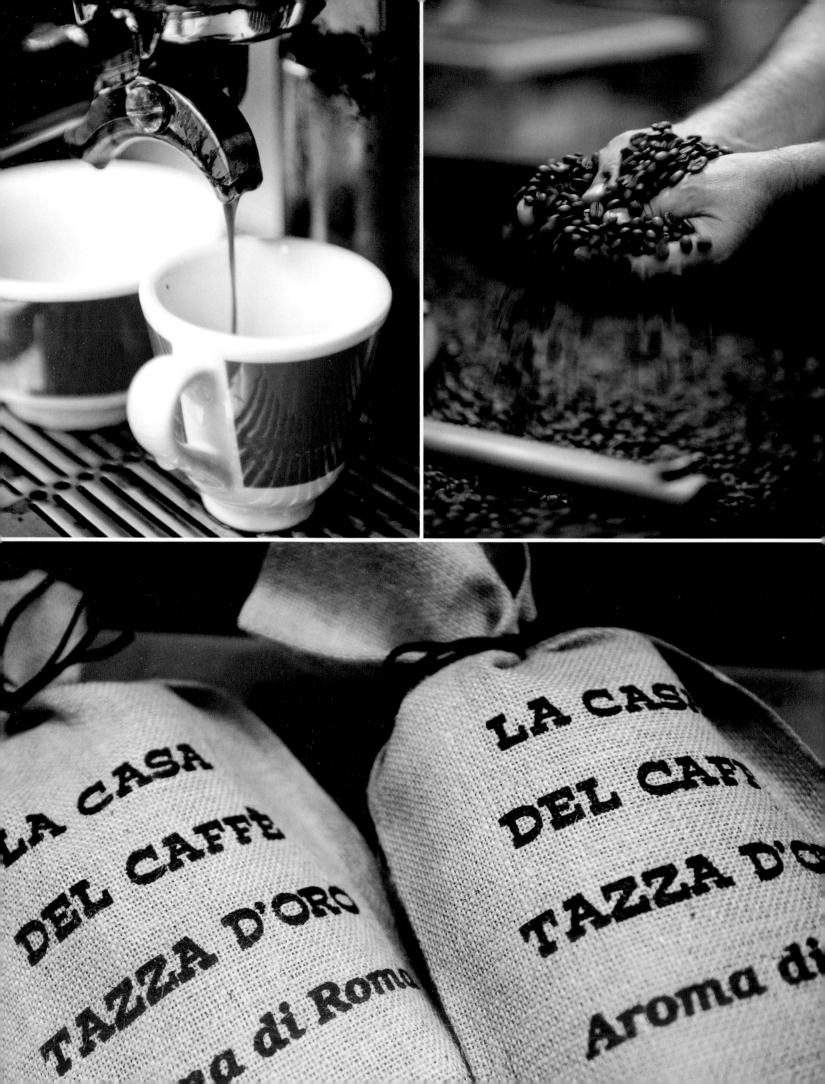

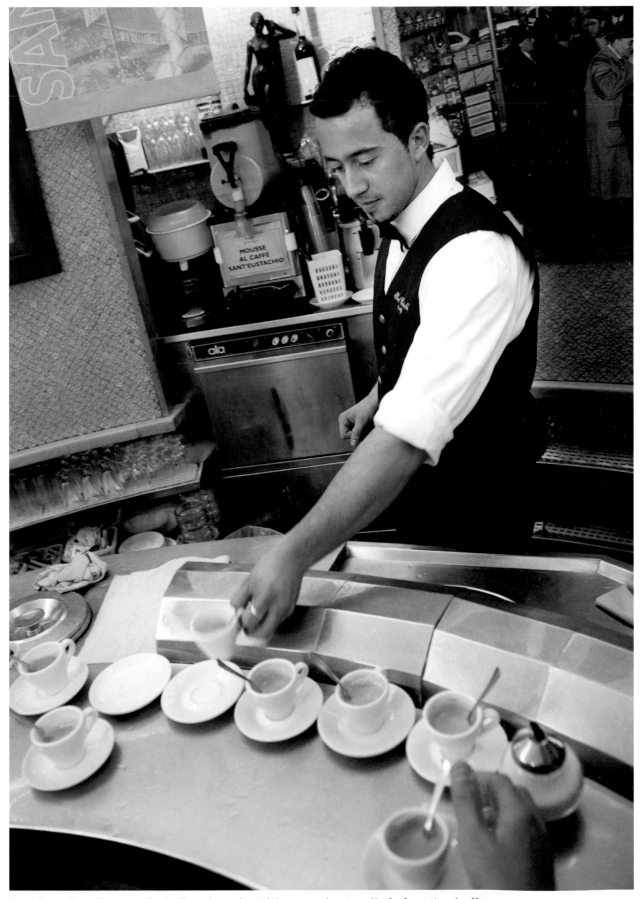

Opposite: La Tazza d'Oro, near the Pantheon, is popular with Romans and tourists alike for fine artisanal coffee.
Above: Founded in 1938, Sant'Eustachio Il Caffè, roasts the finest-quality coffee beans on the premises daily.

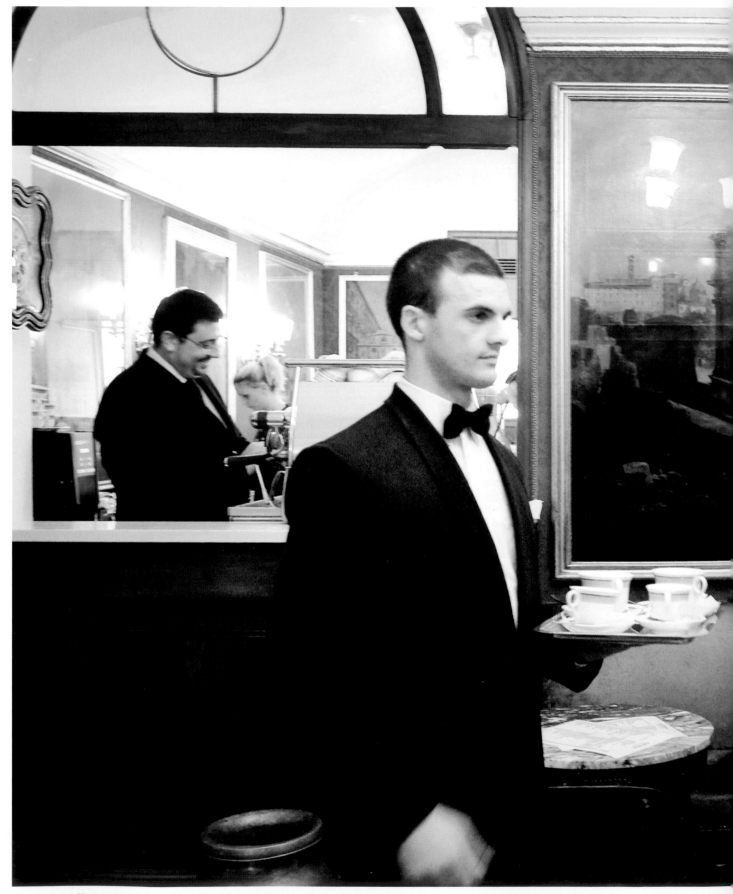

For a classic coffee experience to beat no other, Antico Caffè Greco is one of Italy's oldest cafes, established in 1760. Enter the intimate, nostalgic salons and you can almost hear the whispers of Goethe, Keats, Byron and Cassanova, who sat at the tiny marble tables, enjoying the dark, deep, aromatic coffee.

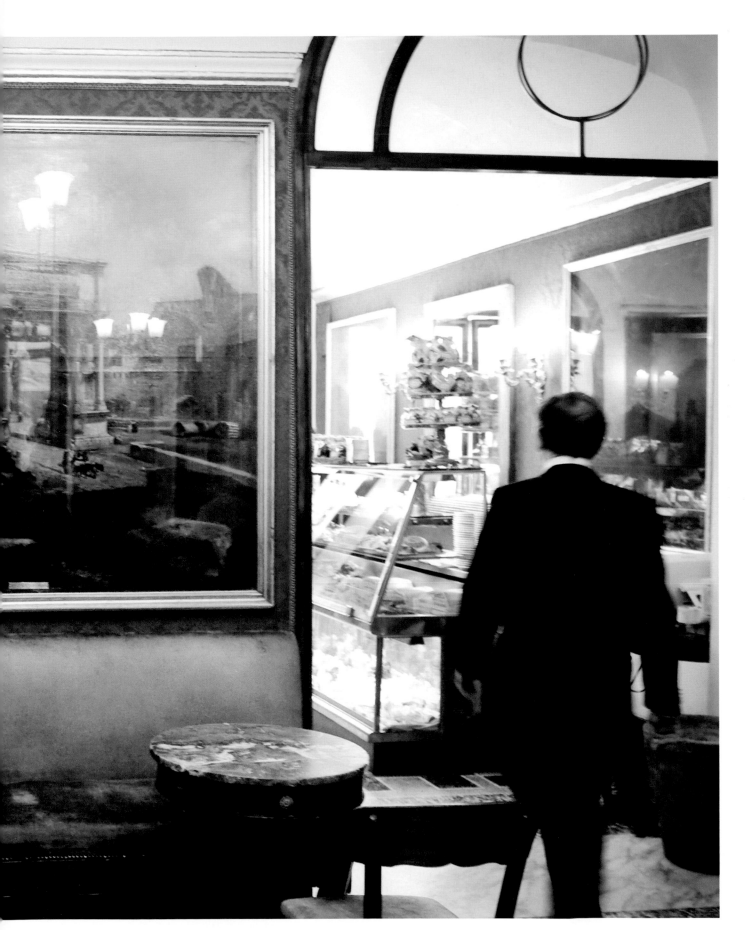

L'APERITIVO

After a long day of work or pleasure (or both), bars and *piazze* across Rome are overflowing at *aperitivo* hour. A popular social occasion to relax and enjoy an appetising alcoholic or non-alcoholic beverage served with *spuntini* (light snacks) before the evening meal.

Take your pick from elegant bow tie service, with stylish martini, Campari soda or cocktail, served with delectable hors d'oeuvres from a luxurious terrace overlooking the Roman skyline.

Perhaps a refreshing *spritz* or Italian artisanal beer at a crowded, local street side bar, buzzing with life and cheer might tempt you.

Or take a seat, *al fresco*, at a table in a grand *piazza* overlooking the magnificent *vista* and enjoy the moment while rounding off the day with a refreshing Italian *Prosecco* (champagne).

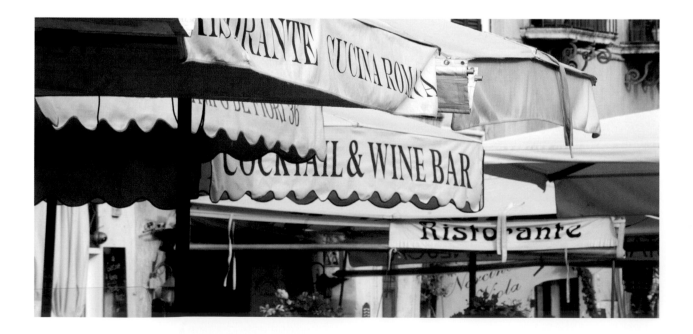

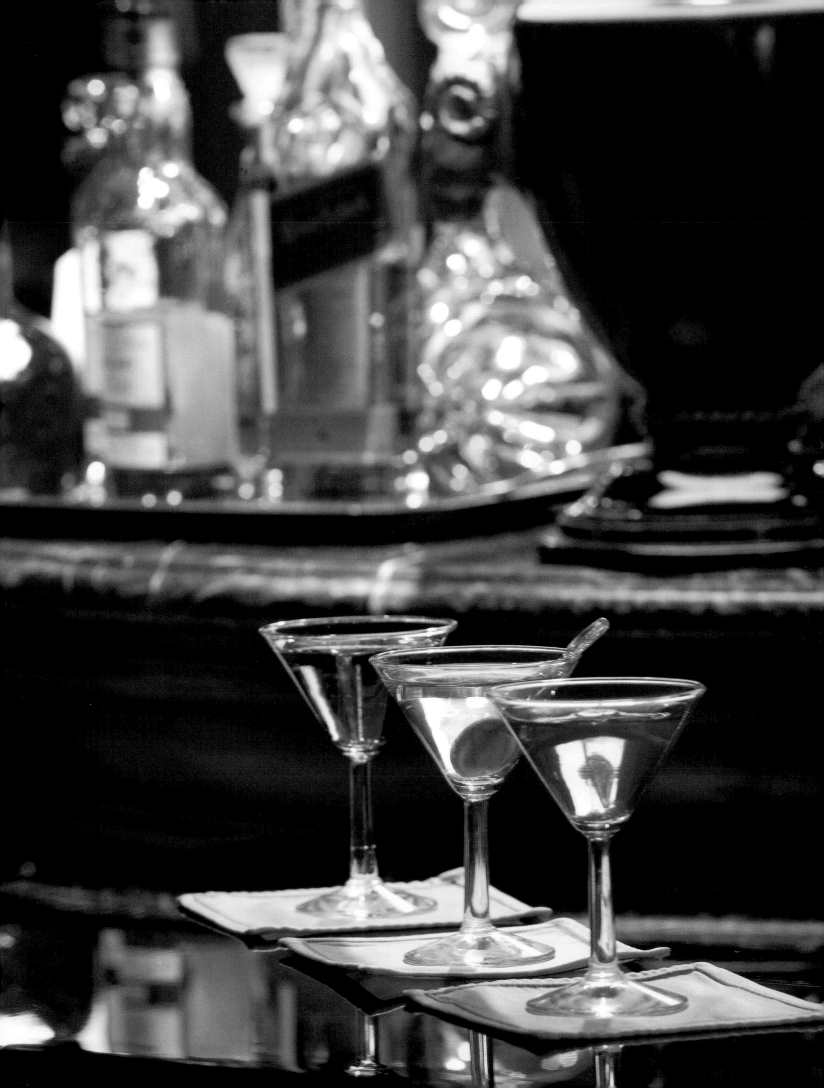

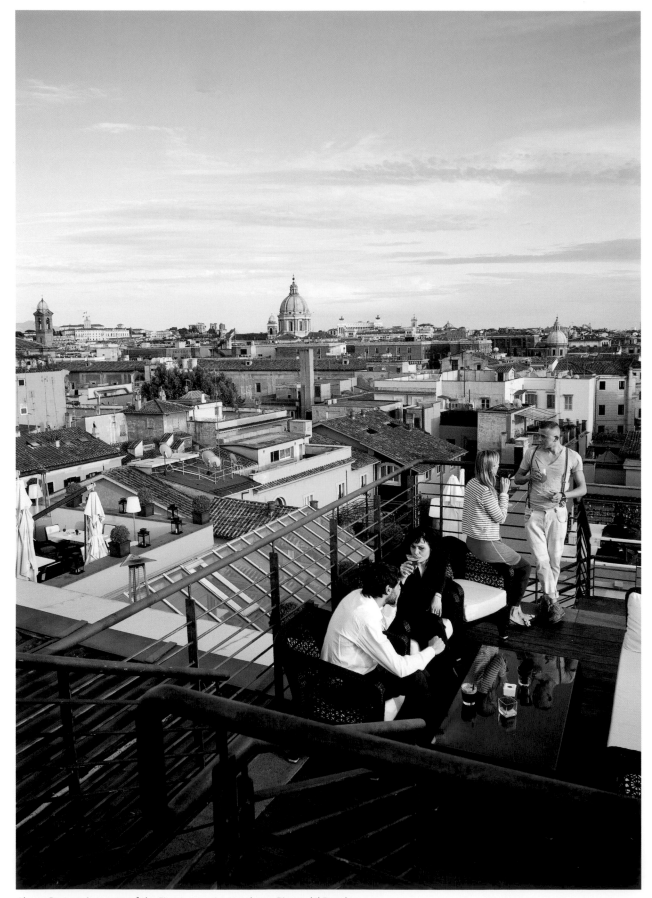

Above: Panoramic terrace of the First Luxury Art Hotel near Piazza del Popolo.
Opposite: Aperitivo hour at Caffè della Pace and Campo de' Fiori

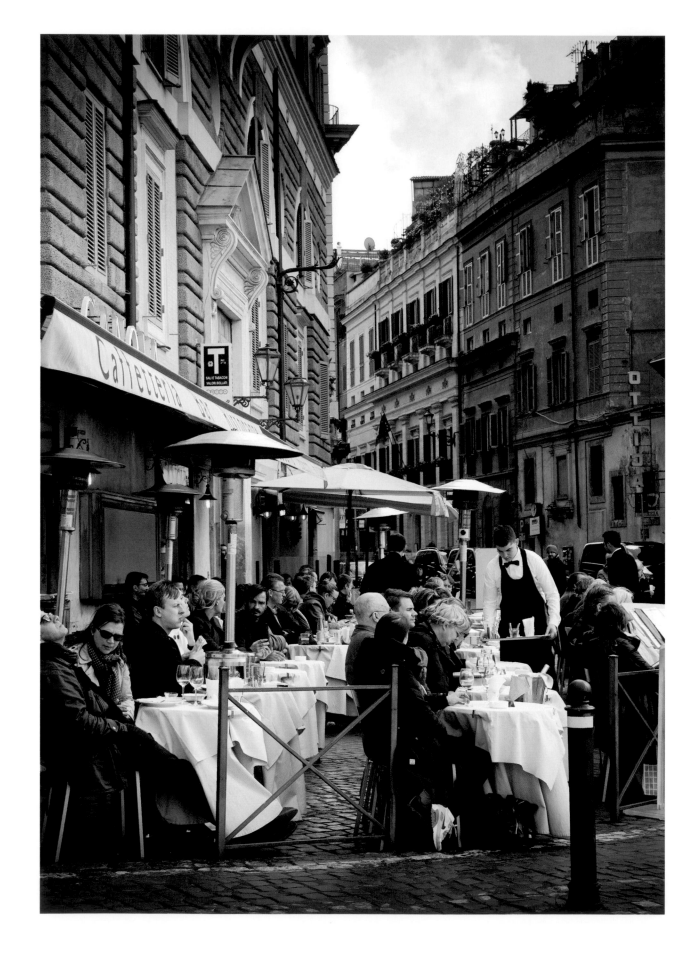

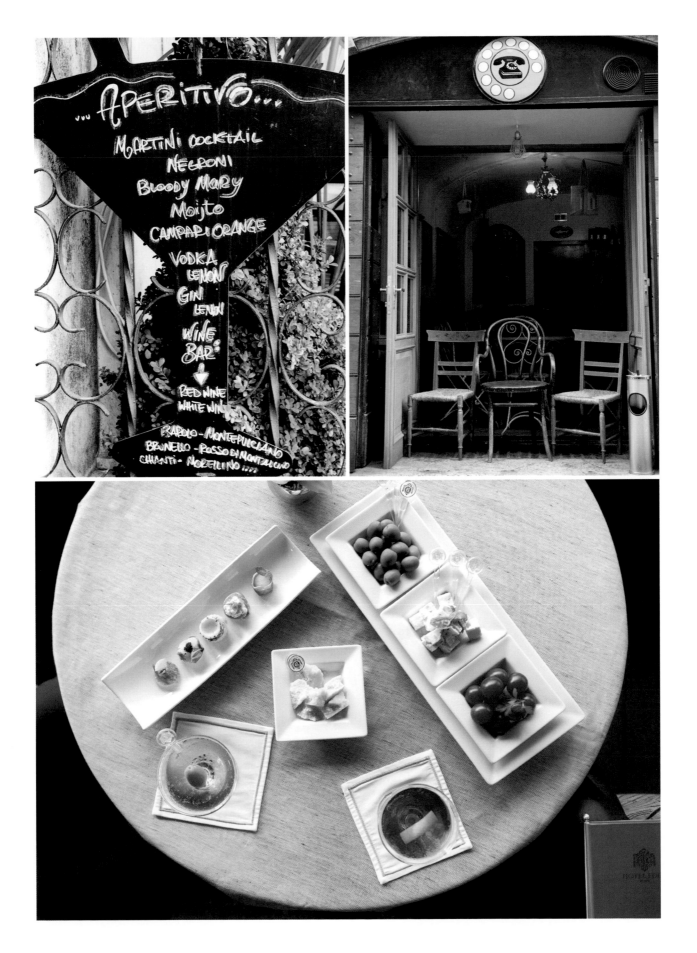

IL DOLCE

Take a walk on the sweet side when in Rome and delight in a flirtatious assortment of Roman *dolce*.

Artisanal gelato made from the highest quality natural ingredients can be enjoyed in a cone or cup and topped with fresh *panna* (cream) and savoured at any time of the day throughout all seasons of the year.

Traditional local *biscotti* (biscuits), *pasticcini* (little pastries), *torte* (tarts) and *cioccolati* (chocolates) create tantalising window displays to tempt your sweet cravings.

The Roman favourite, *crostata di ricotta*, a simple sweet tart made with fresh local ricotta cheese, lemon and a pinch of cinnamon is perfect as a light after-dinner dessert.

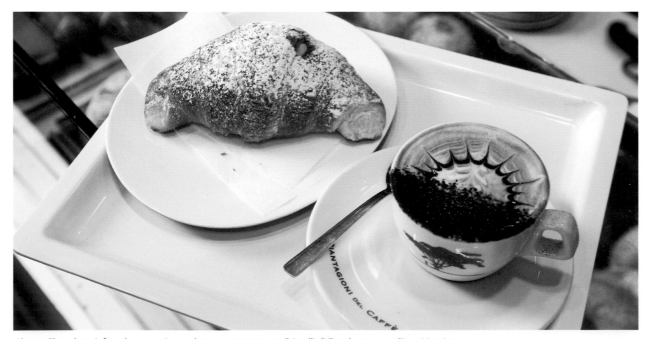

Above: Chocolate-infused cappuccino and cream *cornetto*, at Cristalli di Zucchero, near Circo Massimo.
Right: Moriondo e Gariglio, historic confectionery and makers of the finest quality artisanal chocolates.

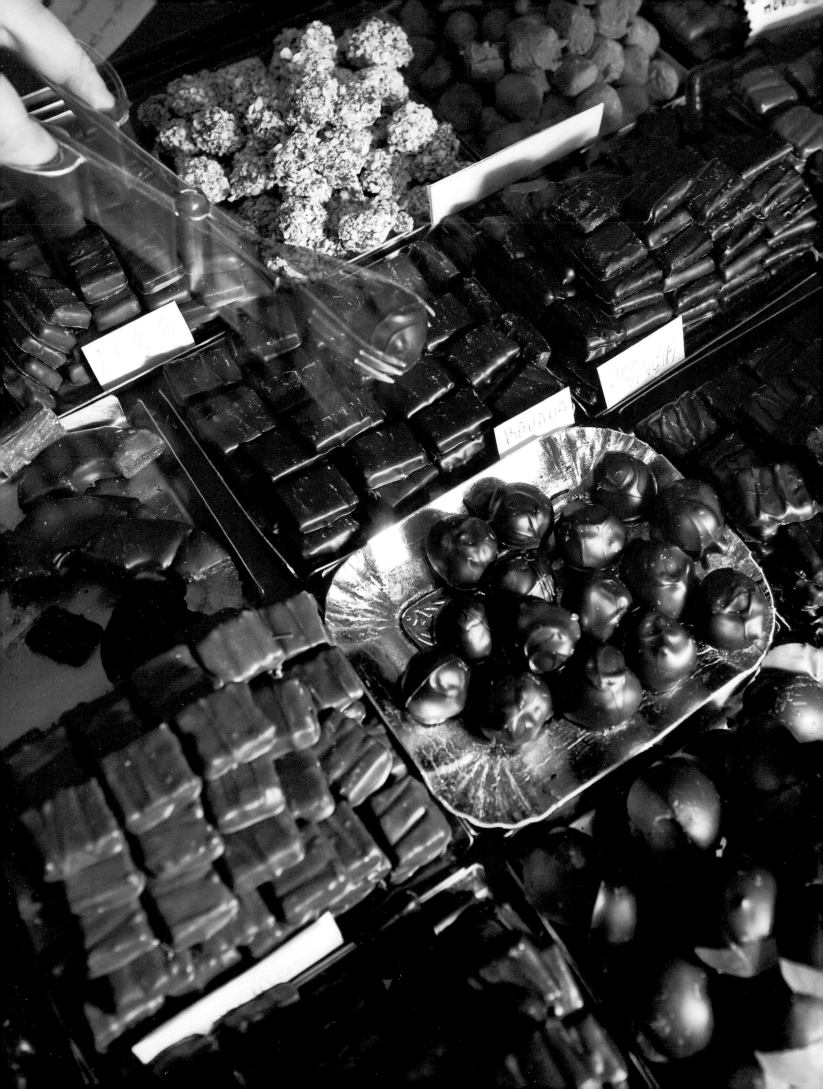

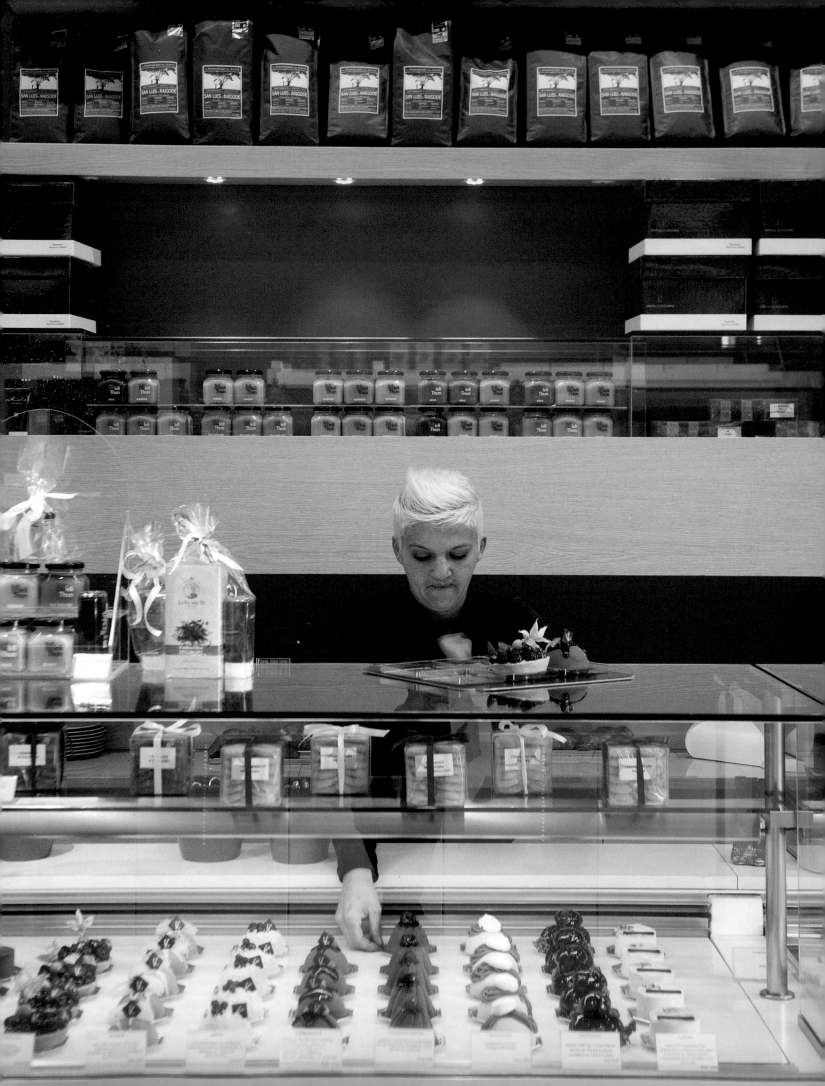

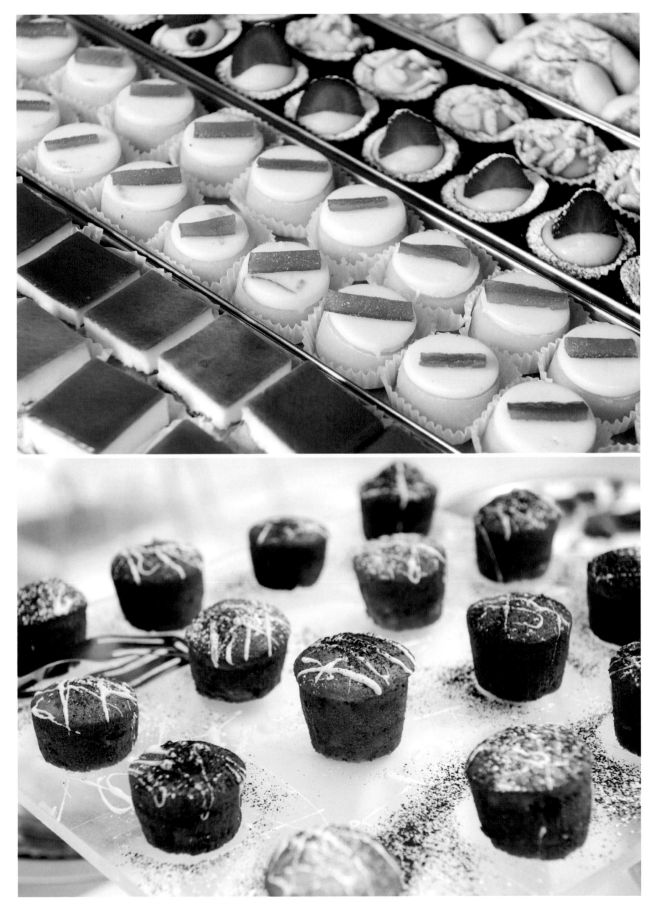

Opposite: A sweet-lover's paradise at Cristalli di Zucchero.
Top: A delectable display of *Cassatina siciliana* and fruit tarts.
Bottom: Delicious *dolce* at Open Colonna, the roof garden restaurant of the Museo Palazzo delle Esposizioni.

RELAX *Rilassare*

Rome's greatest draw card is without doubt the magnificent historic ruins, monuments and sacred sites. The city is also blessed with an abundance of green spaces comprising public villas, private gardens, nature and archaeological reserves and expansive parks.

Villas and landscaped gardens, created by the Italian aristocracy, represent a large portion of Rome's public green areas, the most popular being Villa Borghese, Villa Ada, Villa Torlonia and Villa Doria Pamphili.

The picturesque landscape of the Appia Antica Archaeological and Nature Reserve encompasses an area of 3,400 hectares, incorporating 16 kilometres of the ancient road – Via Appia Antica – the Aqueducts Archaeological Park, farmland of the scenic Caffarella valley, Villa dei Quintili and the tombs of Via Latina as well as many other important archaeological monuments and sites.

Take a break from the hectic pace of the city streets and delight in the serene beauty of the park, while appreciating the historic, artistic and natural heritage of the Roman countryside.

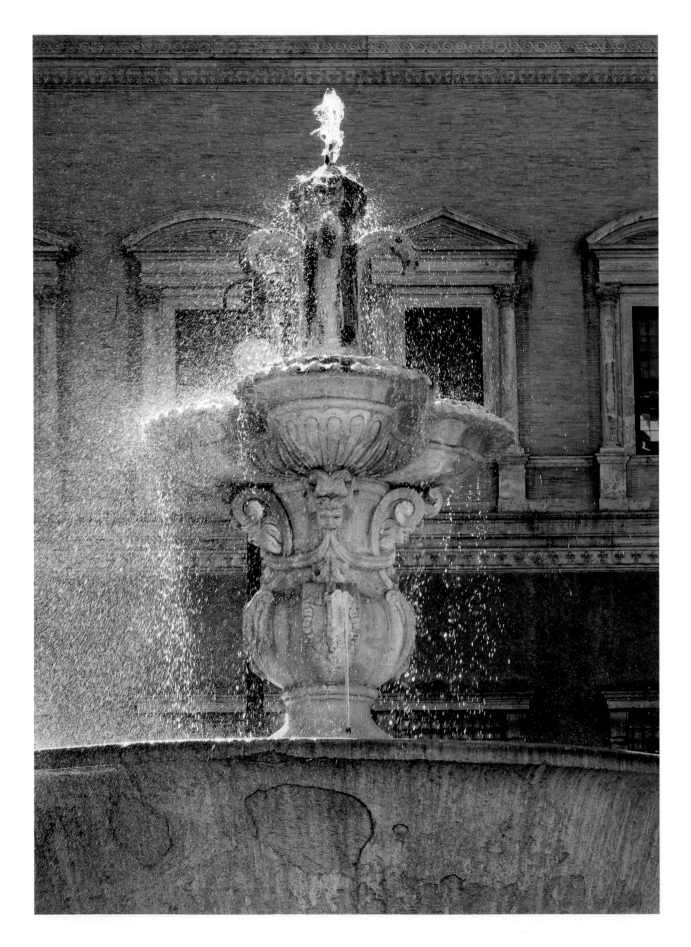

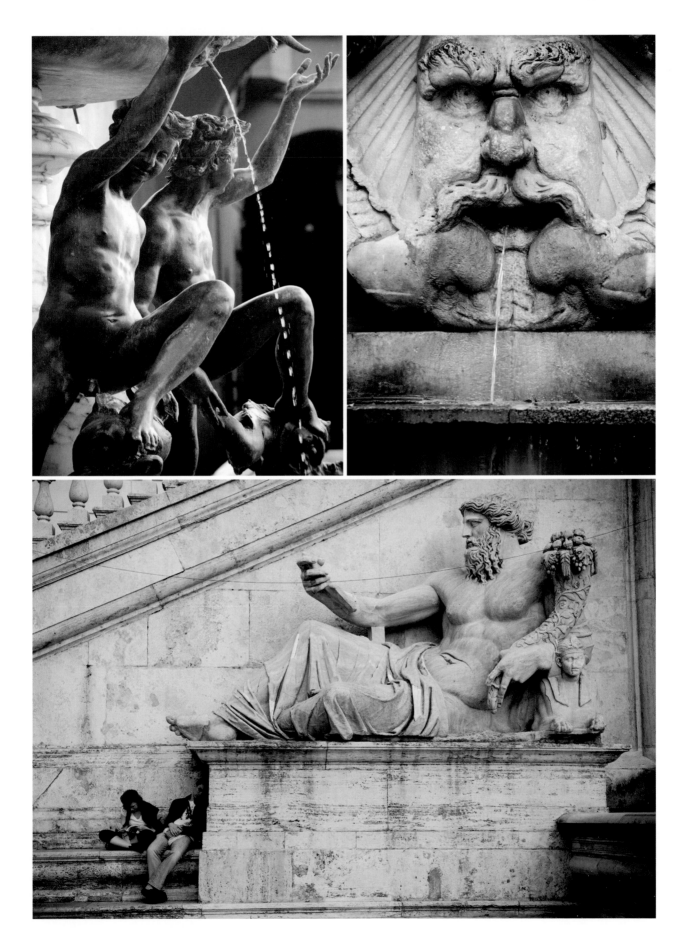

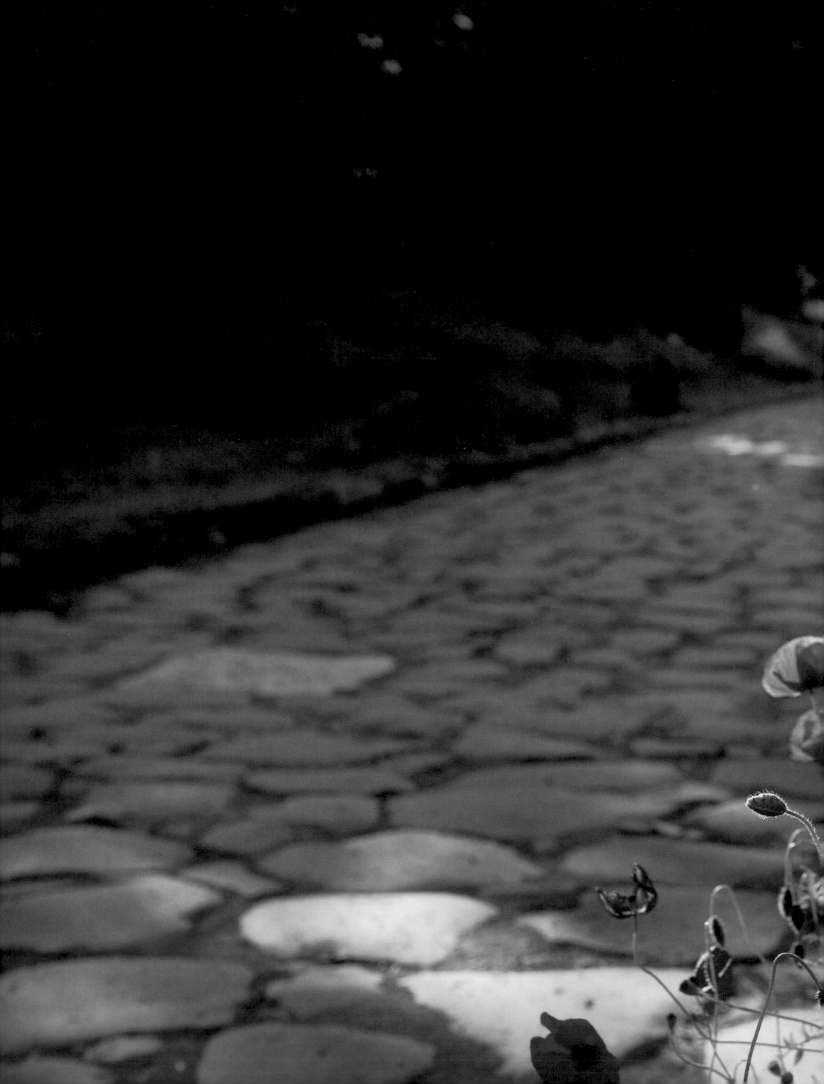

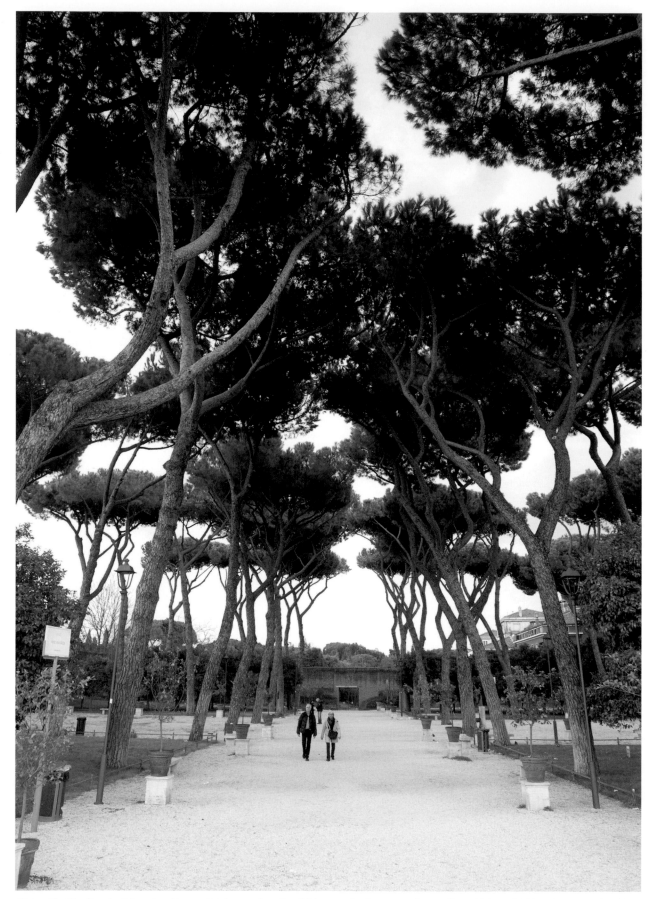

Above: The Giardino degli Aranci, or Orange Garden, on Aventino Hill is an oasis of peace and tranquility with breathtaking views over the city.
Opposite: Eighty hectares of beautiful landscaped gardens at Villa Borghese, incorporating the Galleria Borghese, Villa Medici and Villa Giulia.

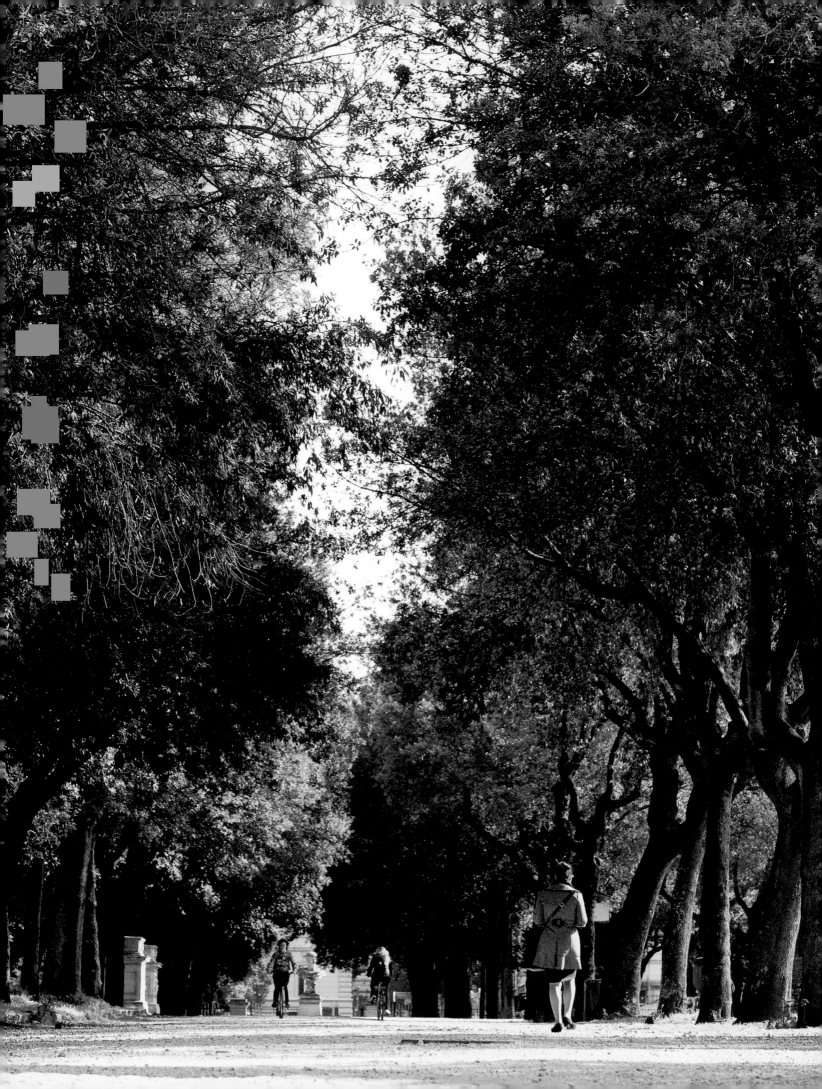

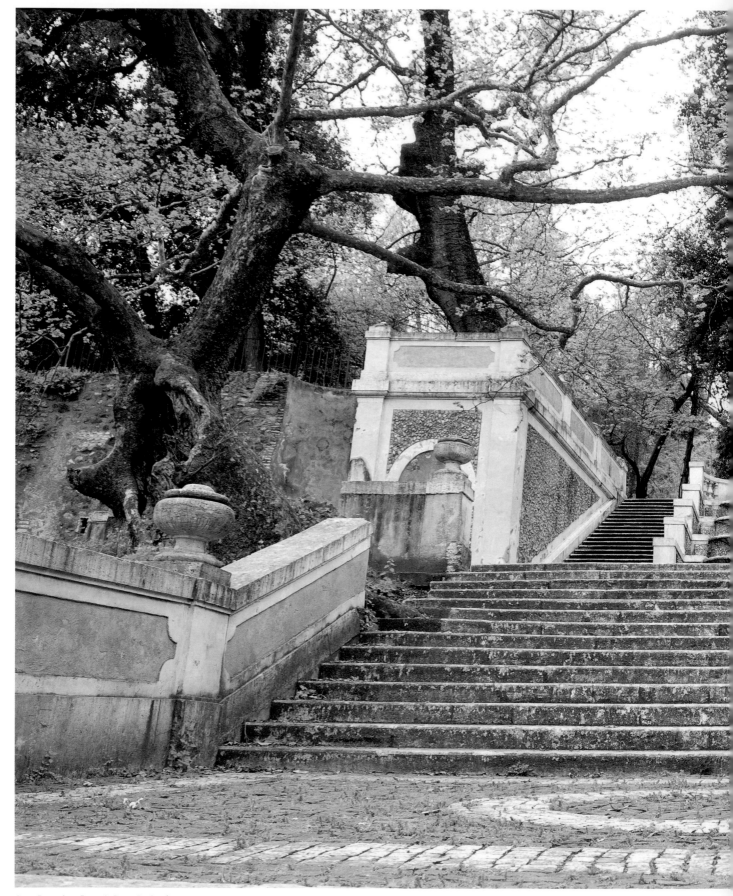

Orto Botanico, Rome's Botanic Gardens.

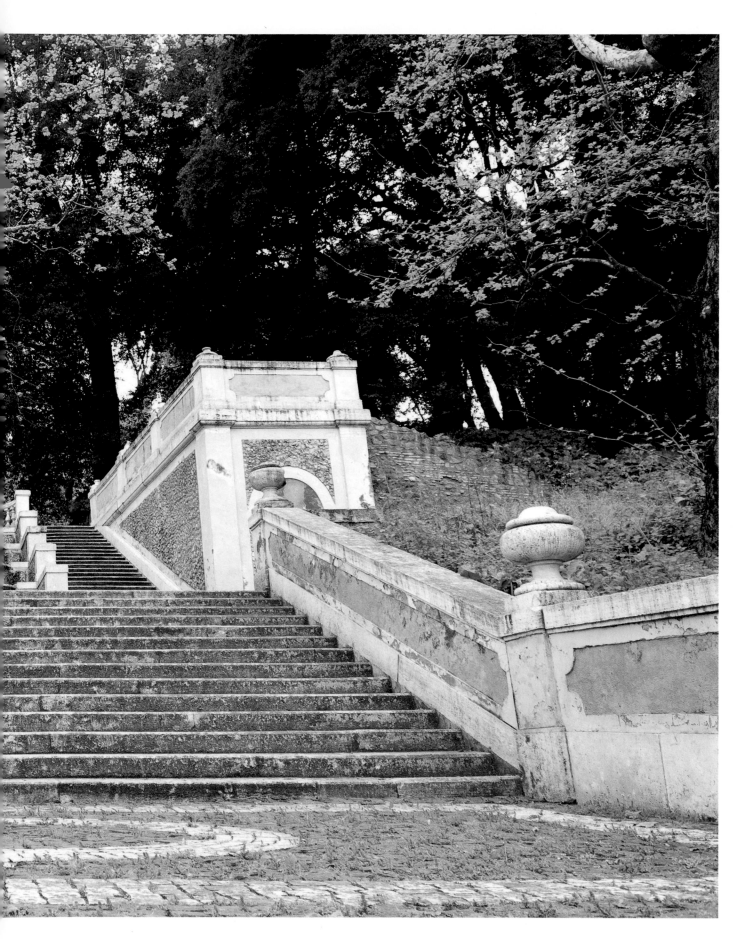

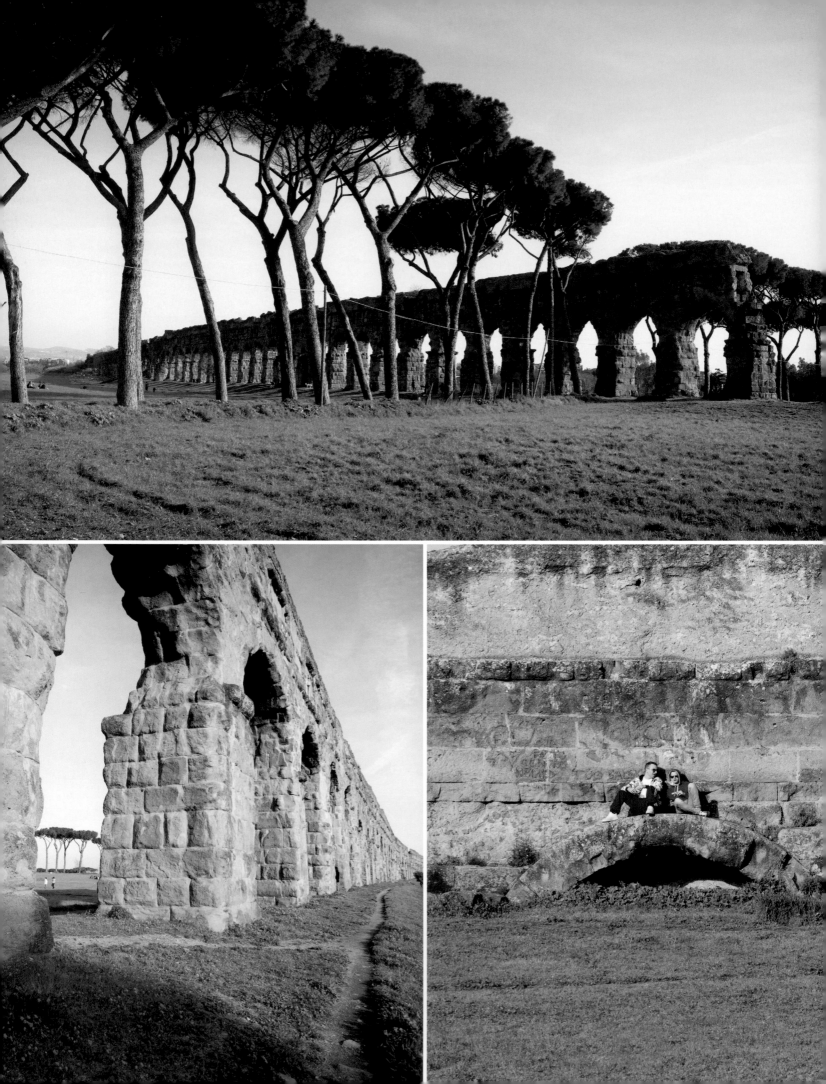

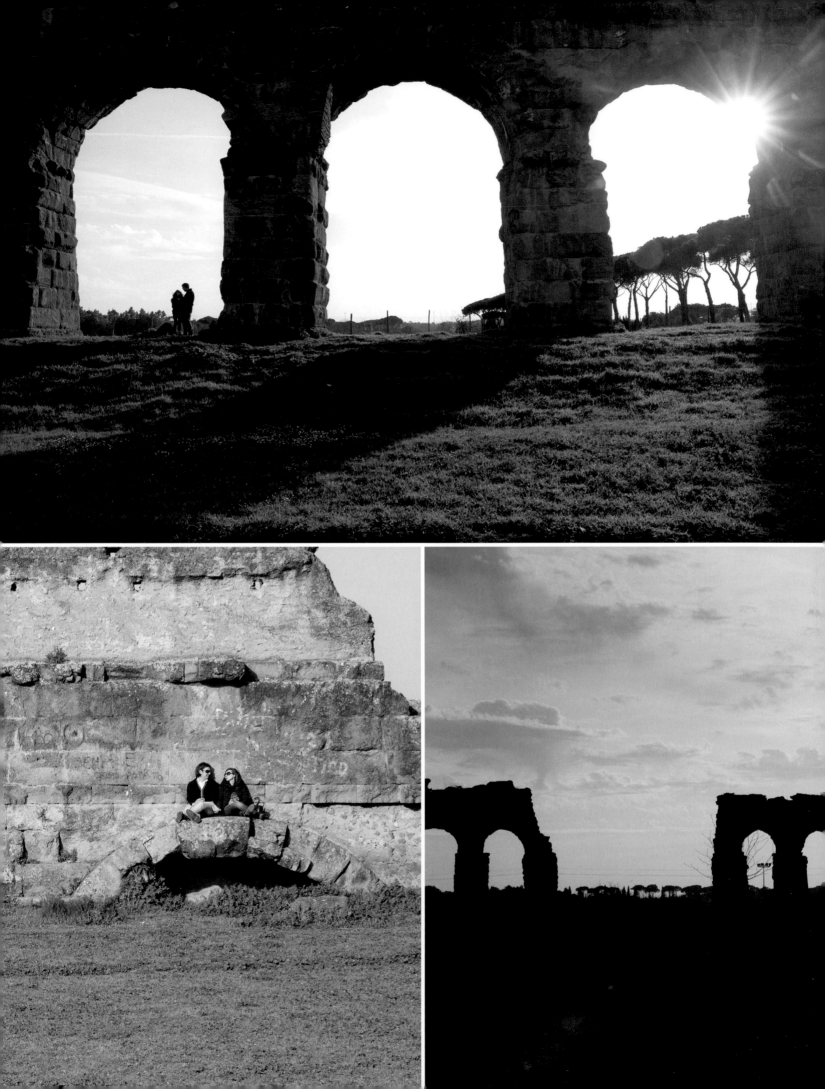

Previous pages: Parco degli Acquedotti (Park of Aqueducts) along the Via Appia Antica is a popular recreational area comprising 15 hectares.
Acqua Claudia (38–52AD) was one of many aqueducts supplying Rome with vital water supplies from springs in the surrounding hills.
Opposite: The enchanting view through treetops in the Orto Botanico, Botanic Gardens on the panoramic slopes of Gianicolo (Janiculum Hill)

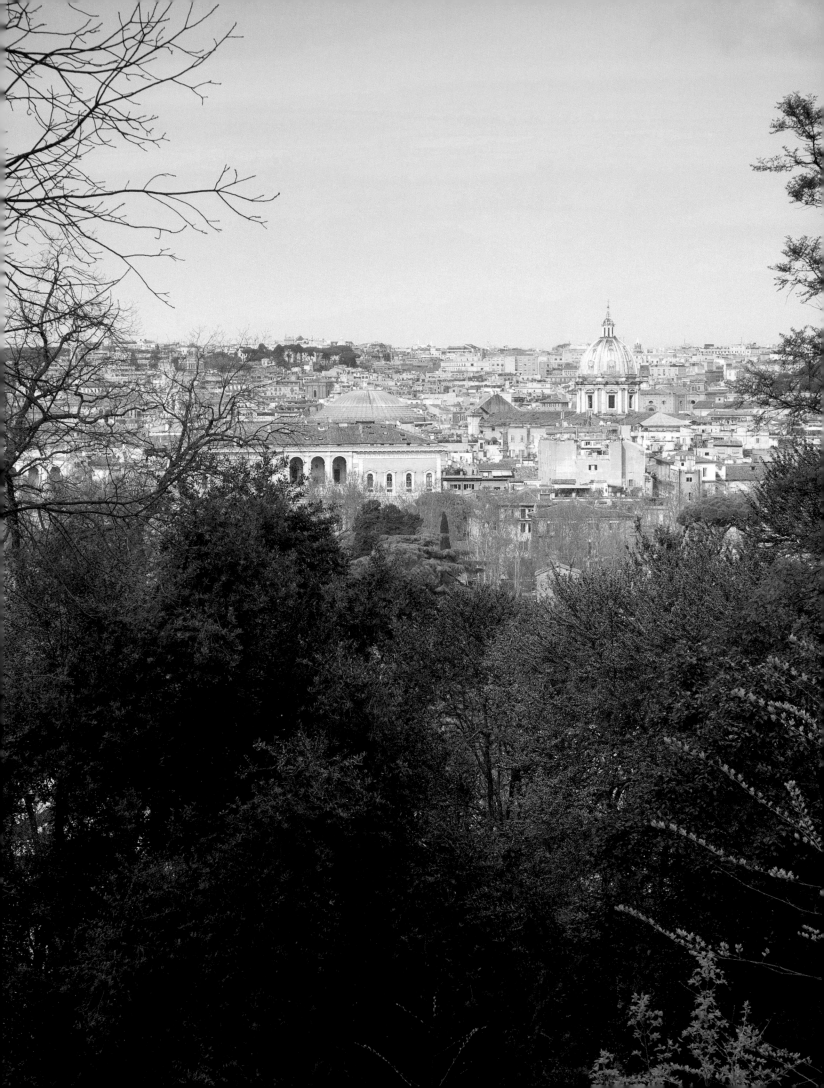

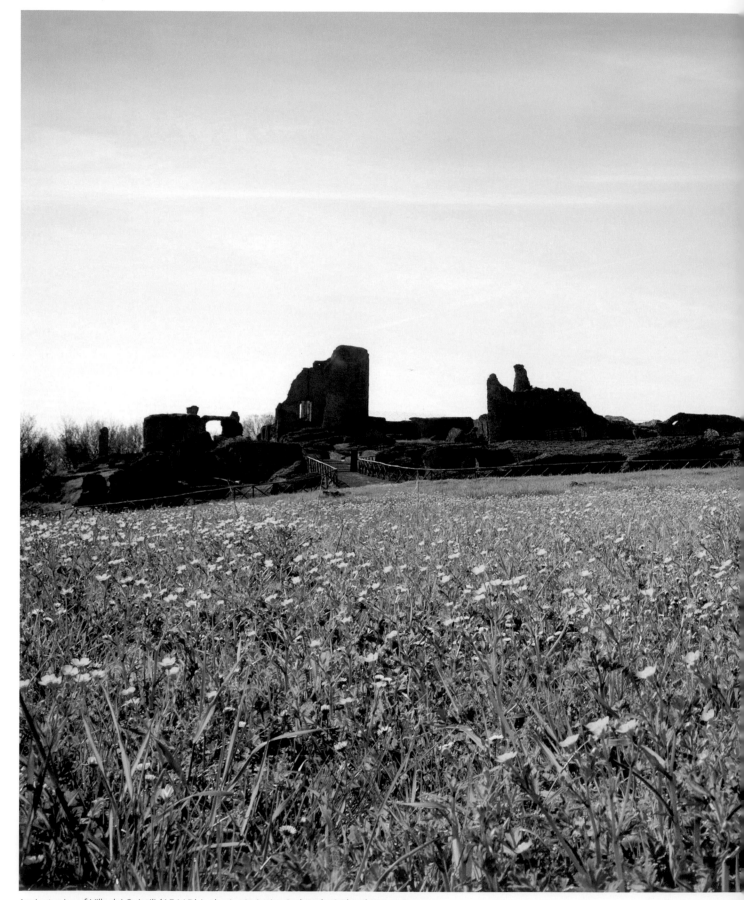

Ancient ruins of Villa dei Quintili (151AD) in the Appia Antica Archaeological and Nature Reserve.

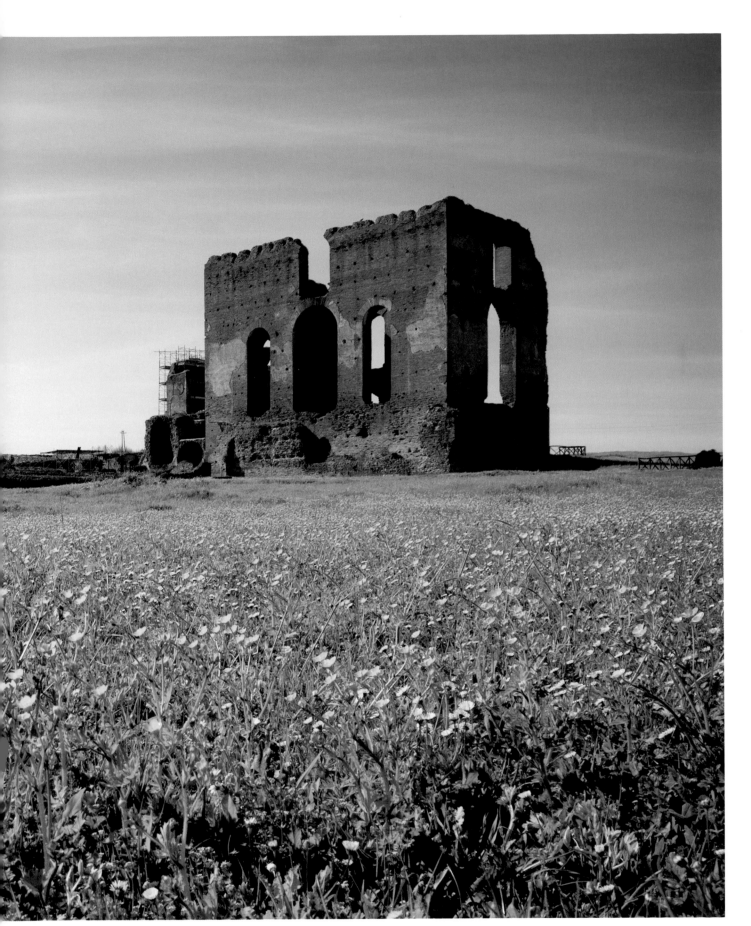

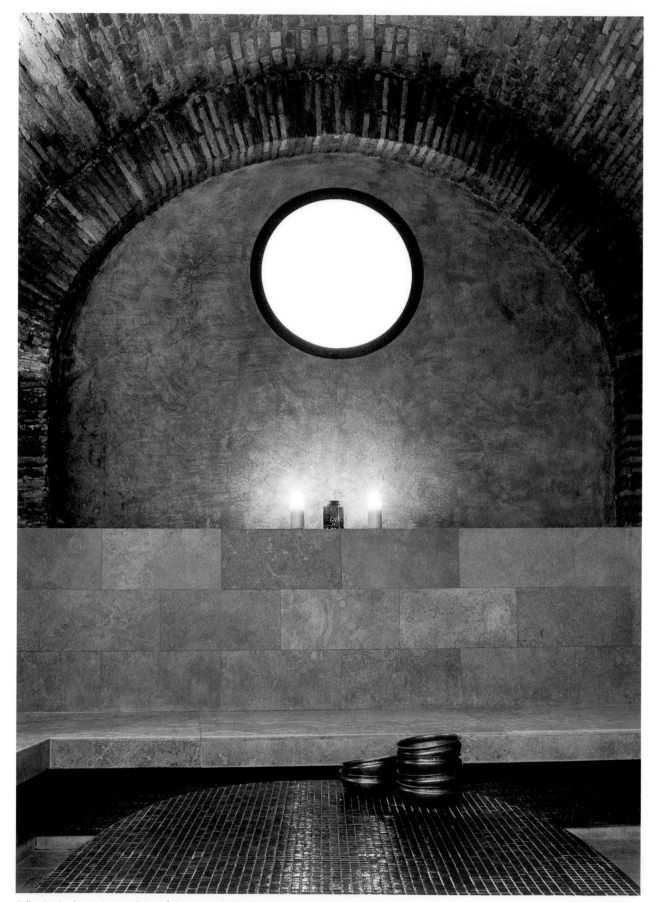

Following in the ancient tradition of the Roman baths, luxurious spas and hammams
such as Acqua Madre (pictured) are an oasis of relaxation and pleasure.

FAITH *La Fede*

No matter where you may find yourself in Rome, you can be sure to be immersed amongst a multitude of sacred sites and places of worship.

From the imposing form of Saint Peter's Basilica, which dominates the Roman skyline, to more than 900 Renaissance and Baroque churches adorning street corners, piazzas and grand boulevards scattered across the city.

Wander the districts and discover concealed cloisters imparting stillness and peace, fallen temples recalling pagan gods and street corner Madonnas watching from oval frames, poised to remind us of our own faith.

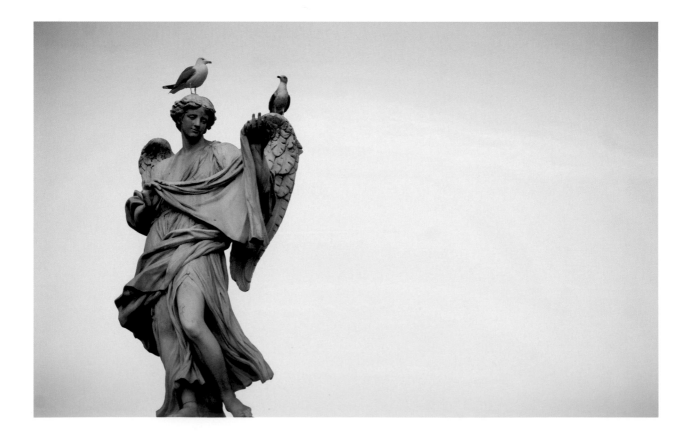

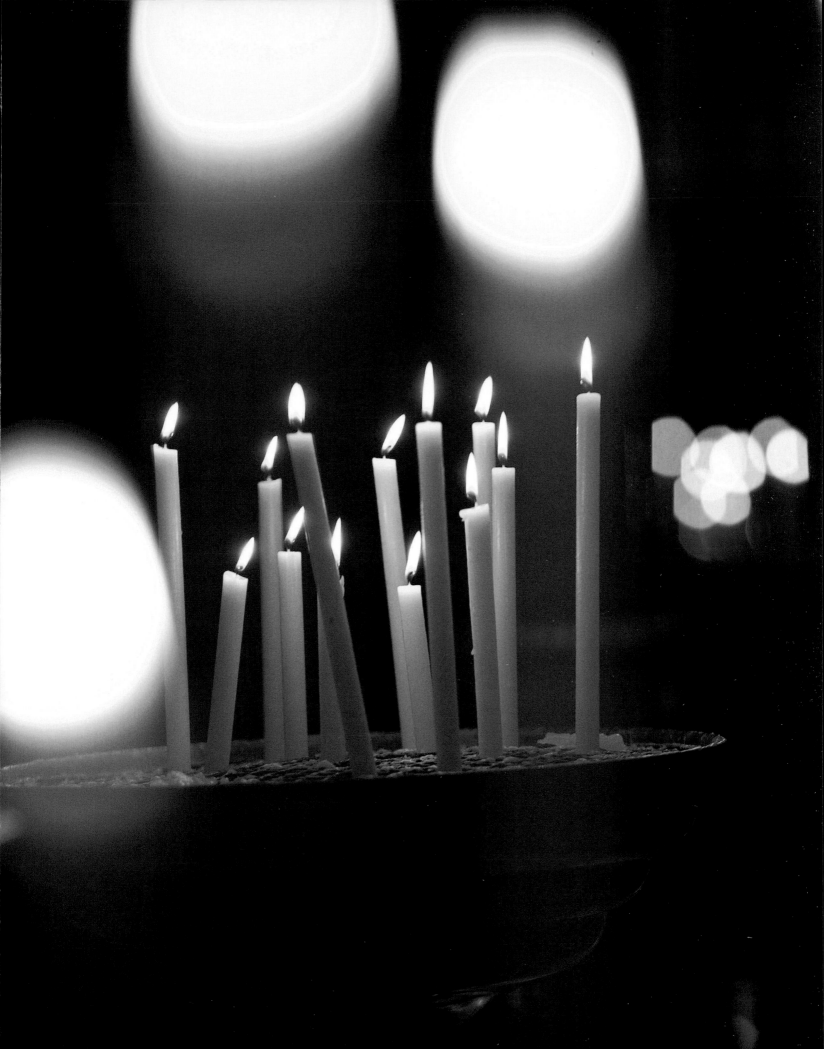

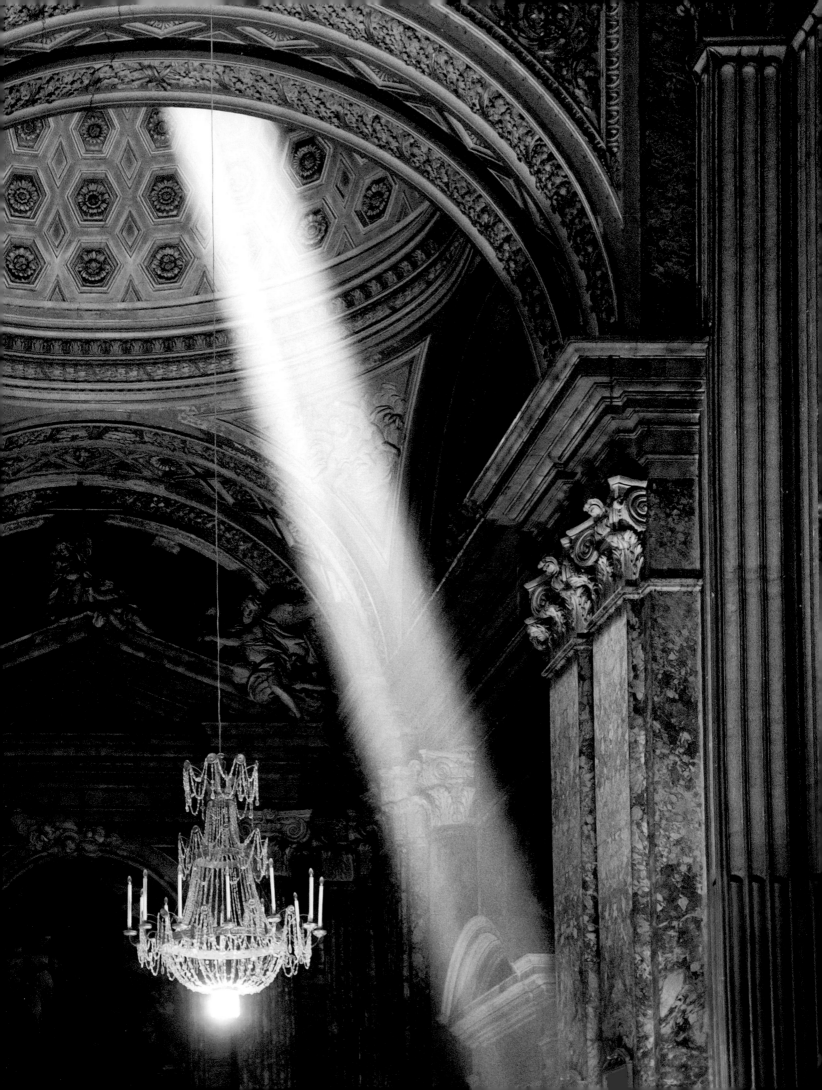

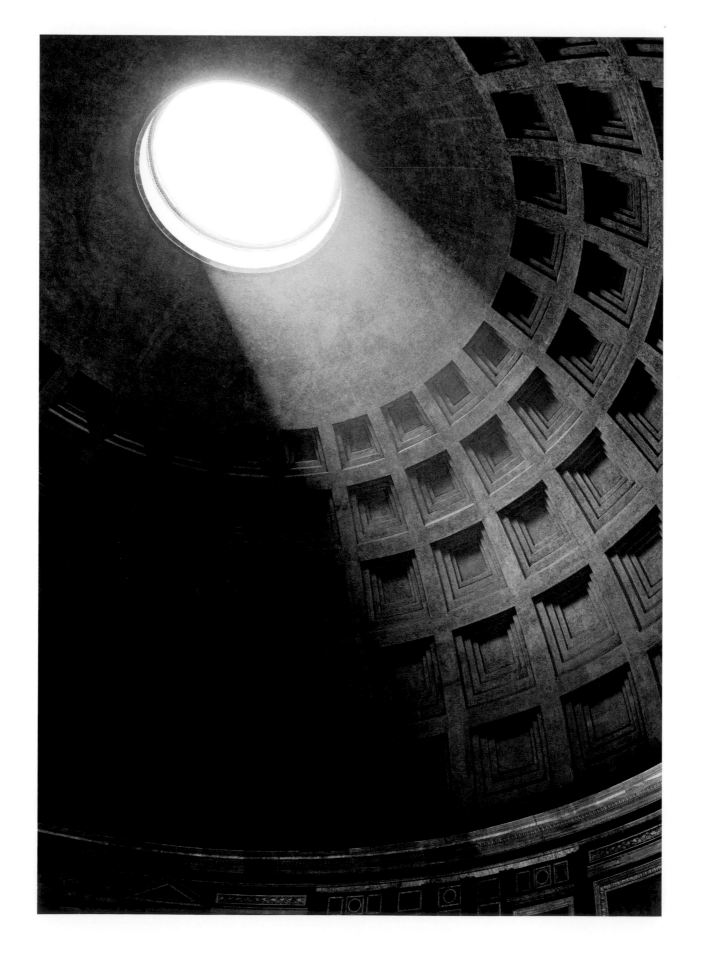

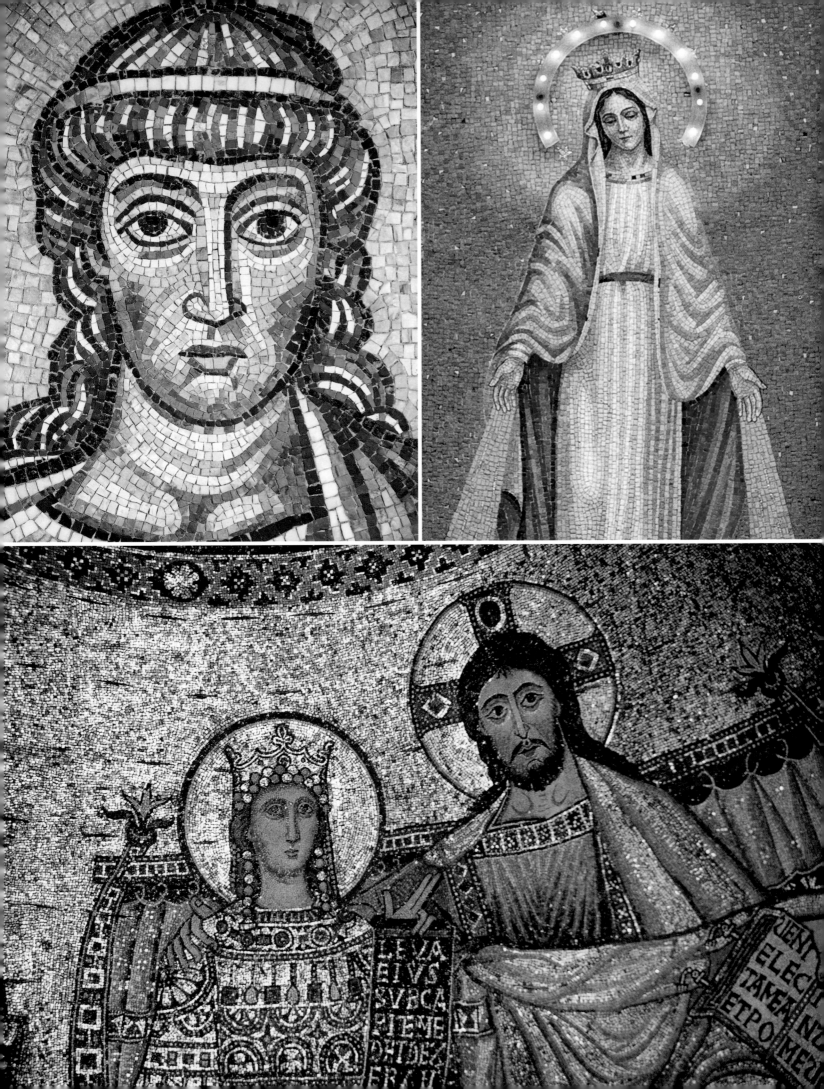

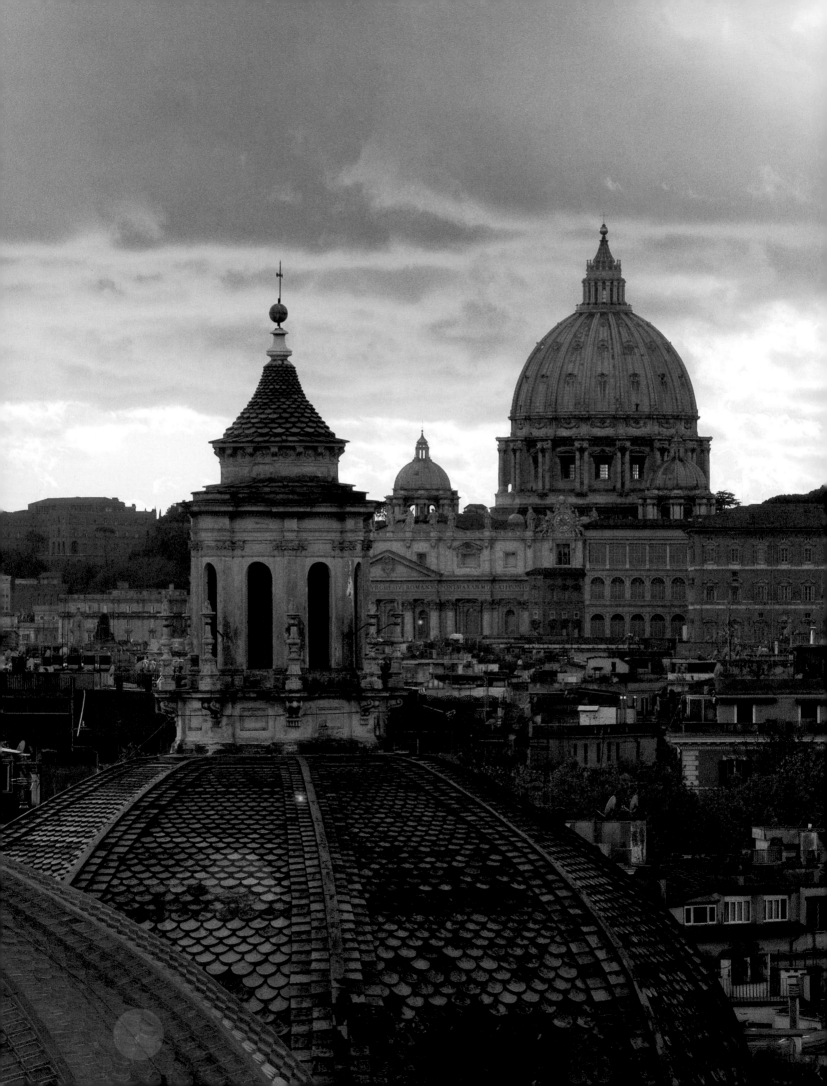

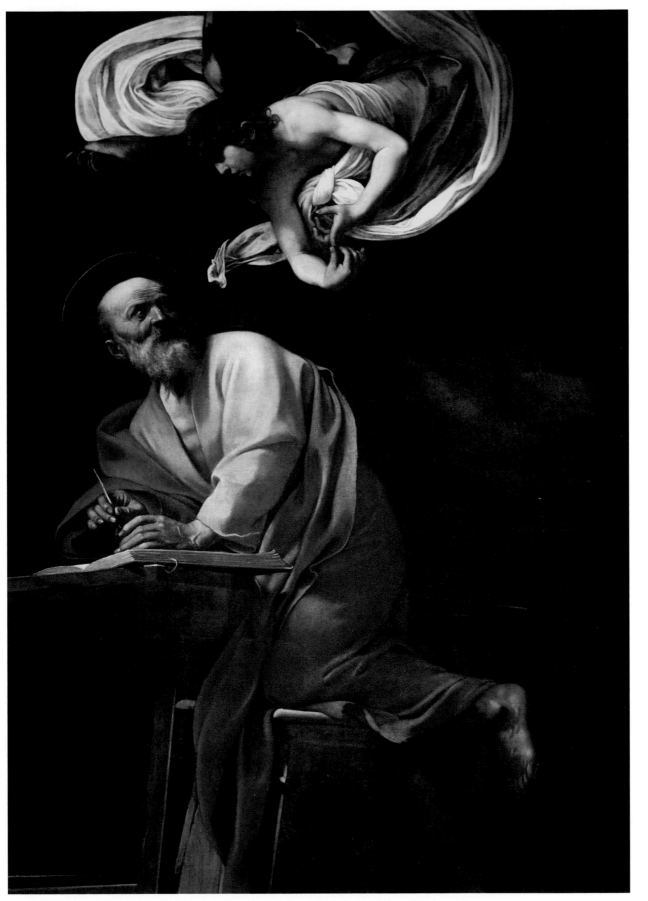

In the church of San Luigi dei Francesi, an evocative painting by Caravaggio, *The Inspiration of Saint Matthew.*

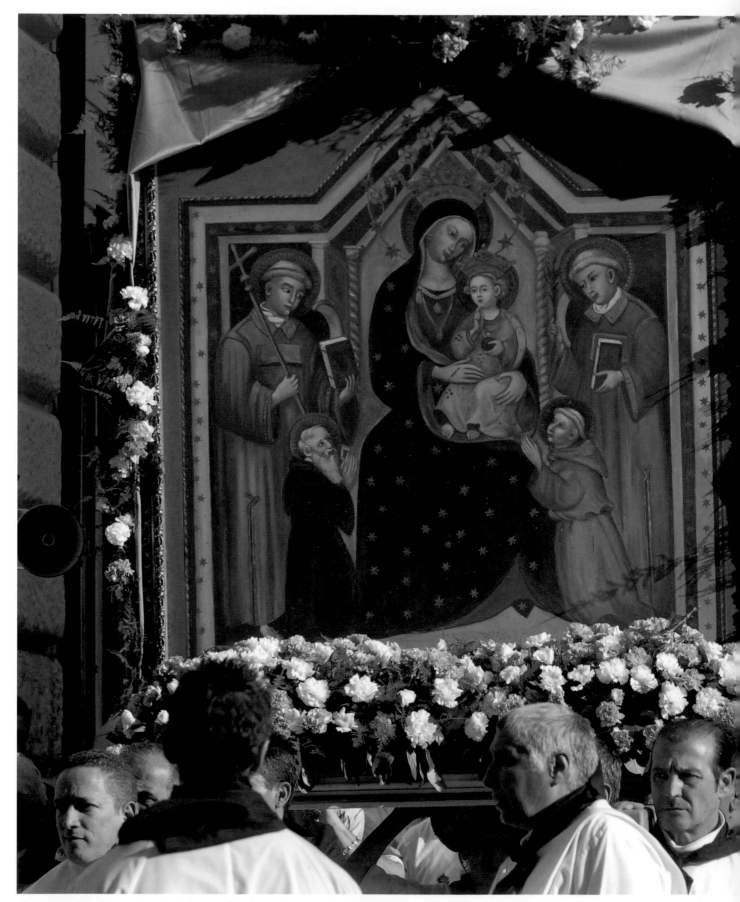

Above: In April, a religious procession in honour of Madonna dei Monti takes place through the tiny streets of the district.
Opposite bottom right: Artisan workshop, La Bottega dell'Arco, on Via del Pellegrino, restoring sacred artworks.

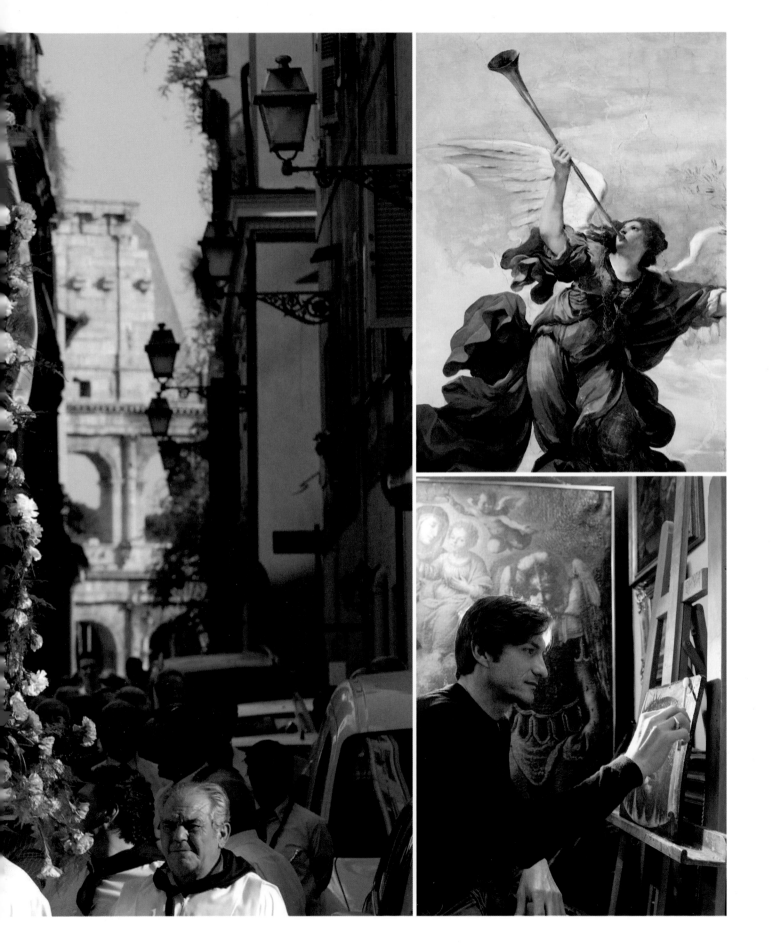

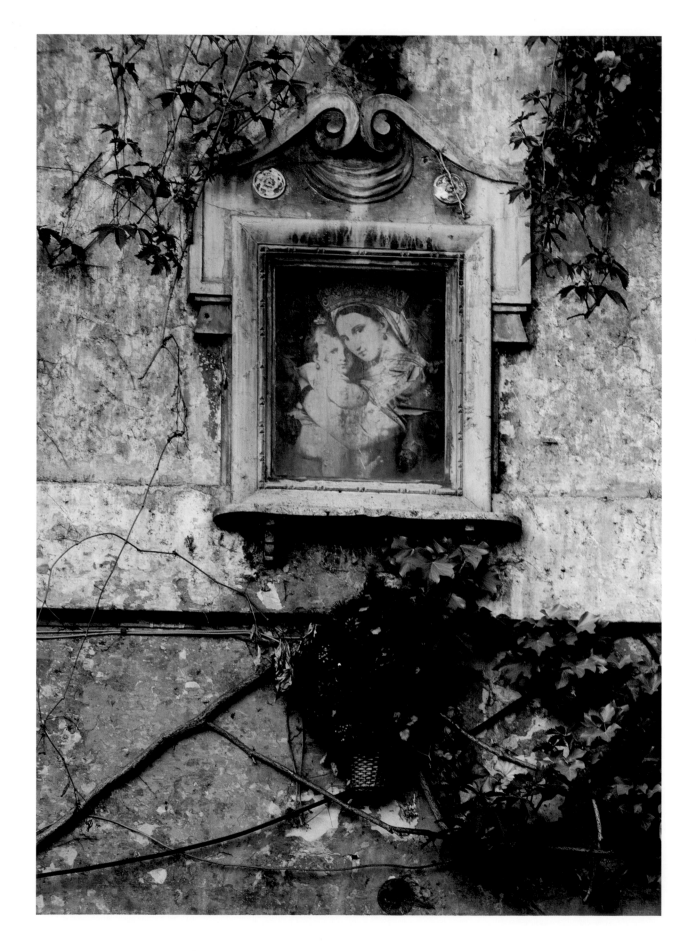

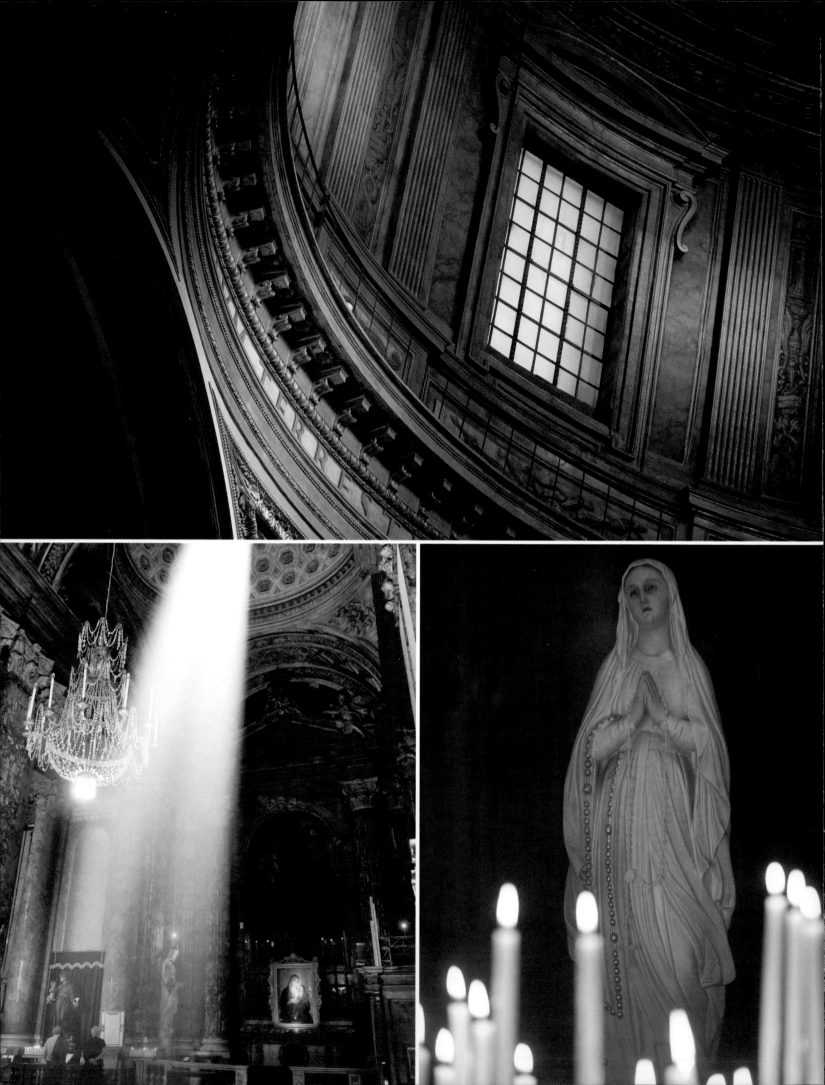

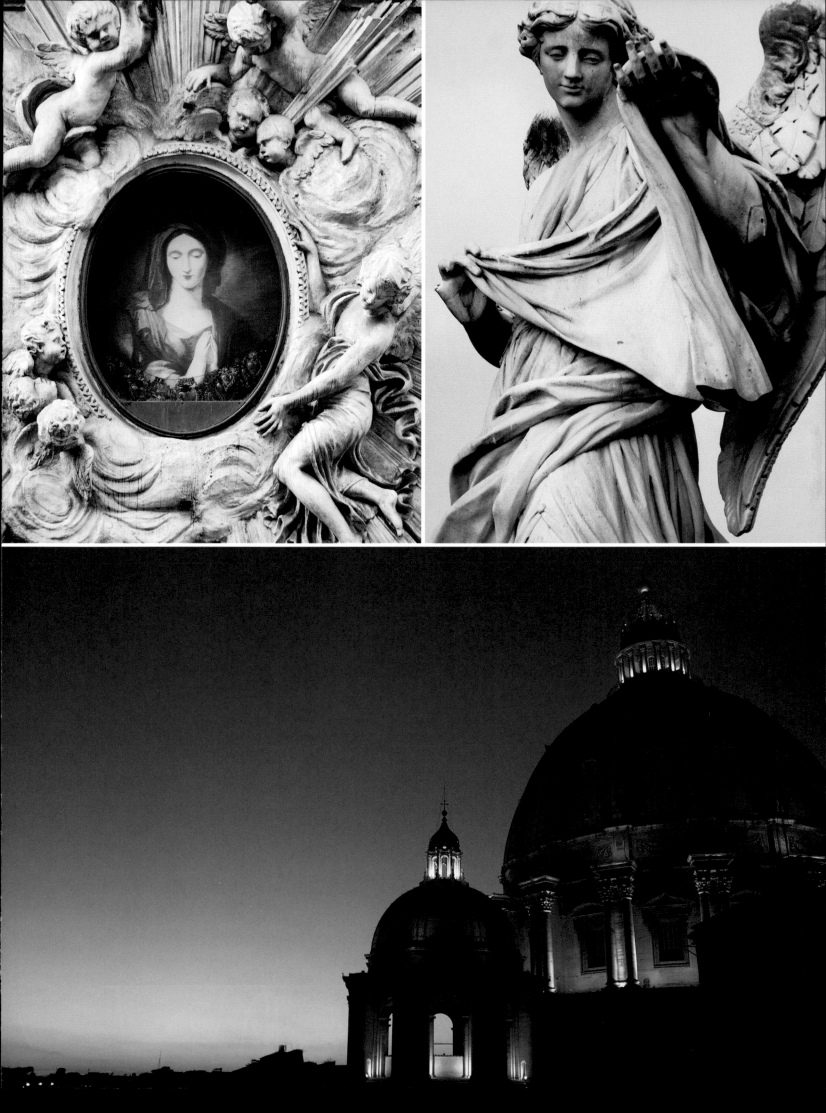

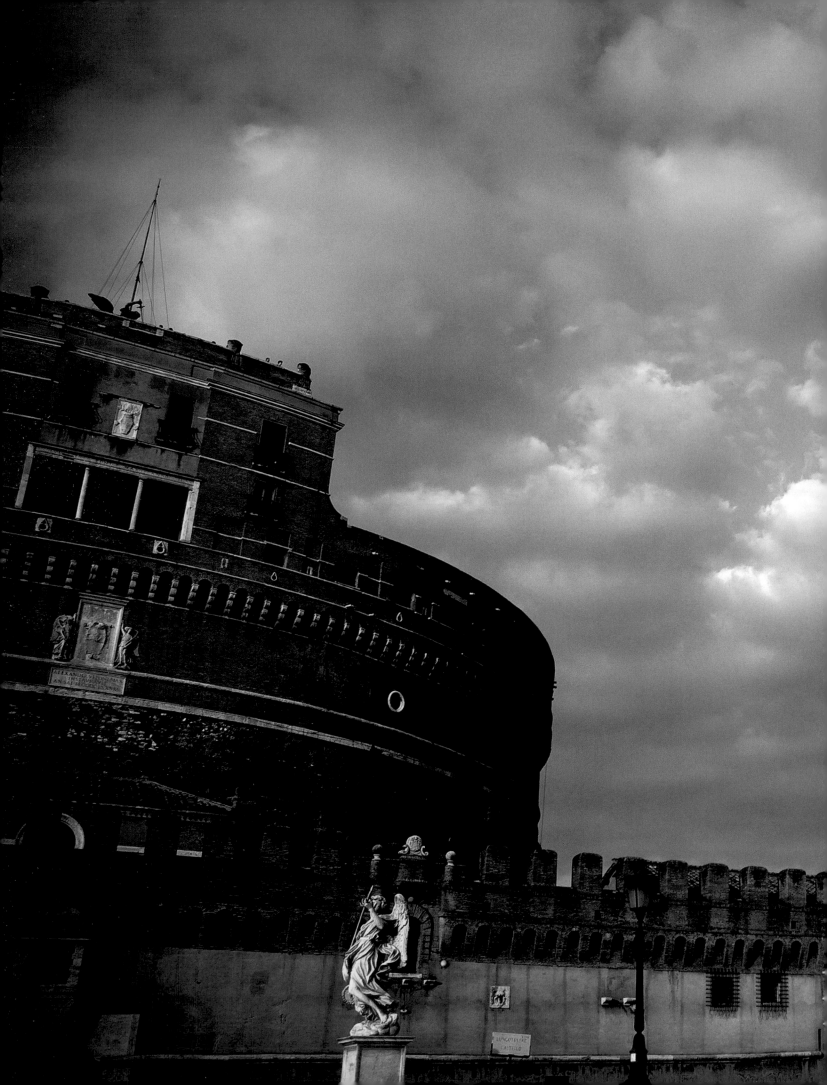

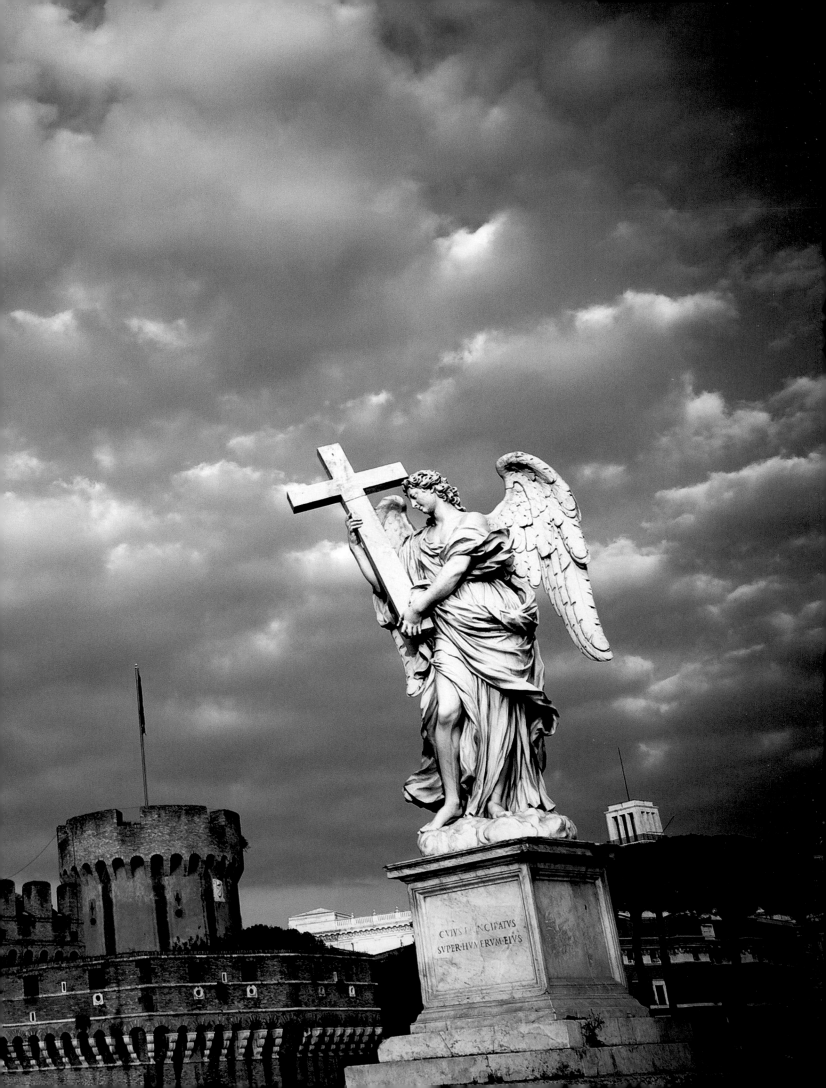

SHOPPING *Fare lo shopping*

In Rome, it is easy to get sidetracked by the alluring and deliciously tempting window displays, gracing thoroughfares and alleyways throughout the city centre.

Whether your palate craves fine designer Italian couture, vintage and second-hand glamour, tenderly restored antiques or finely crafted artisanal wares, Rome has a sumptuous assortment to cater for every taste and wallet.

The Spanish Steps district is without doubt, the celebrity of Rome's fashion world. Via Condotti, Via del Babuino and Via Frattina draw a huge crowd, every day of the week and at any time of the year. It is the place to see and to be seen. Gucci, Prada, Dior, Missoni and Armani adorn perfectly pouting mannequins in shop windows as well as the 'beautiful people' sauntering down the fashionable streets.

For a more relaxed shopping experience, stroll down a few modest alleyways where you will discover independent, young, talented designers, artists and artisans creating one-off, signature pieces. Via del Governo Vecchio near Campo dei Fiori, Via del Boschetto and Via Urbana in *rione* Monti and Via dei Coronari close by Piazza Navona are a few such alleyways.

And for a shopping experience somewhere in the middle, Rome's major thoroughfares are a consumer's heaven, with shops of all sizes and varieties eagerly awaiting to entice you and your pocket. Head to Via Nazionale off Piazza della Repubblica, Via del Corso from Piazza Venezia, Via Cola di Rienzo near the Vatican and Via del Tritone from Piazza Barberini, to name a few.

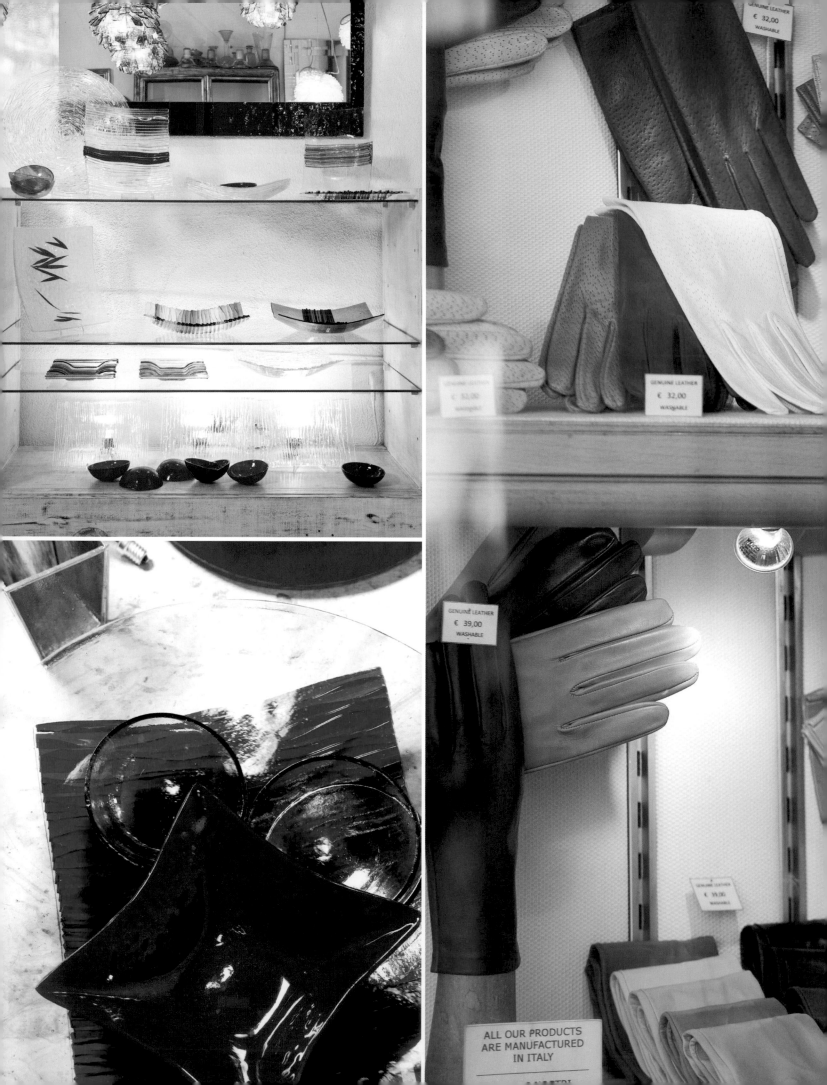

GENUINE LEATHER
€ 32,00
WASHABLE

GENUINE LEATHER
€ 32,00
WASHABLE

ALL OUR PRODUCTS
ARE MANUFACTURED
IN ITALY

GENUINE LEATHER
€ 39,00
WASHABLE

GENUINE LEATHER
€ 39,00
WASHABLE

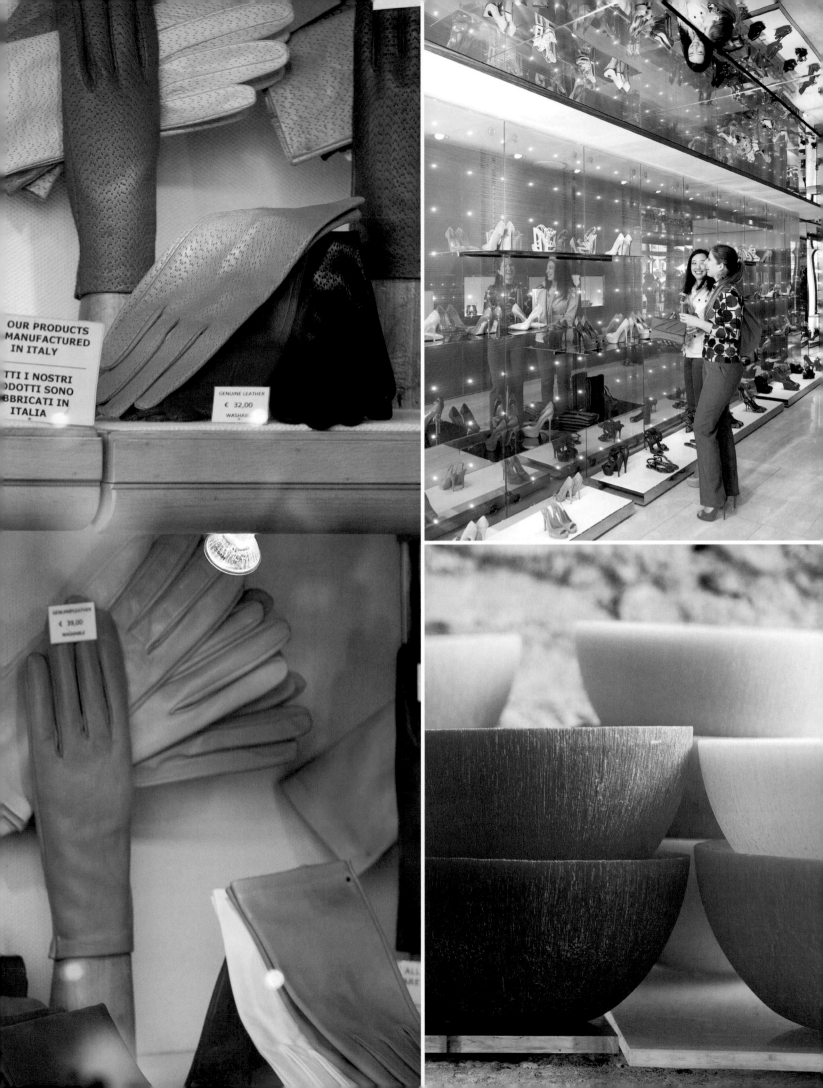

OUR PRODUCTS
MANUFACTURED
IN ITALY

TTI I NOSTRI
ODOTTI SONO
BBRICATI IN
ITALIA

GENUINE LEATHER
€ 32,00
WASHAB

GENUINE LEATHER
€ 39,00
WASHABLE

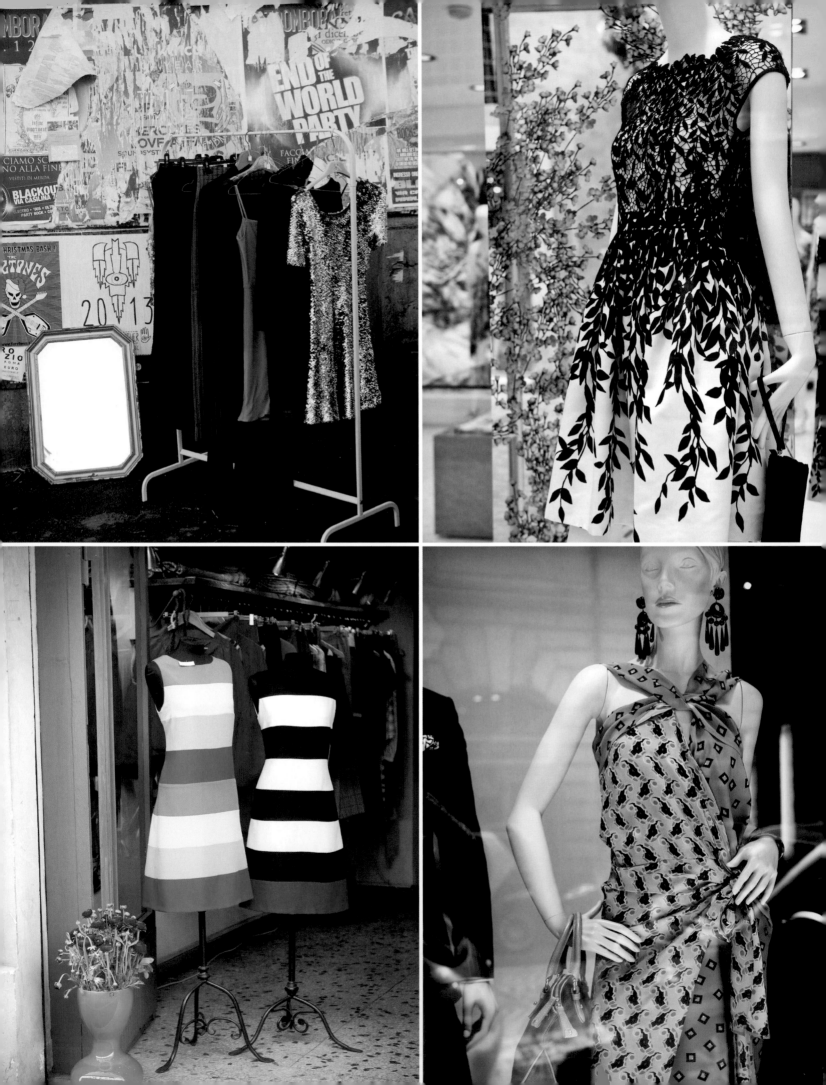

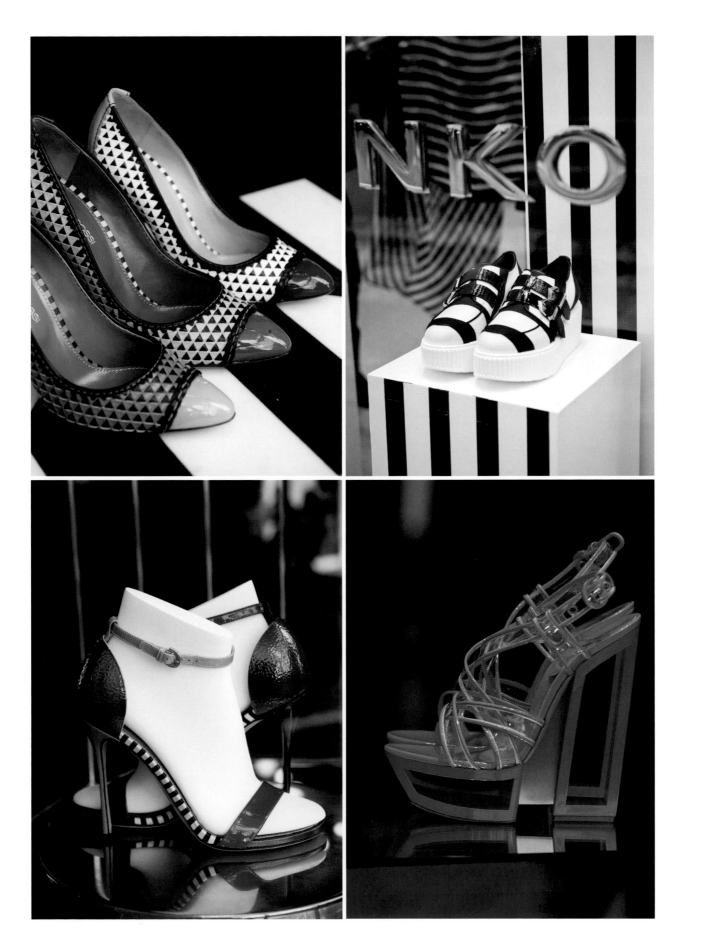

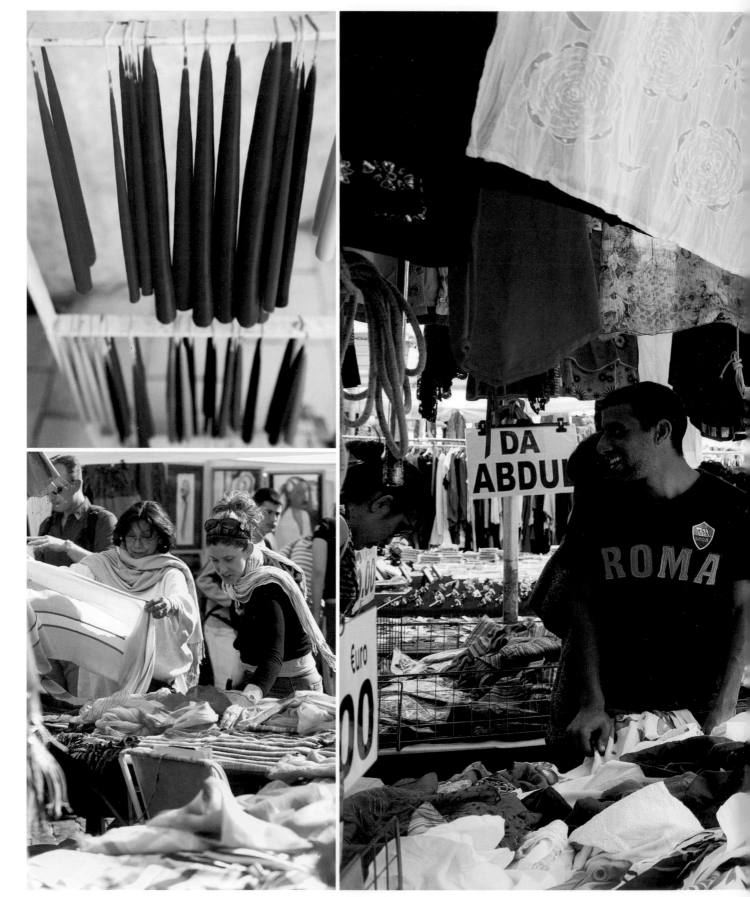

Top: La Casa della Luce, the candle store in Monti, an artisan workshop crafting original pieces from wax and wrought iron.
Main photo and bottom left: Bancarelle, or market stalls, at the Porta Portese Markets, where flea markets are held every Sunday in the Trastevere district.

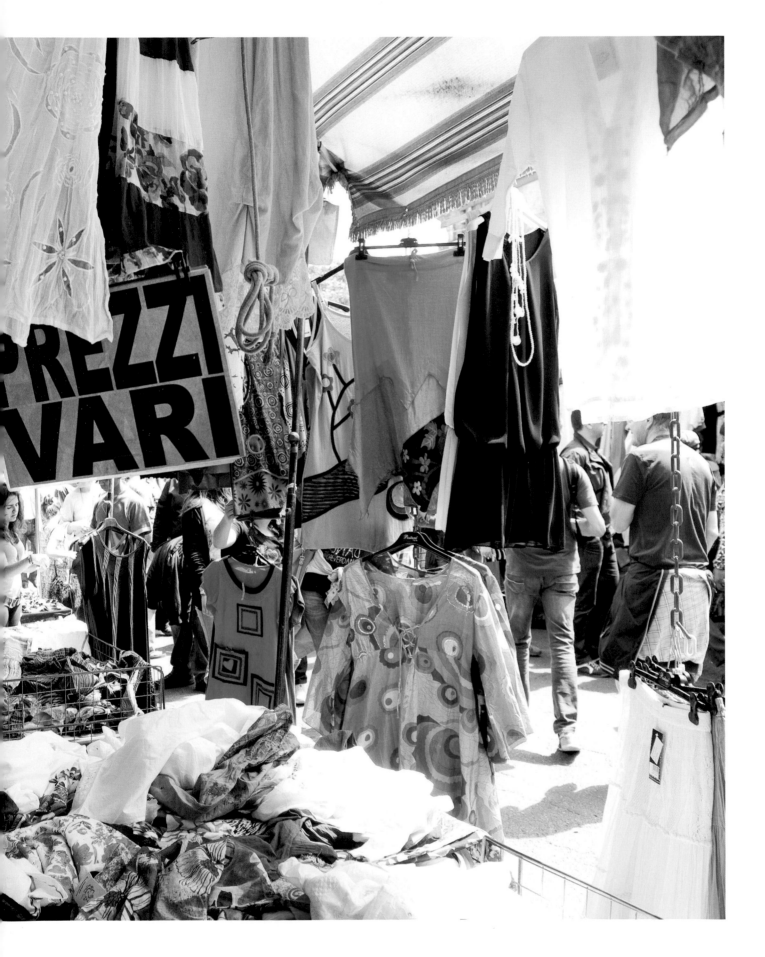

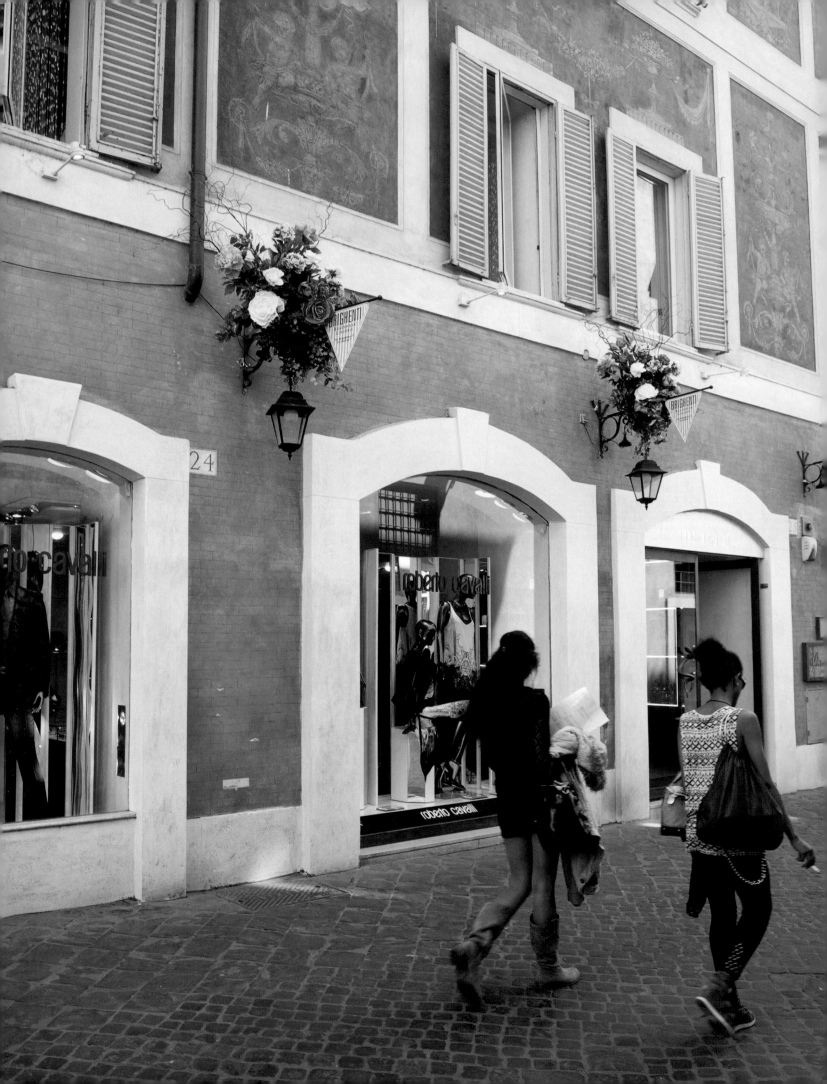

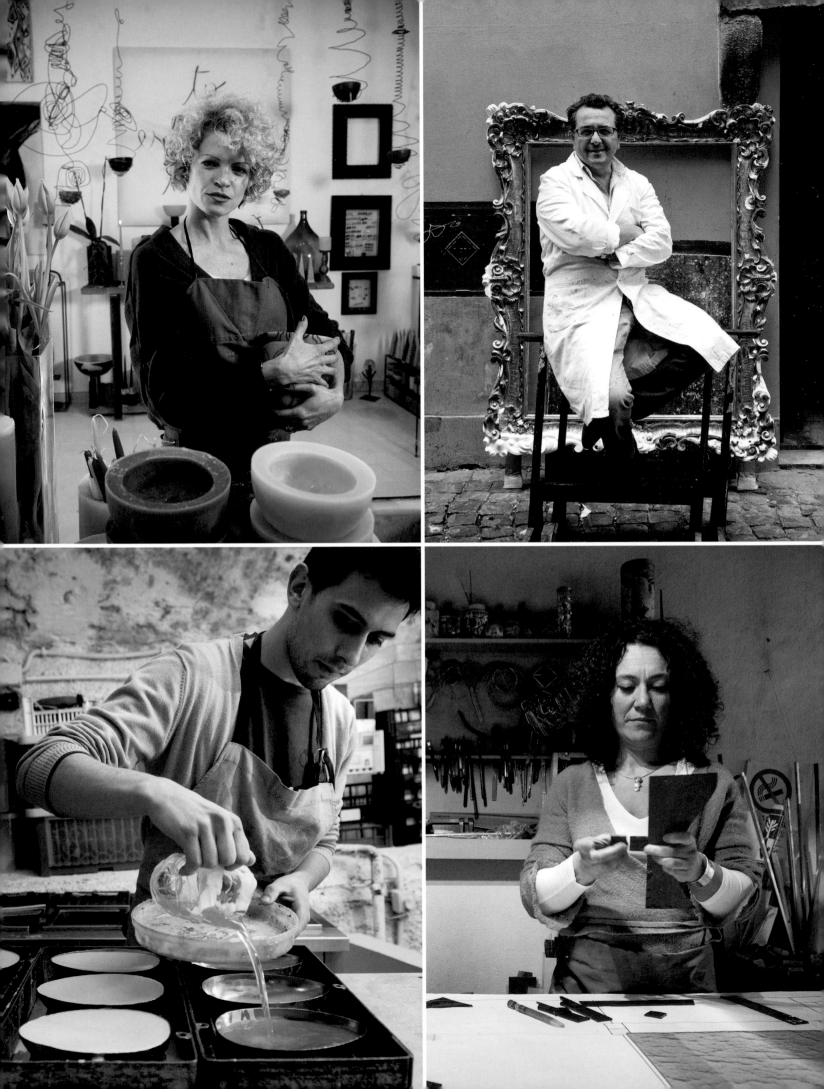

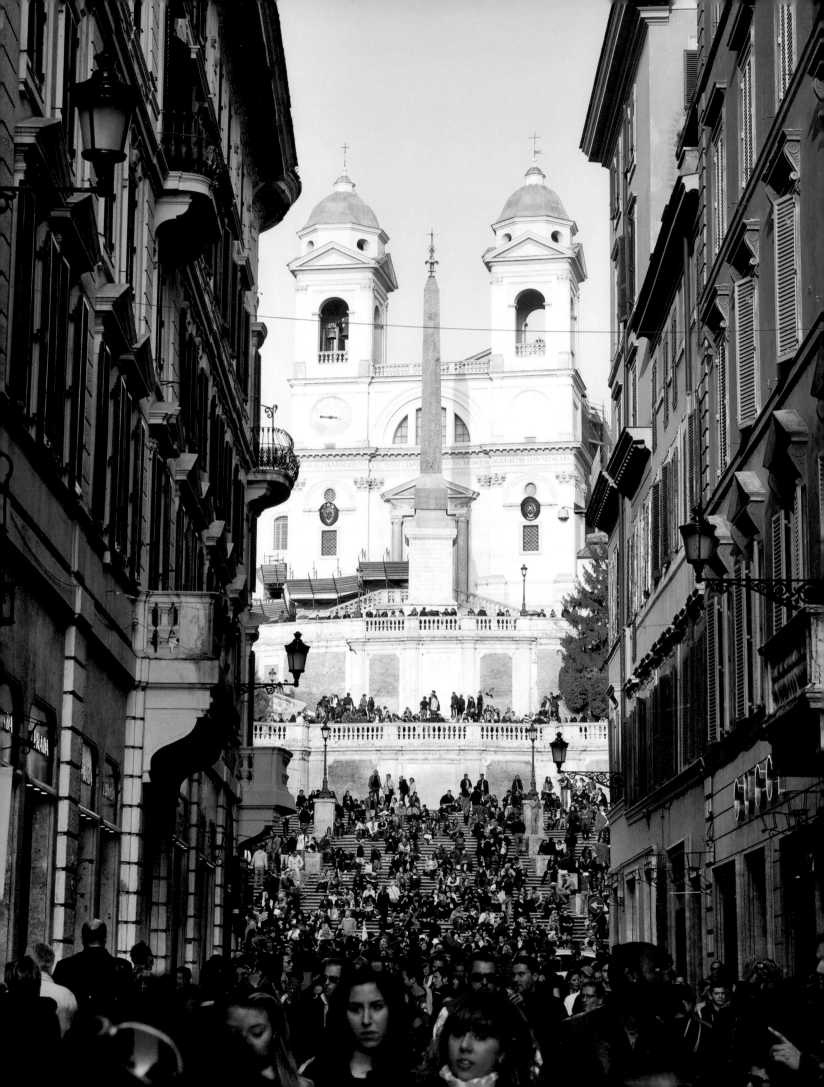

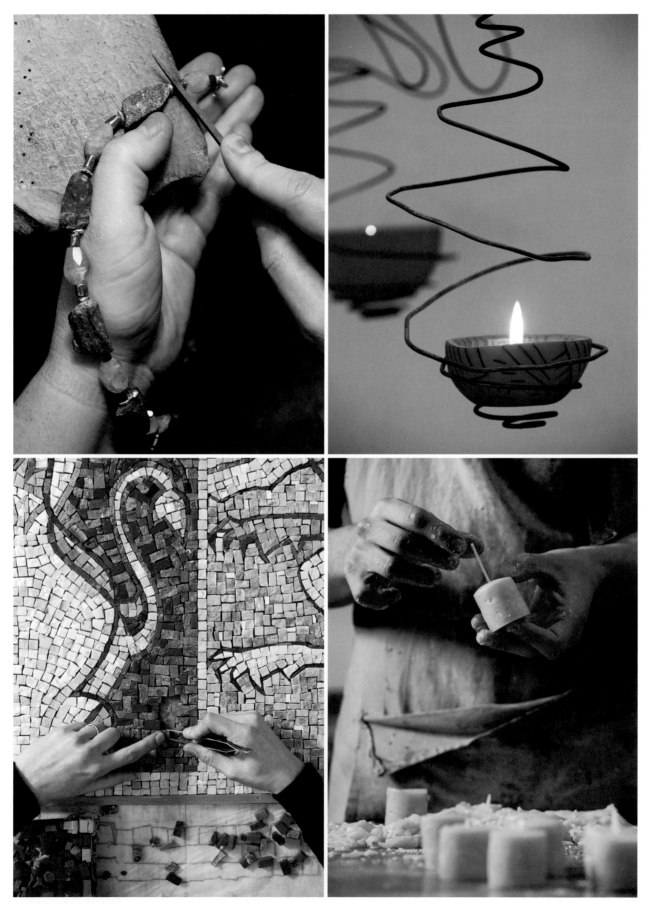

Artisan workshops scattered throughout the historic centre offer quality hand-crafted original pieces: Agentia creates sculptured jewellery designs (top left); La Casa della Luce creates original pieces from wax and wrought iron (top right and bottom right); Studio Cassio is a mosaic designer and school (bottom left).
Previous page: Fersini Restauro, restorers of antique frames (top right); Silice workshop and showroom for handcrafted glassware (bottom right).

LOVE *L'Amore*

Love conquers all.

– VIRGIL, ANCIENT ROMAN POET

Love… *Amore…* Feel it, see it, experience it! Rome has it in abundance.

Whether you find yourself strolling hand in hand with the one you love, or enjoying a solo escapade of discovery, Rome's beating heart will enchant you, romance you and seduce you.

Delight in a gesture of love that greets you at a street corner caffè – a barista's perfectly crafted heart of frothy milk decorating your early morning *caffè espresso macchiato* or *cappuccino*.

Relish in a cultural and creative feast at the magnificent Galleria Borghese boasting one of Europe's most prized artistic collections. Be captivated by the alluring sensuality of Bernini's *Ratto di Proserpina* or the master brushstrokes and sublime colour palette of Tiziano's *Amor Sacro e Amor Profano* – Sacred Love and Profane Love.

Feel your heart sing along with the serenade of a charming busker and his endearing piano accordion, slowing the frenetic pace of the city streets with a nostalgic ensemble of love songs.

Jump double-up onto a vintage Vespa and recreate the romantic scene from the classic movie *Roman Holiday* and ride the bumpy, musical cobblestones, just as Audrey Hepburn and Gregory Peck did.

Or simply experience the magic as the summer moon emerges over the silent monoliths of the ancient city.

Opposite: Exquisite details of Pluto's grasp of the flesh of Proserpina, Bernini's Baroque masterpiece at the Galleria Borghese

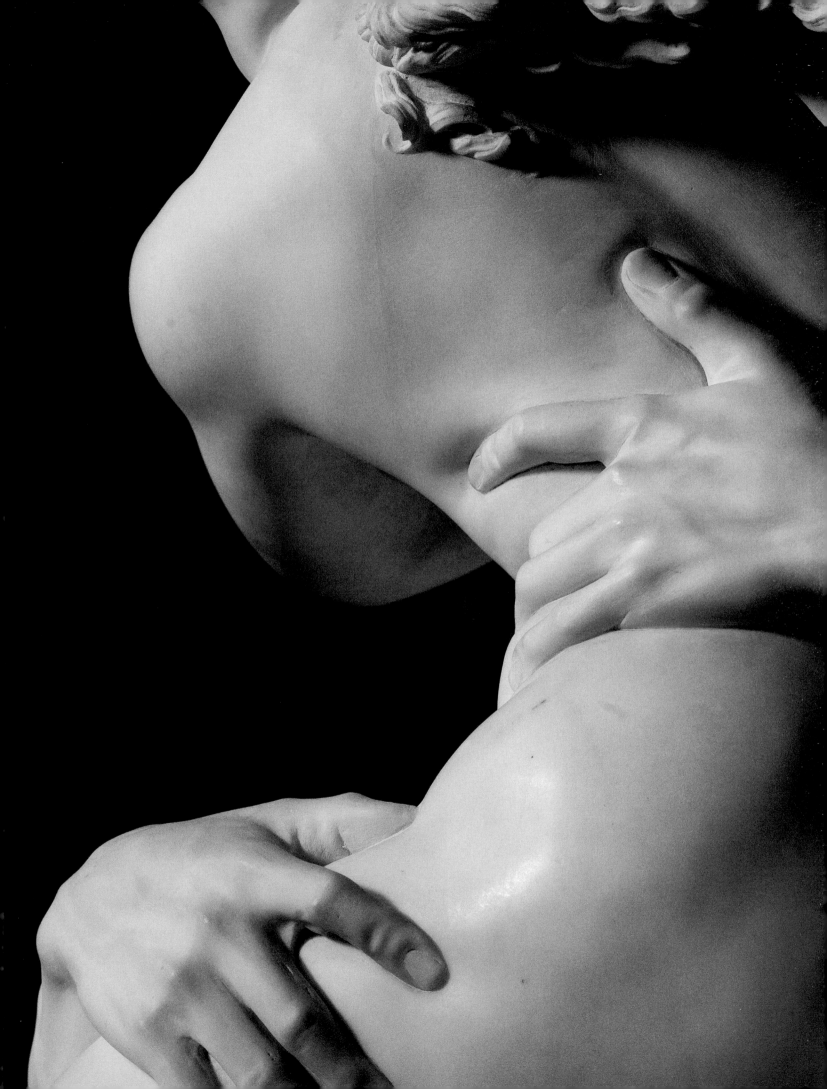

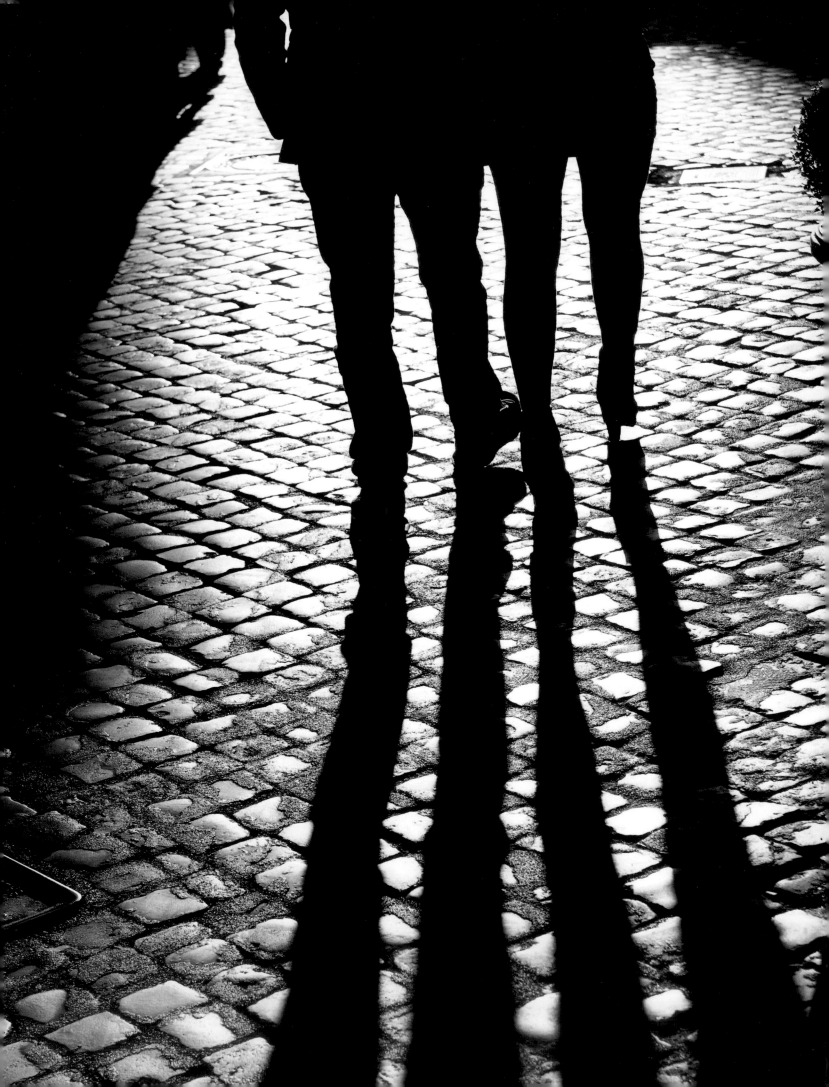

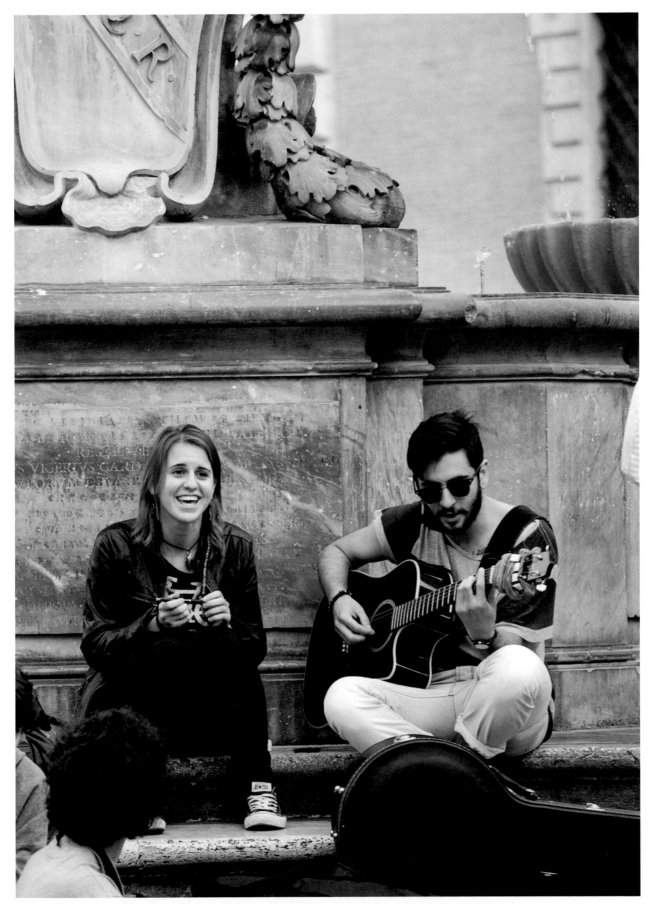

Following page: Details from the cycle fresco, *The Loves of the Gods,* by Annibale Carracci, in the Farnese Gallery, Palazzo Farnese.

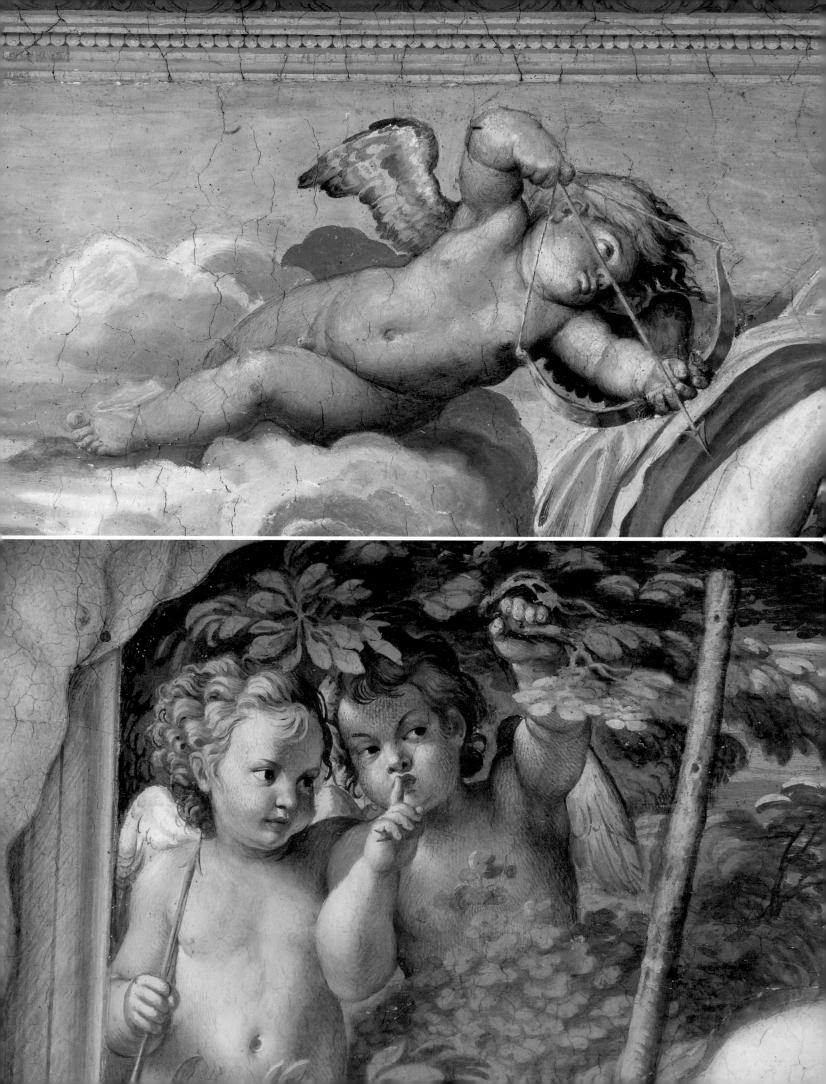

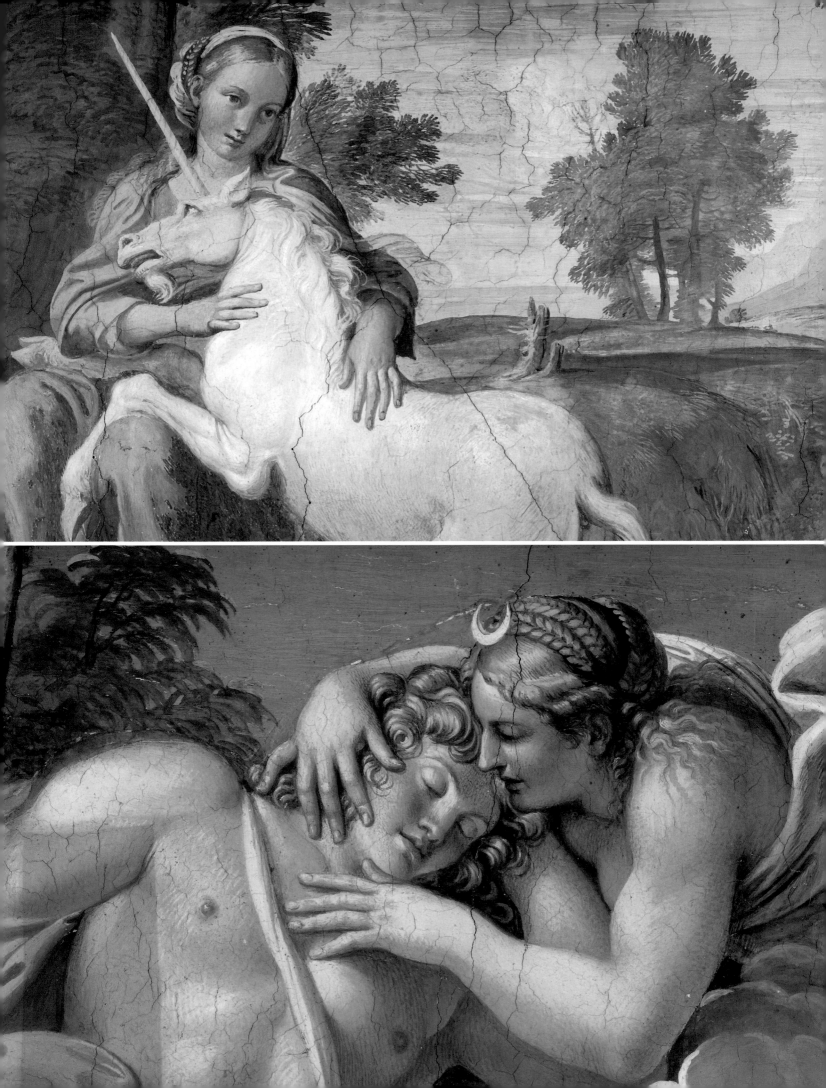

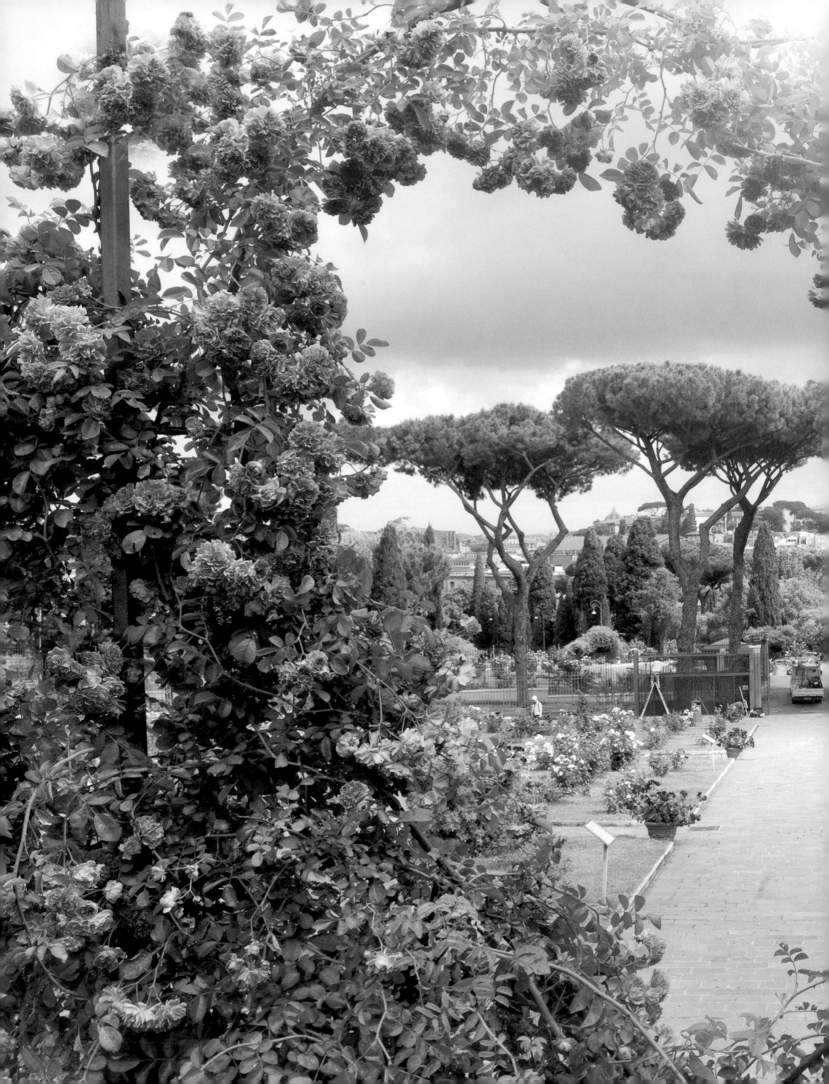

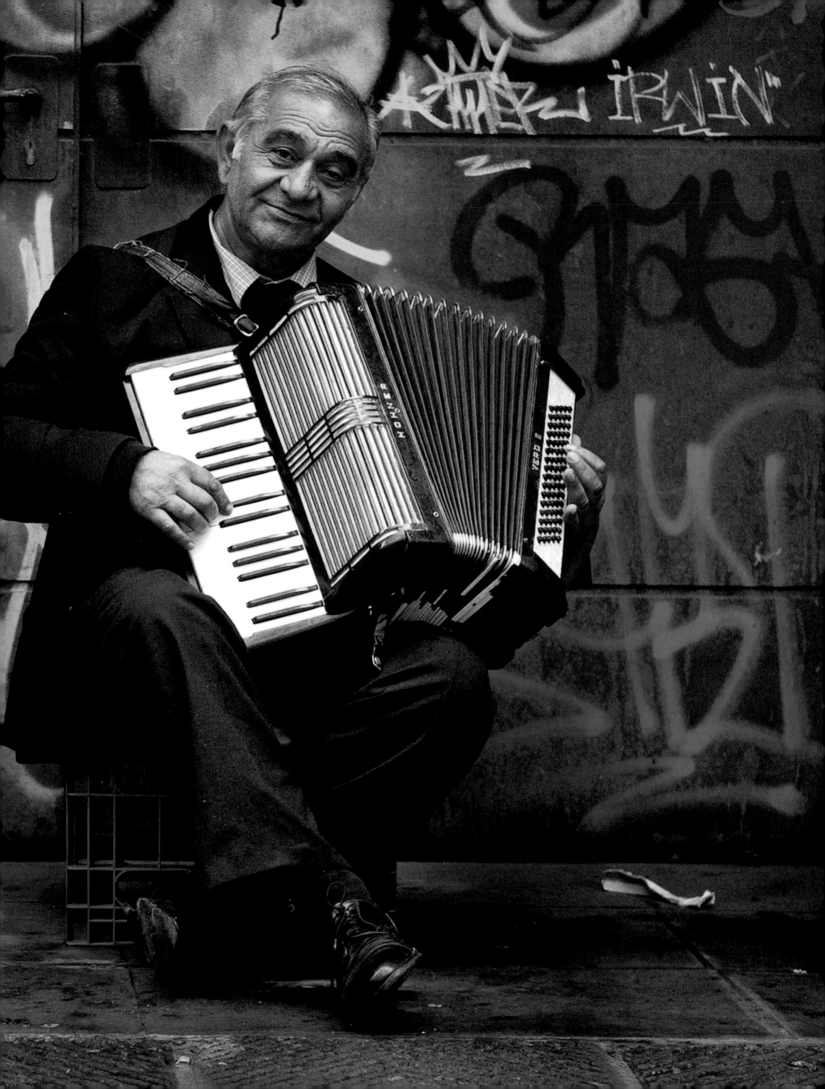

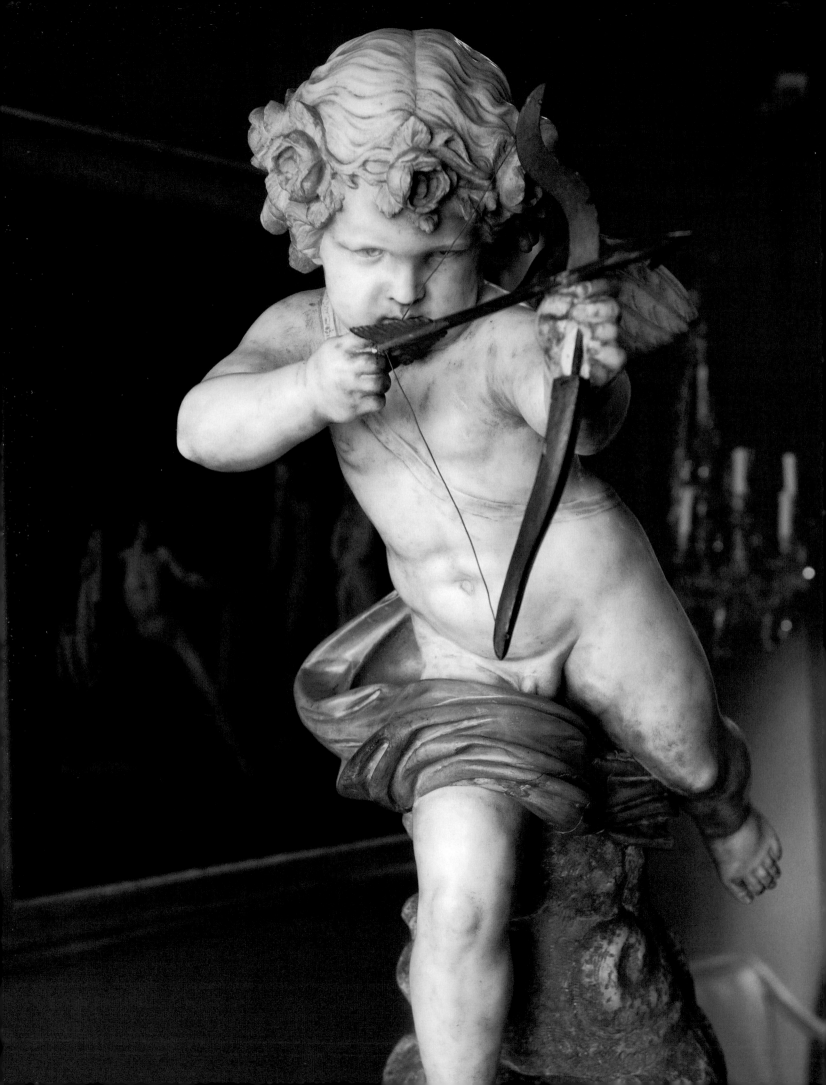

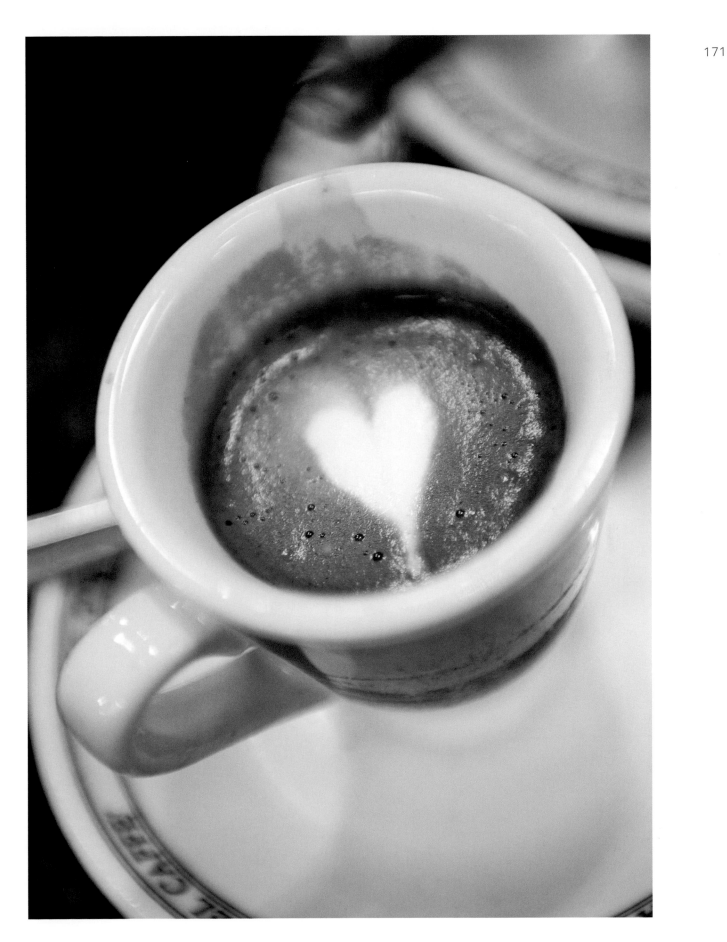

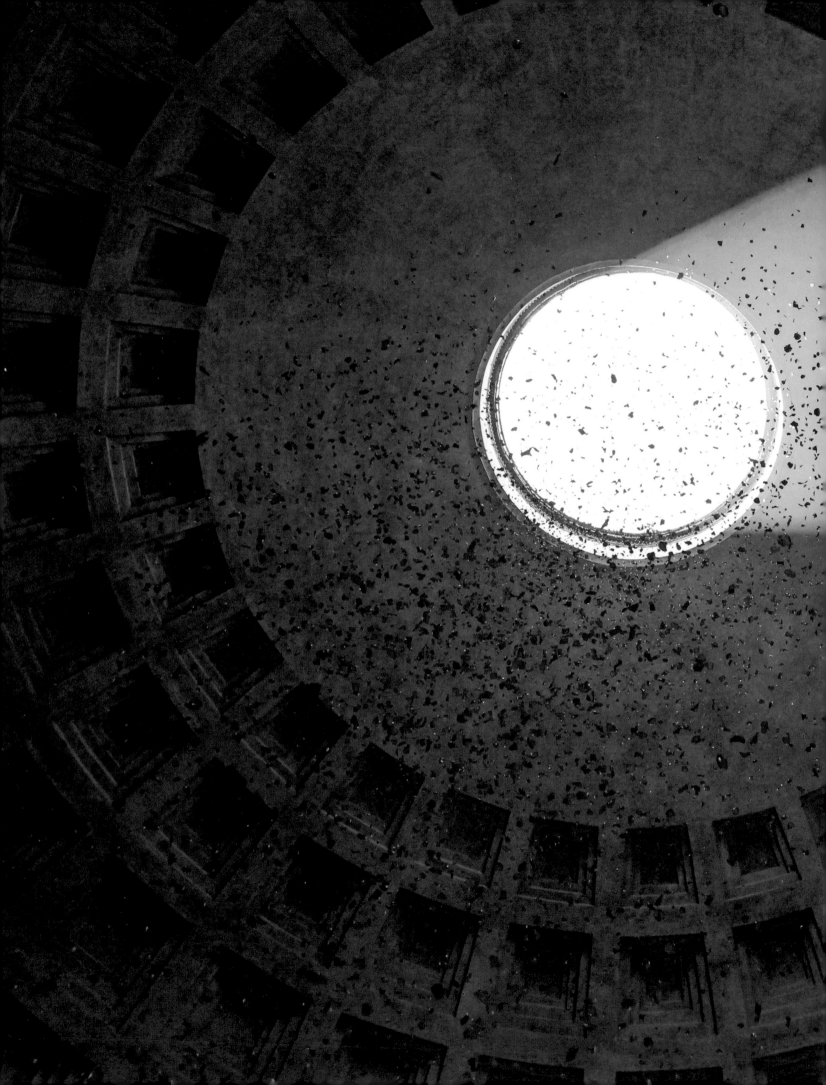

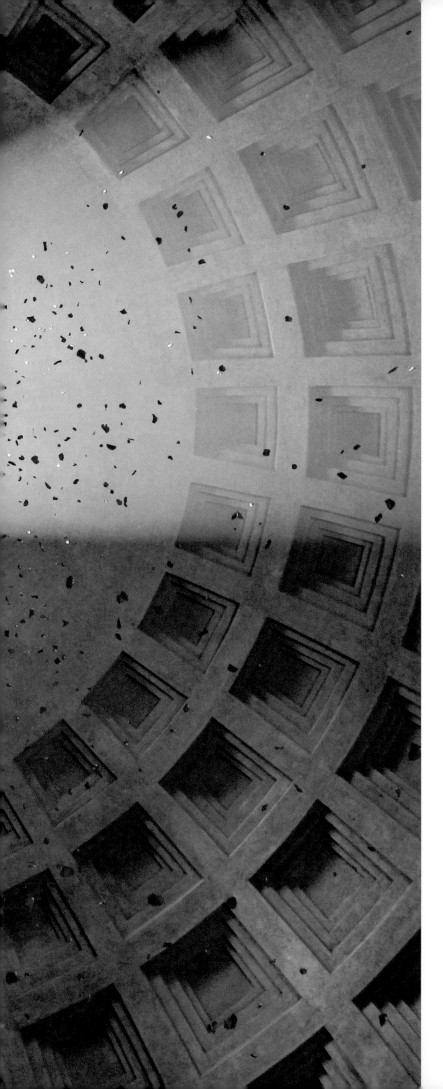

Ti prego Maria

gettami un fiore

che Io possa un poco odorare

come un pegno d' amore

che mi ha fatto tanto soffrire.

Il tuo mazzo gettamelo

che di te ancora e mai

io saro' sazio

I beg of you Mary

throw me a flower

so that I may gather its perfume

this is like the token of love

that made me suffer so.

Throw me your bouquet

not now and not ever

will I have my fill of you.

— **FRATELLI MANCUSO**

Left: The spectacular ceremony of showering rose petals on Pentecost Sunday, falling from the Pantheon's oculus, evoking the descending Holy Spirit. Photographer: Aaron Borchardt

STROLL *La Passeggiata*

To live in Rome and not to walk would, I think, be poor pleasure

– HENRY JAMES

Walking is a favourite Italian pastime – and why wouldn't it be, when you can immerse yourself among timeless and sumptuous surroundings, to free your mind from your daily cares?

In Rome, *la passeggiata*, better known as *namose a fà du passi* in Roman dialect, is the perfect way to unwind and relax.

Slow down your pace as the Romans do for a late afternoon or midnight stroll with a creamy gelato along a romantic cobblestone street, while admiring the Renaissance and Baroque façades.

For the fashionistas – don your best 5-inch heels and Gucci bag for a meander in the Tridente district of the Spanish Steps. Admire the art, beauty and couture of the alluring window displays along Via di Ripetta, Via del Corso and Via del Babuino, making the triangle forming Il Tridente.

For an unforgettable Sunday stroll, join the locals on Rome's most iconic road, Via Appia Antica. Built in 312 BC and connecting Rome with Italy's south, the 16-kilometre stretch of stone-paved road is now part of a tranquil nature and archaeological park, Parco Regionale dell' Appia Antica.

Lined with towering umbrella pines, ancient tombs, ruins, sculptures and crumbling Latin-inscribed plaques, a stroll along these well-worn boulders will take you on a journey of your imagination down two thousand years of Rome's magnificent history.

Opposite: Piazza del Popolo, the People's Square, a major pedestrian access point between Via del Corso and Piazzale Flaminio in the *rione* of Campo Marzio.

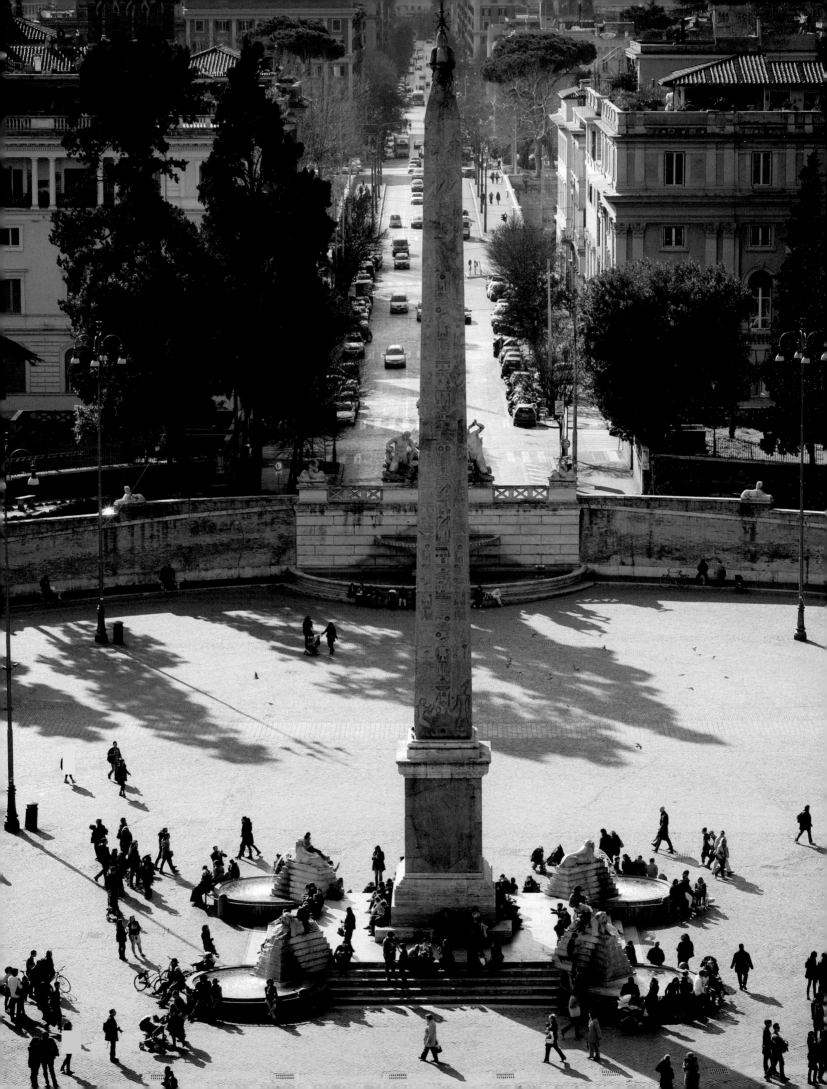

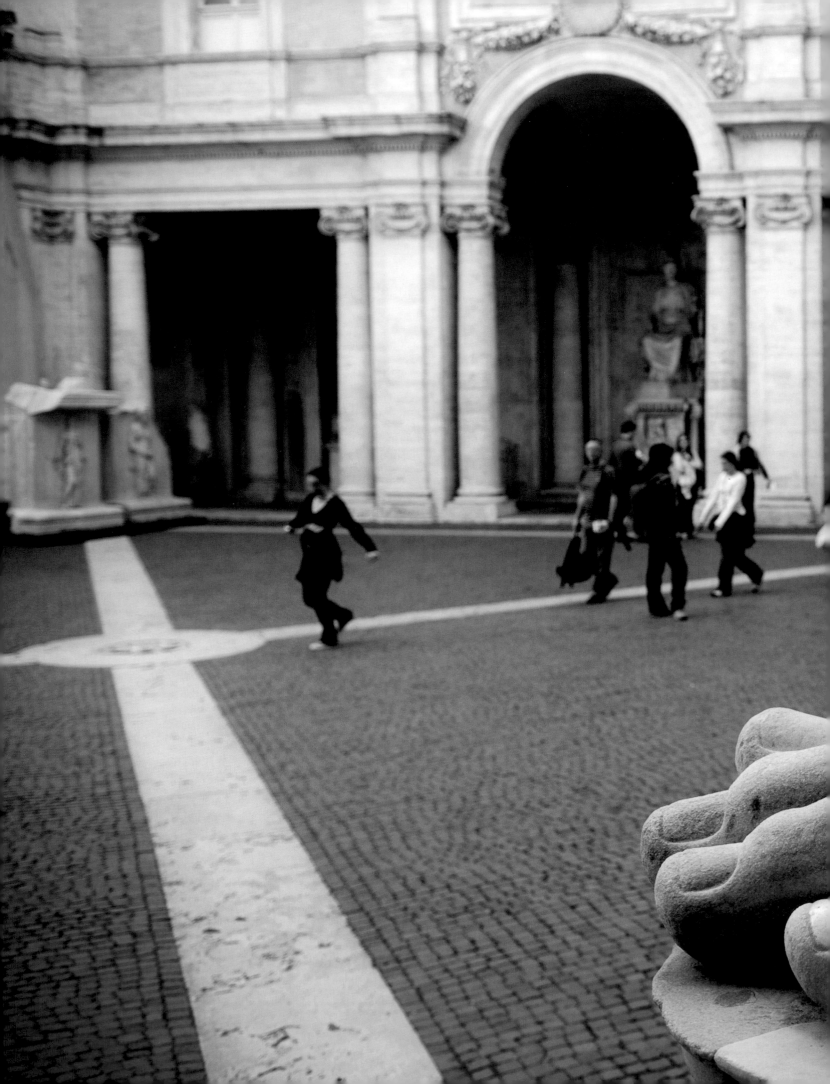

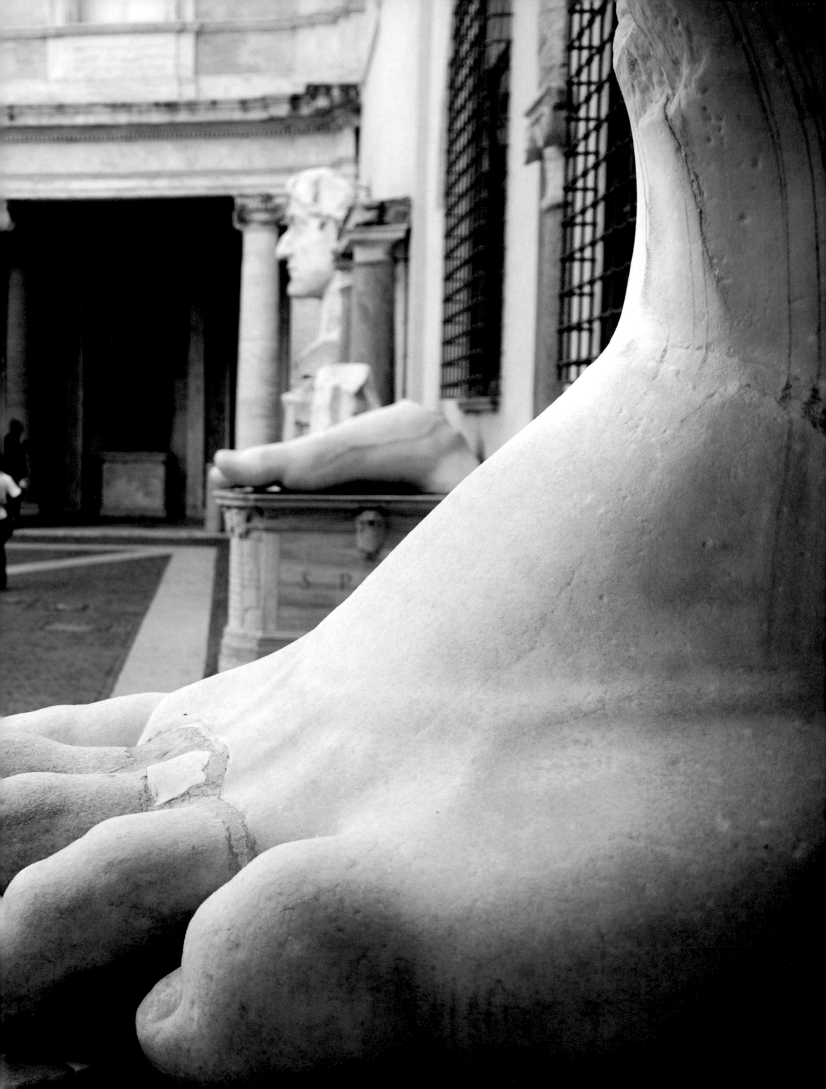

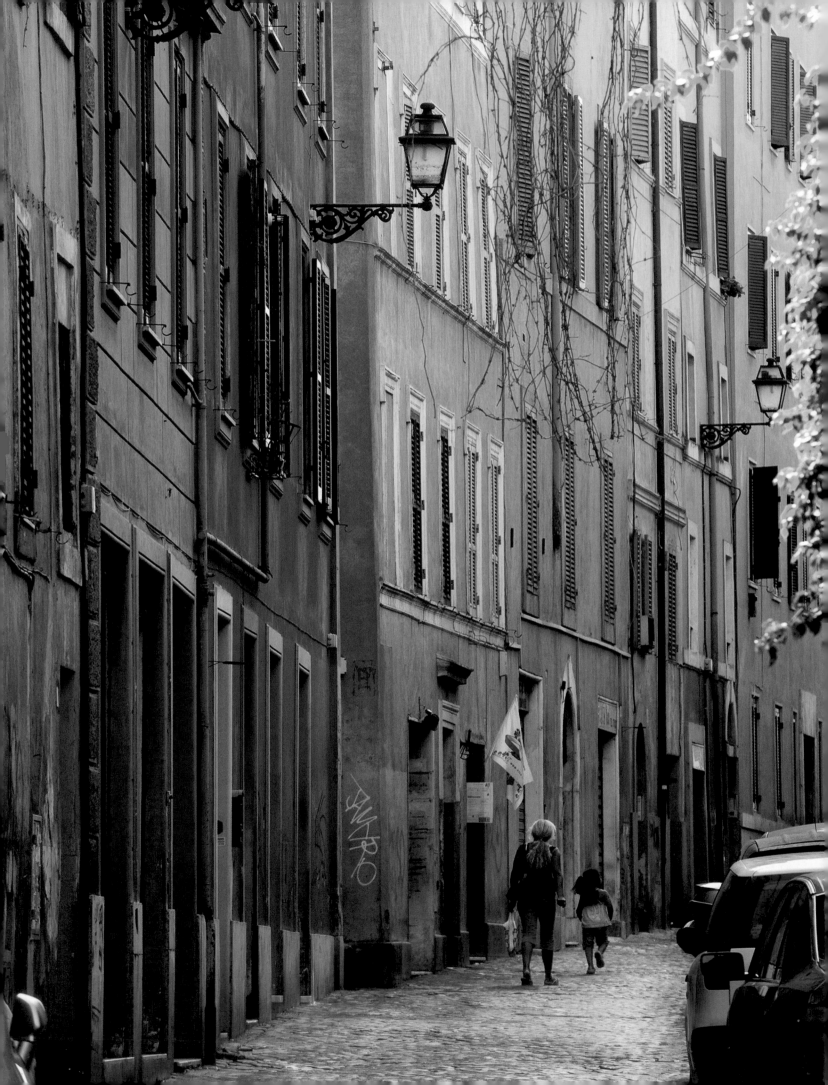

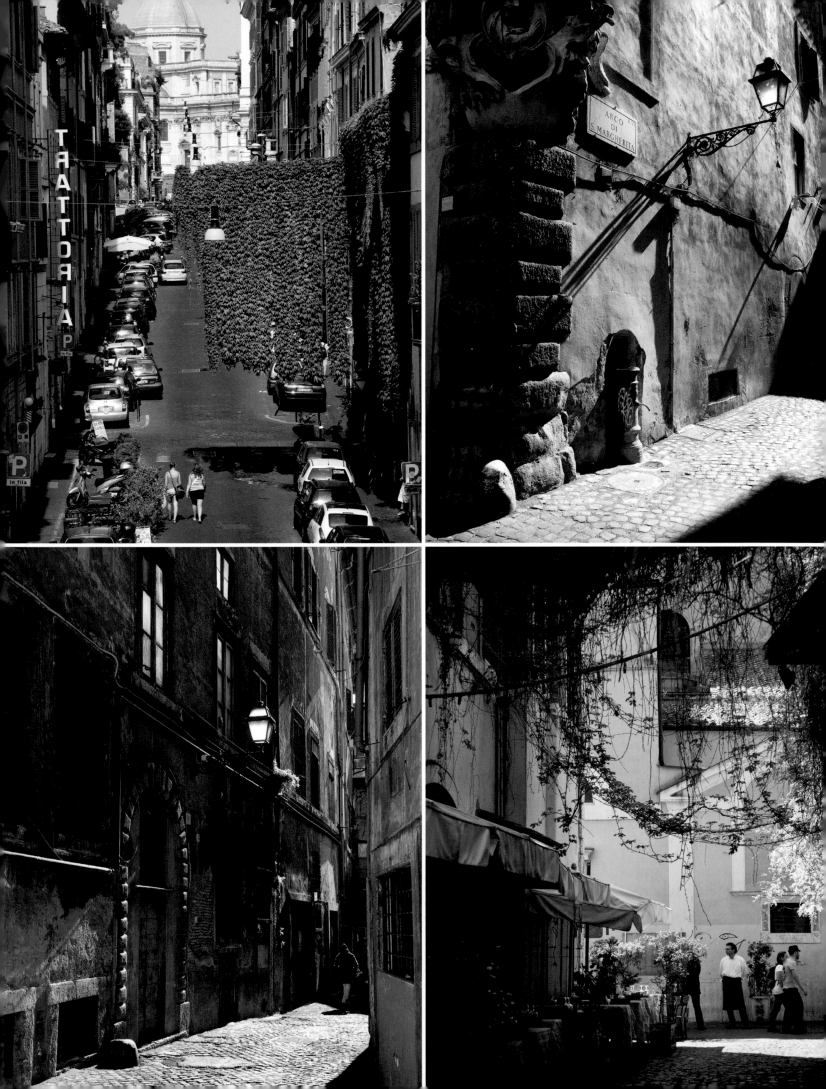

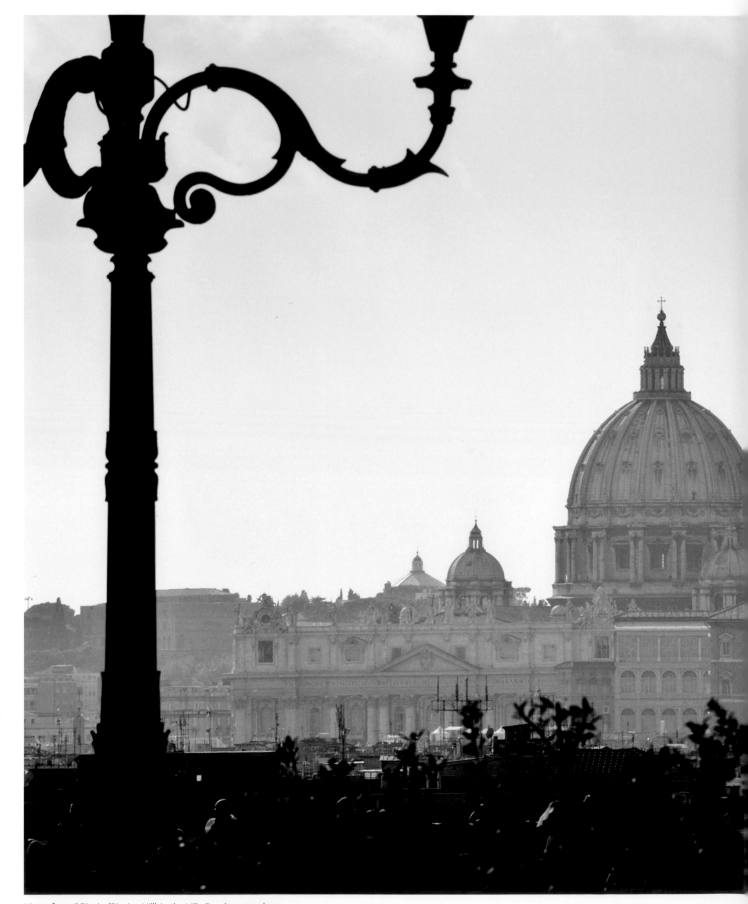

Views from Il Pincio (Pincian Hill) in the Villa Borghese gardens.

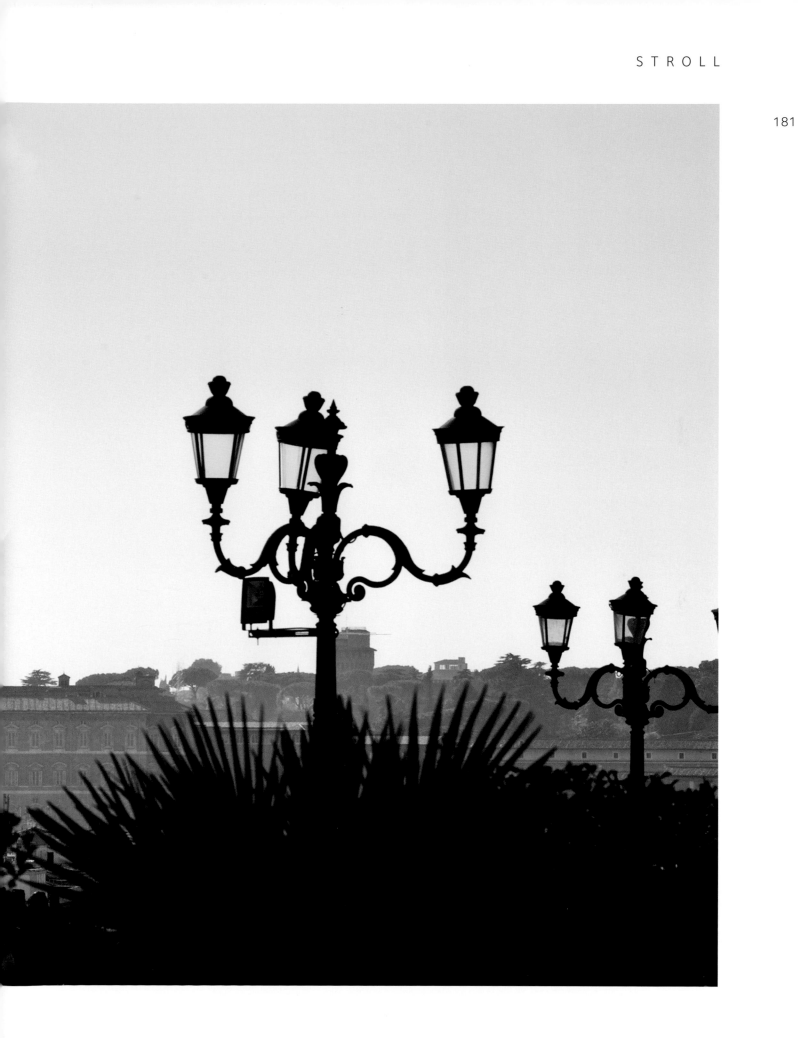

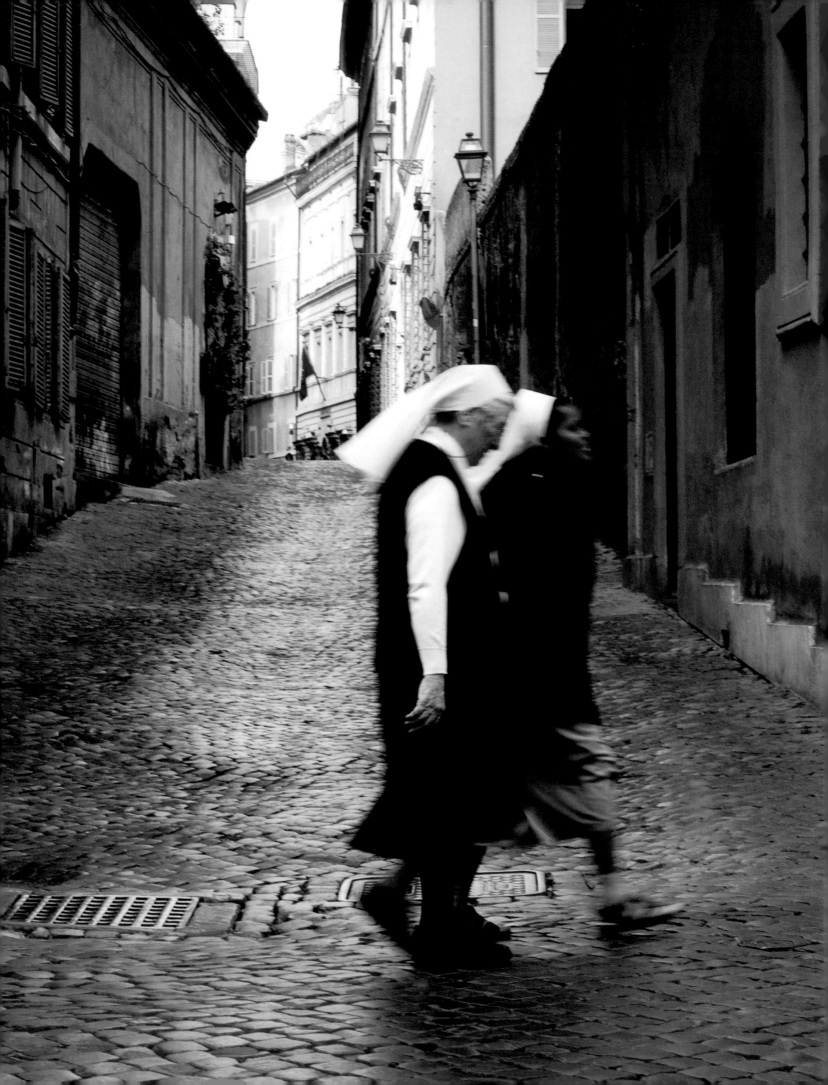

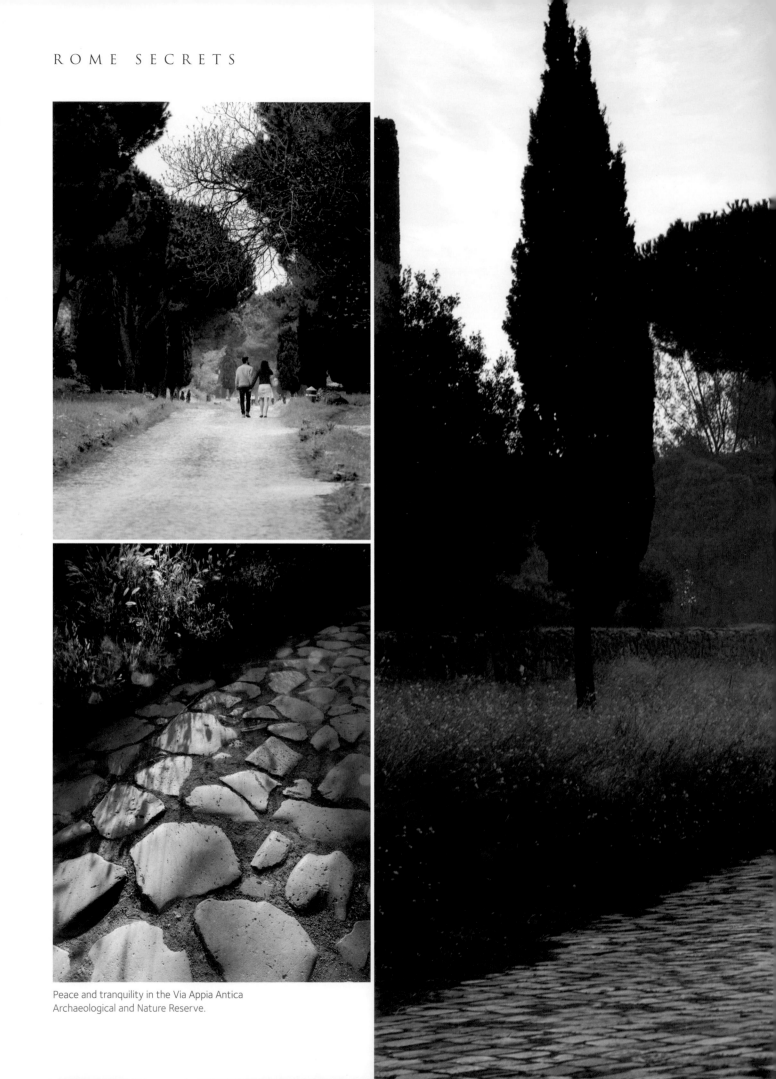

Peace and tranquility in the Via Appia Antica
Archaeological and Nature Reserve.

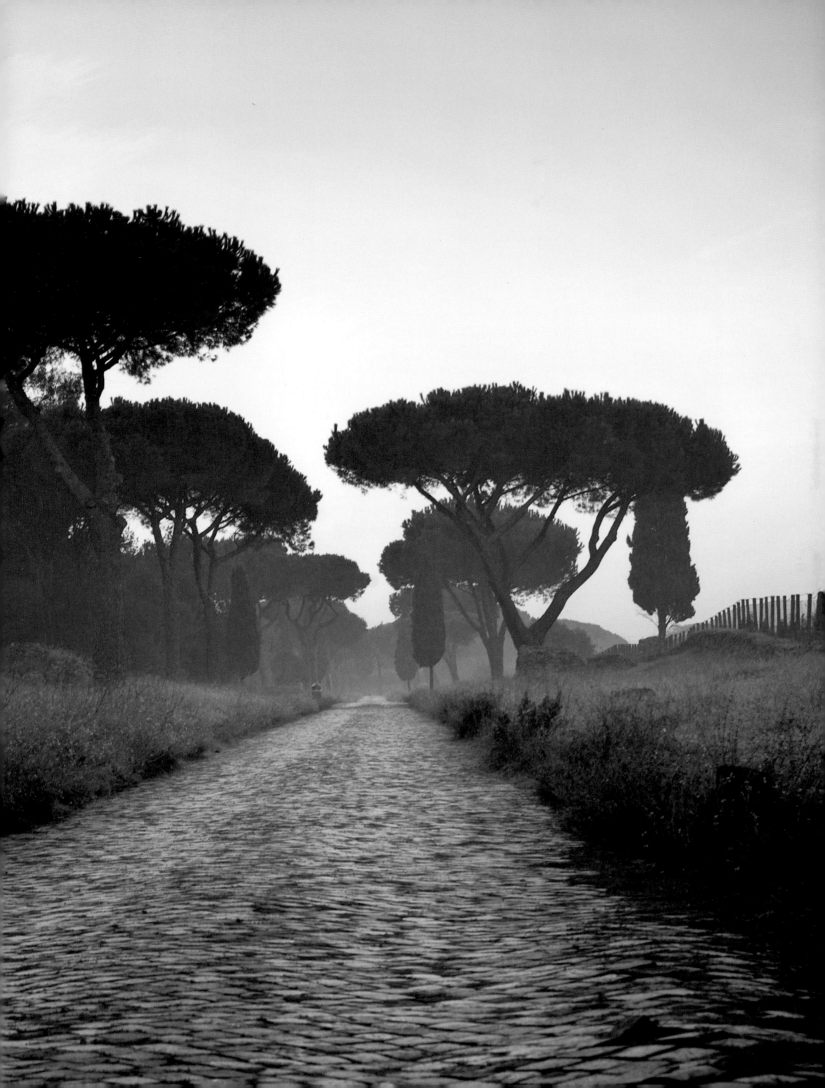

The Aurelian Walls have been guarding Rome's historic centre for centuries. Built during the reign of Emperor Aurelian between 271 and 275AD and spanning 19 kilometres, the fortified city walls encompass the ancient city centre.

Venture beyond any one of the city gates past the city periphery and into the *campagna romana* (Roman countryside) and you will be delightfully surprised at what you will find.

Drive half-an-hour east of the city walls to the Tiburtine hills and the intriguing village of Tivoli, the aristocratic summer playground of ancient imperial Rome.

Villa Adriana, constructed between 118 and 134AD as the summer retreat for Emperor Hadrian, is a complex of over 30 buildings set among fields of wildflowers and olive trees and sprawling over 120 hectares.

A UNESCO World Heritage-listed site, Villa Adriana is a masterpiece of Greek, Egyptian and Roman architectural influences, embellished with an exquisite collection of artefacts, marble statues and intricate mosaics and frescoes.

Neighbouring Villa d'Este, built 1,500 years later, under the commission of the governor of Tivoli, Cardinal Ippolito II d'Este, is a classic example of a 16th-century Italian garden. Terraces cascading from the imposing villa with elaborately designed water features, majestic, towering fountains and spouting, gnarled gargoyles characterise the splendour of this impressive villa.

Cultural, musical and theatrical events are staged at both villas over the summer months, making for an unforgettable experience in such evocative settings.

Revive your childhood spirit as you embark on an adventure through a fantasy forest of giant monsters, fighting dragons, unicorns and other imaginary creatures, at the Parco dei Mostri (Park of the Monsters), Bomarzo, an archeological park an hour's drive north of Rome.

Prince Pier Francesco Orsini was inspired to create the Sacred Woods of Bomarzo in the 16th century in loving memory of his wife. Serpentine pathways meander through the mystical parklands with moss-covered creatures, gods and warriors carved from the stone cliffs that characterise the area in the Viterbo province of Lazio.

Be enchanted by the mystical gardens of Giardino di Ninfa in the Latina province, south-east of Rome. A fairytale, English-inspired garden of rambling roses, Cypress pines, wisteria, ornamental trees and arum lilies flourishing amongst the crumbling ruins of stone bridges, frescoed walls and serene ponds, inspiring new life and beauty in the once abandoned medieval village of Ninfa.

Named after the mythical goddess of the forest and water, Ninfa was settled at the base of Monte Lepini bordering the neighbouring swamplands. The spirit of the beautiful goddess lives on in the feminine ambience of the garden, the delicate floral details, rambling perfumed pathways and corners and the tranquility of the brooks and waterfalls sparkling with sunbeams, dancing across the water.

Opposite: The romantic gardens and silent ruins of Giardino di Ninfa.
Following pages: The Maritime Theatre in the UNESCO World Heritage-listed Villa Adriana at Tivoli.

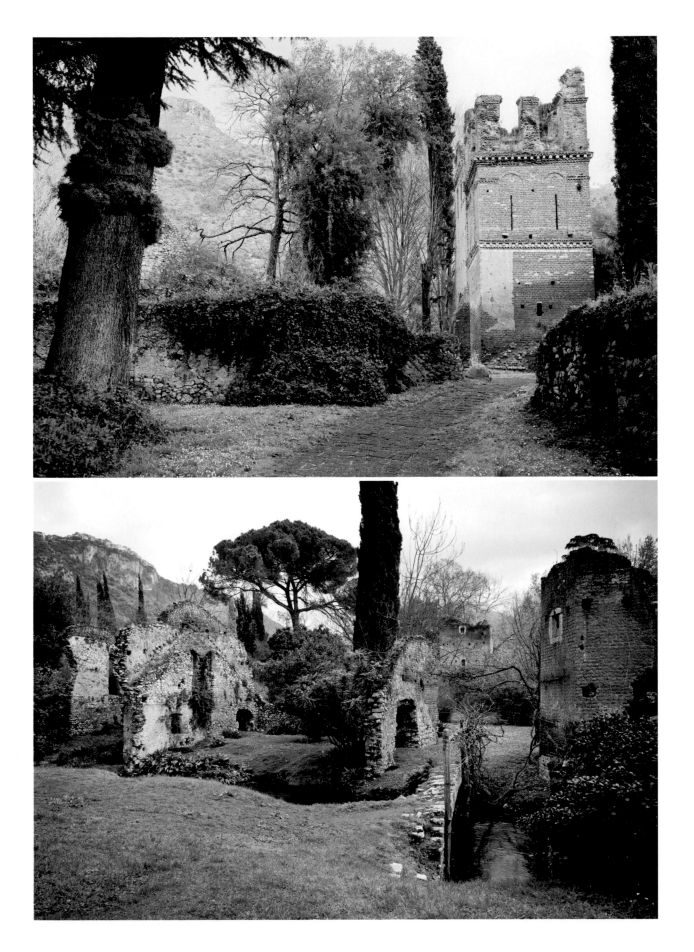

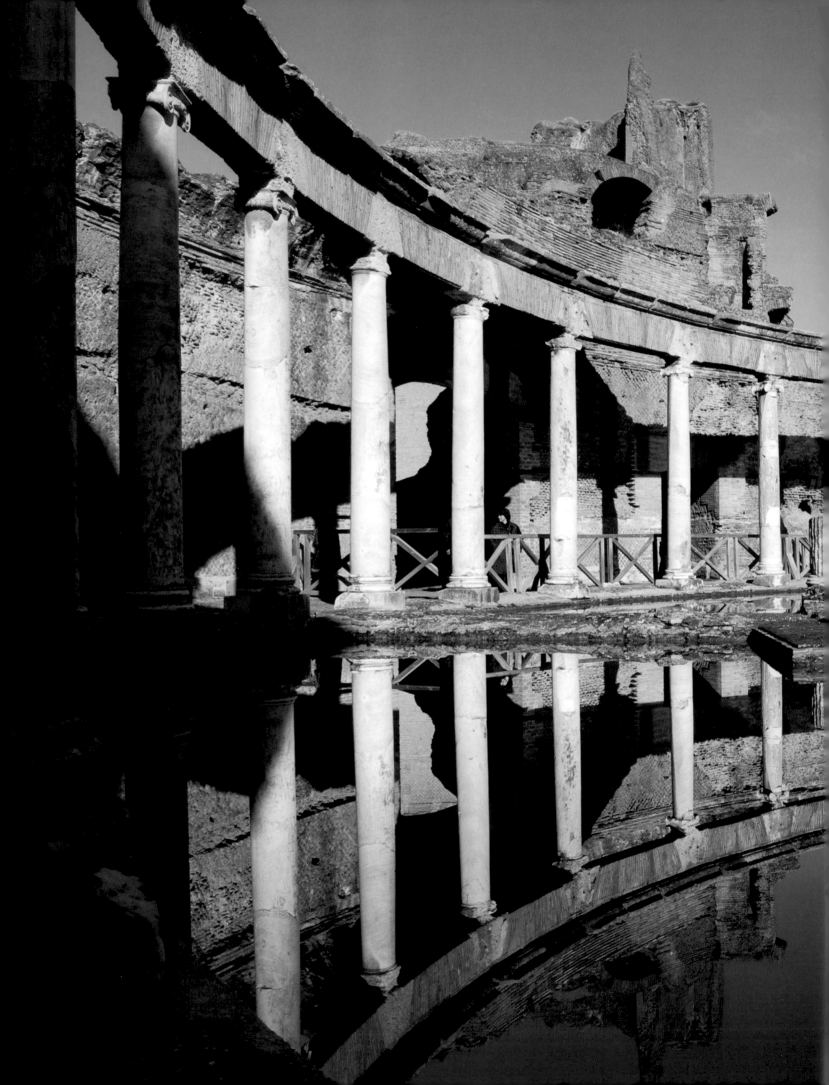

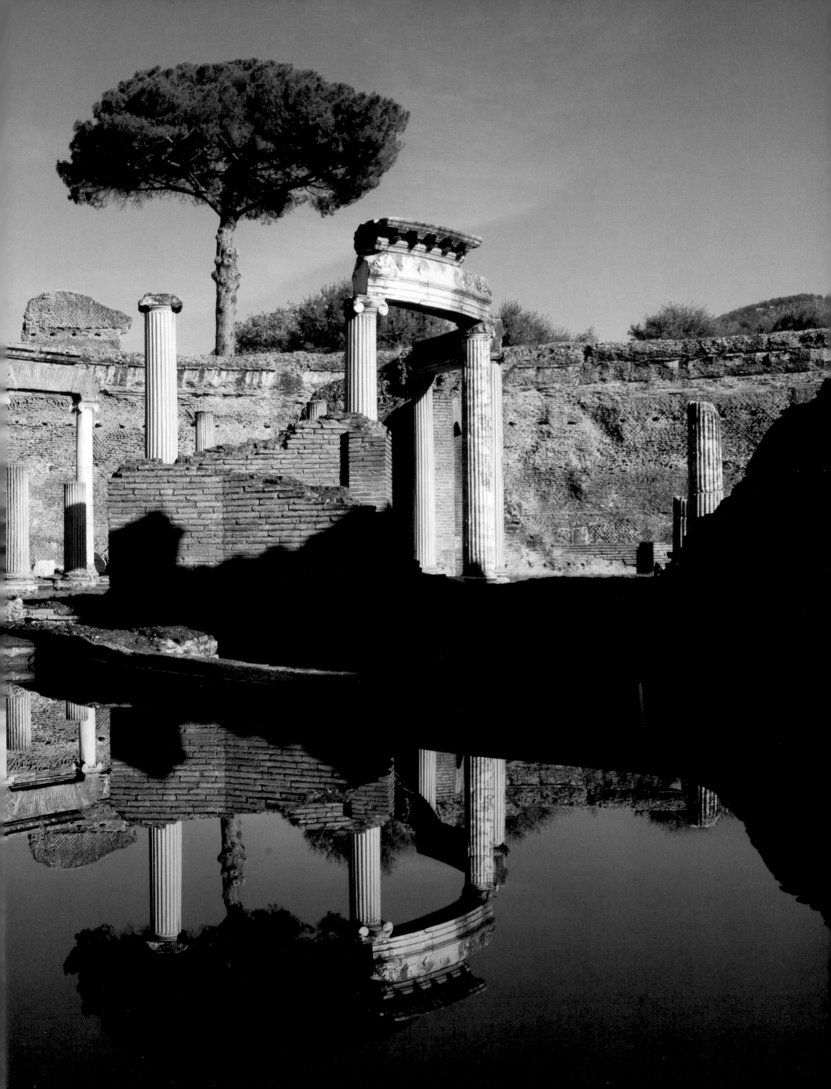

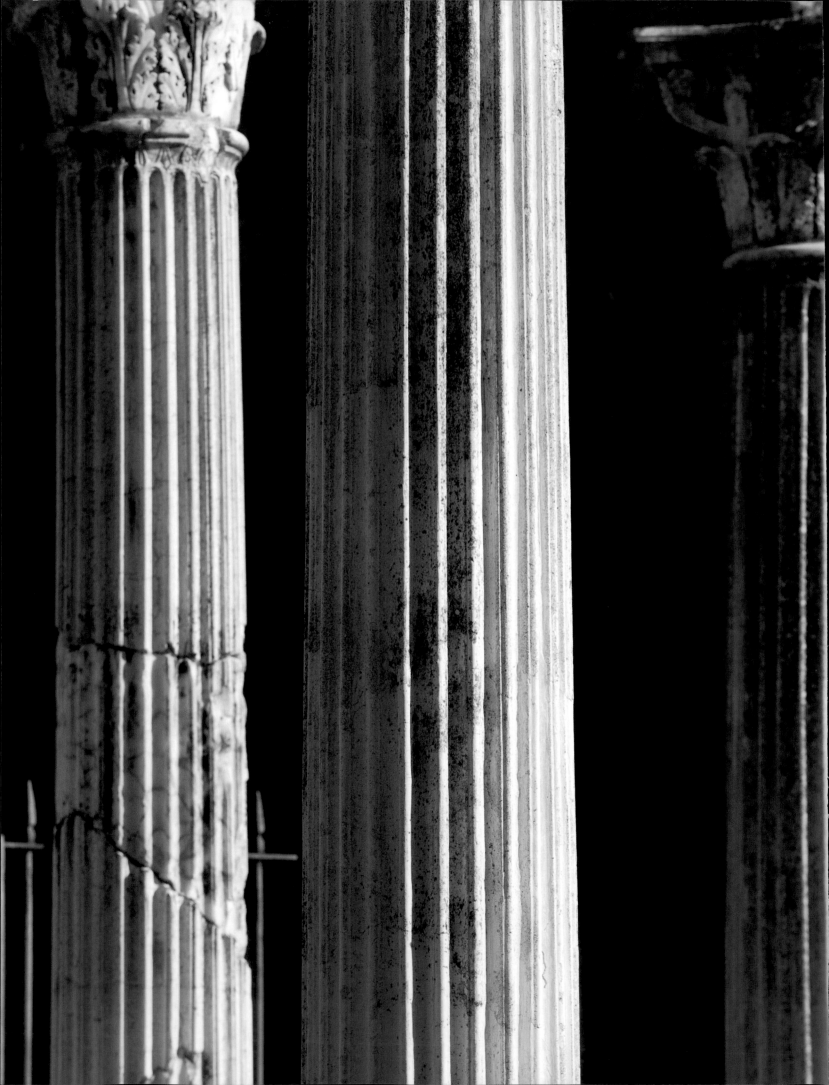

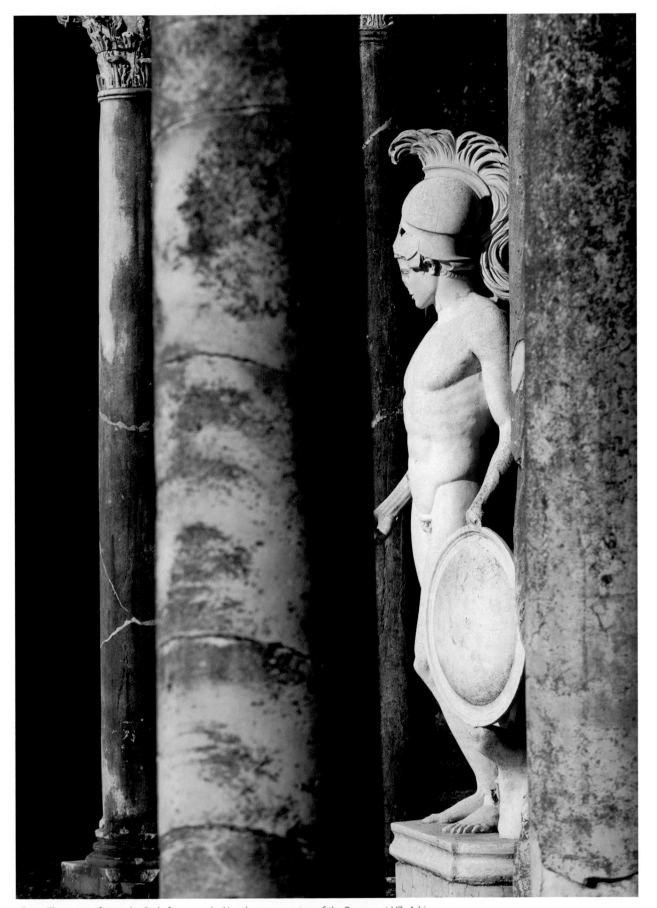

Above: The statue of Ares, the God of war, overlooking the serene waters of the Canopus at Villa Adriana.
Following pages: Villa d'Este in Tivoli and Parco dei Mostri (Park of the Monsters) in Bomarzo.

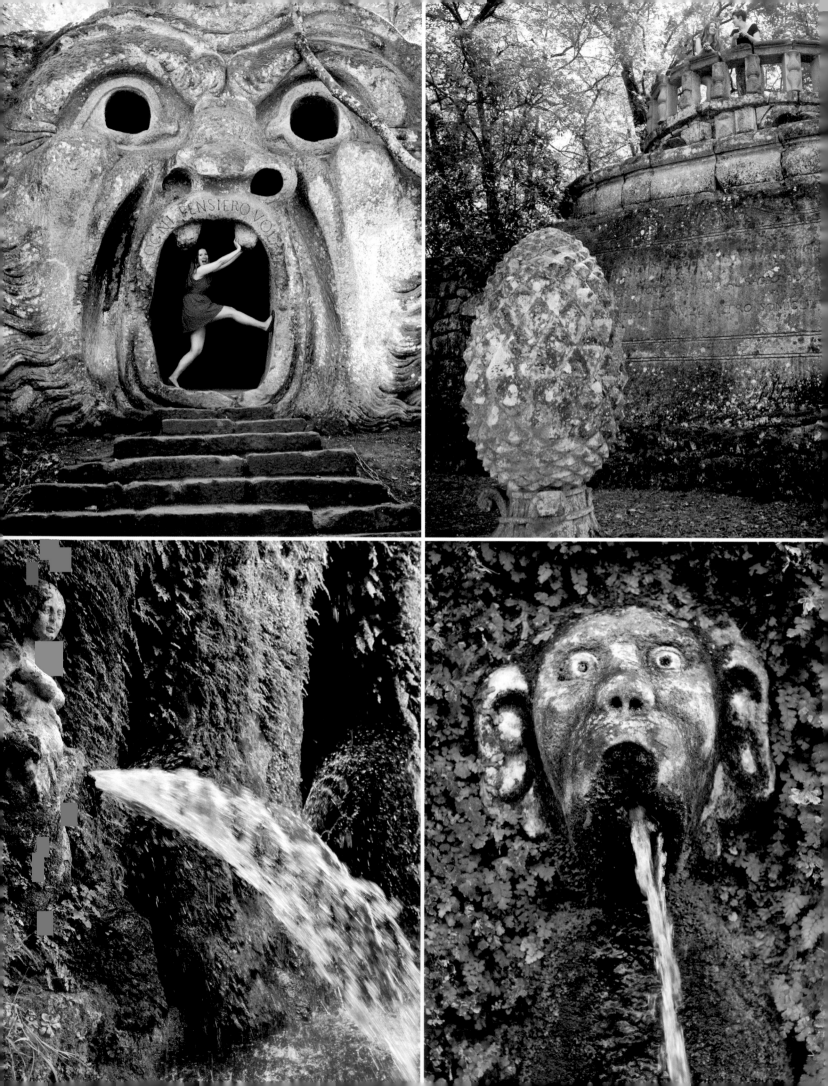

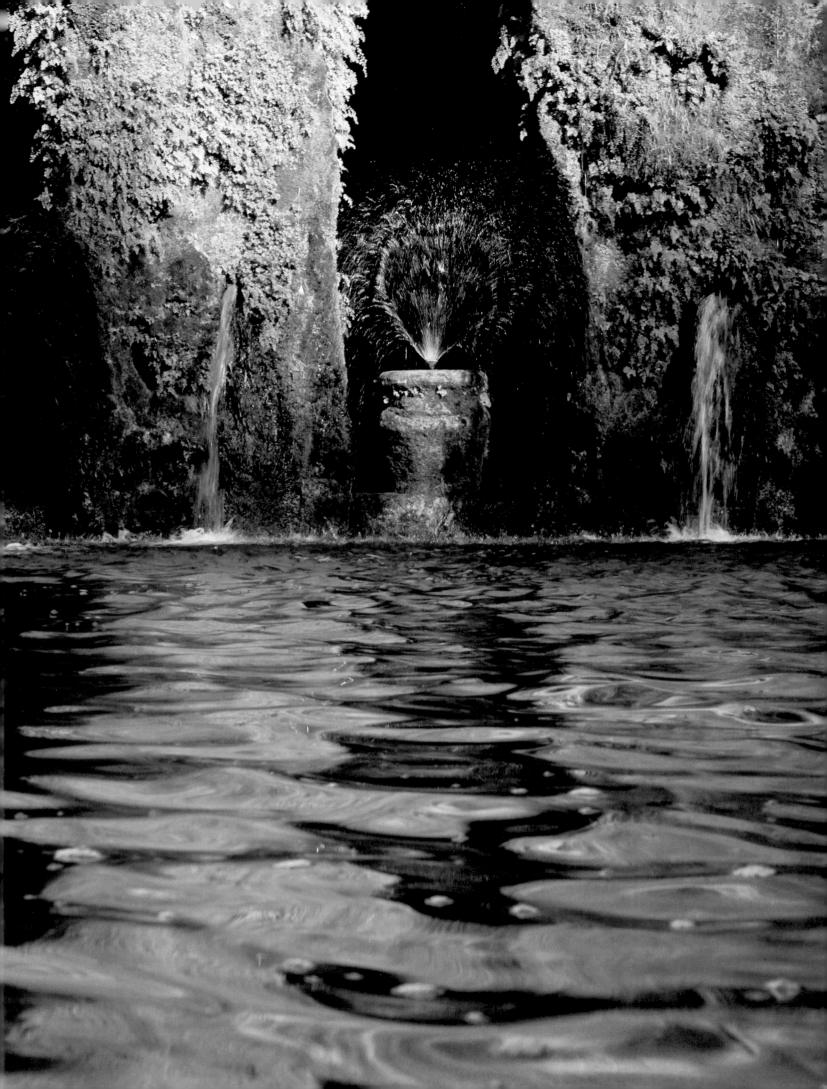

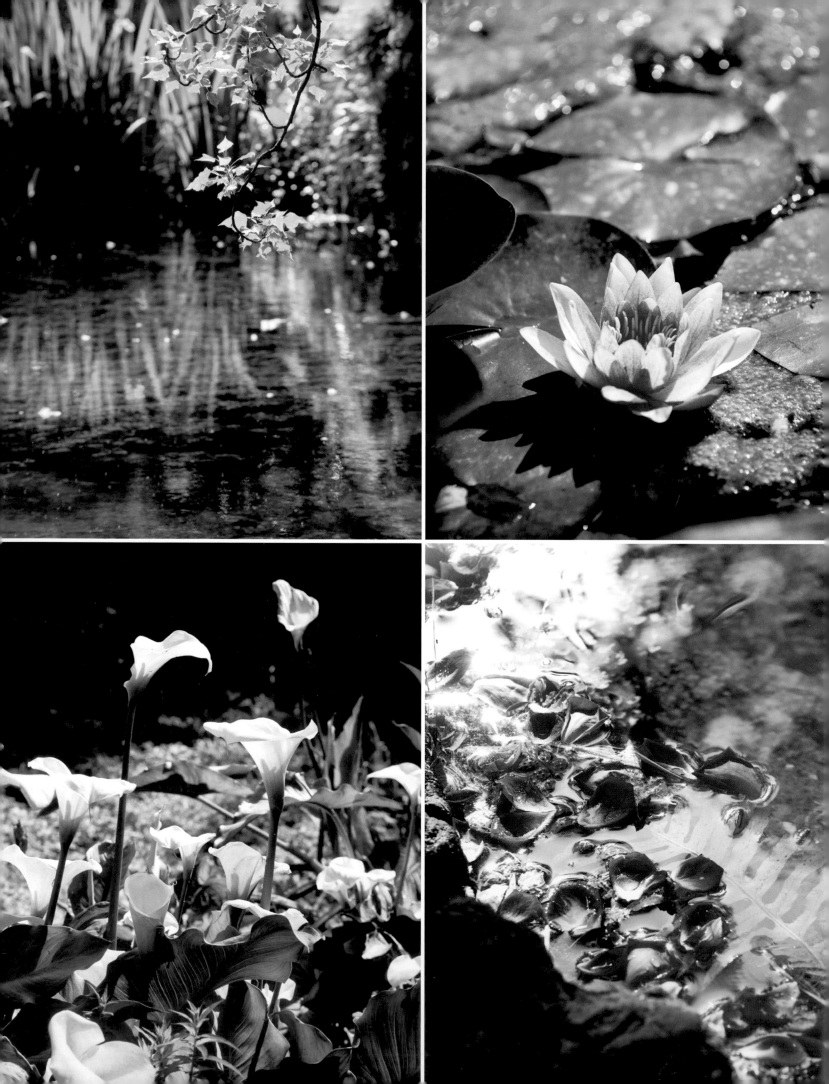

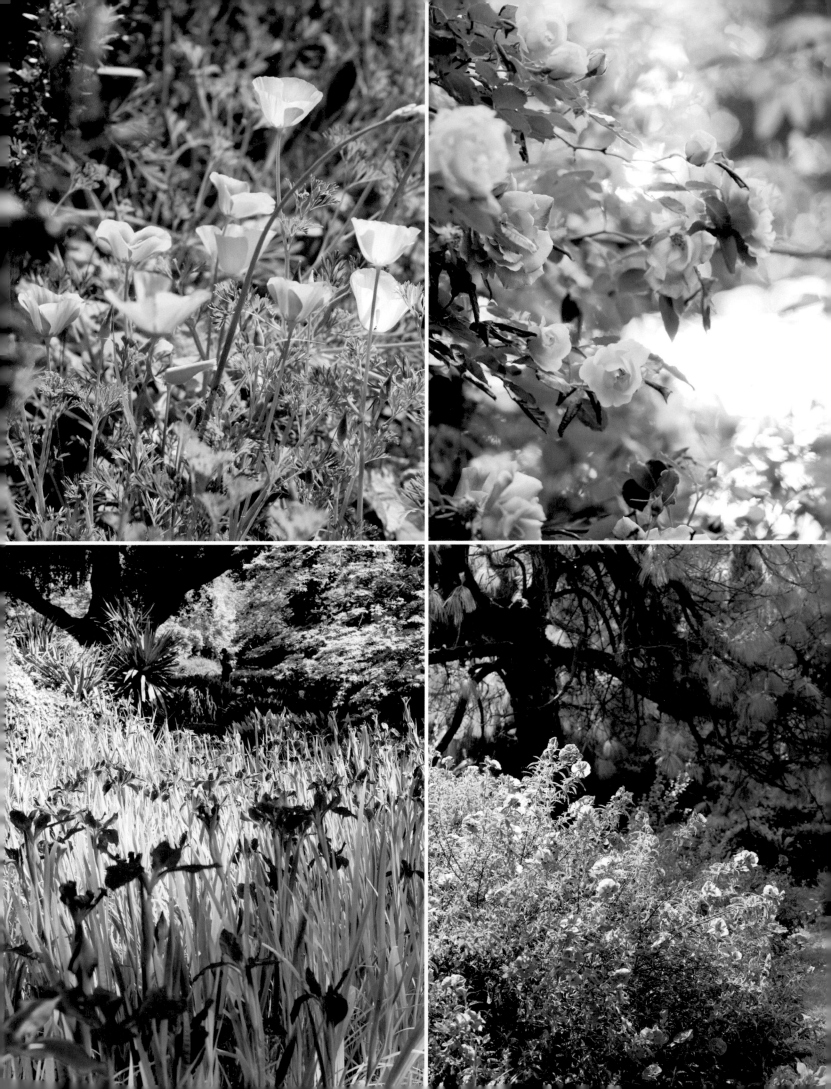

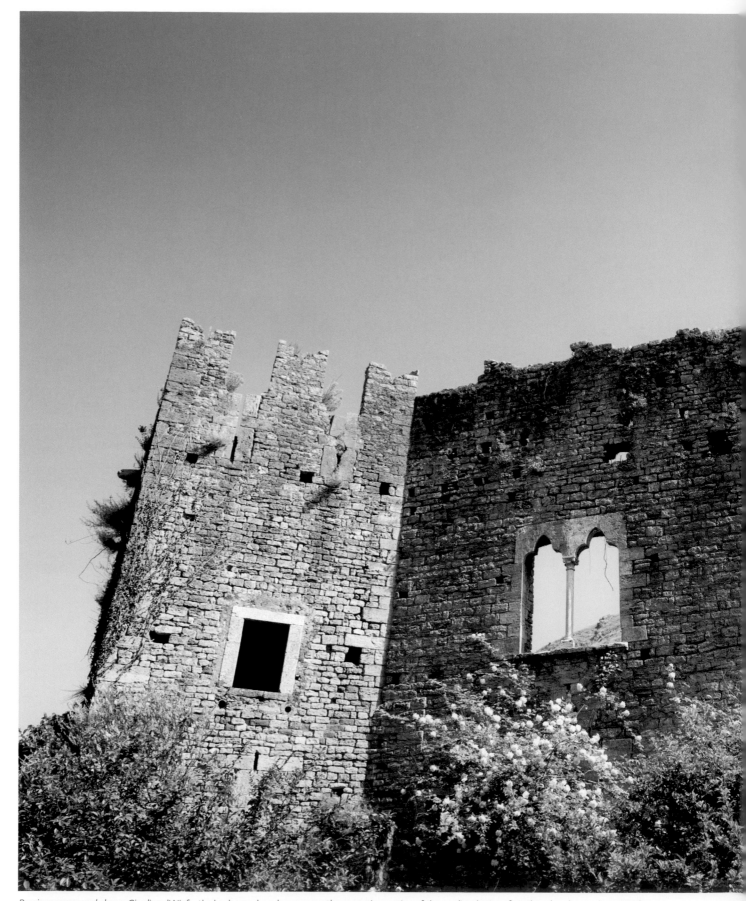

Previous pages and above: Giardino di Ninfa, the landscaped gardens among the evocative setting of the medieval ruins of castles, churches and municipal buildings of Ninfa. They feature ornamental cherry blossoms, magnolias, Japanese maples and many varieties of roses and aquatic plants, as well as many shrubs to provide food for over 100 species of bird life.

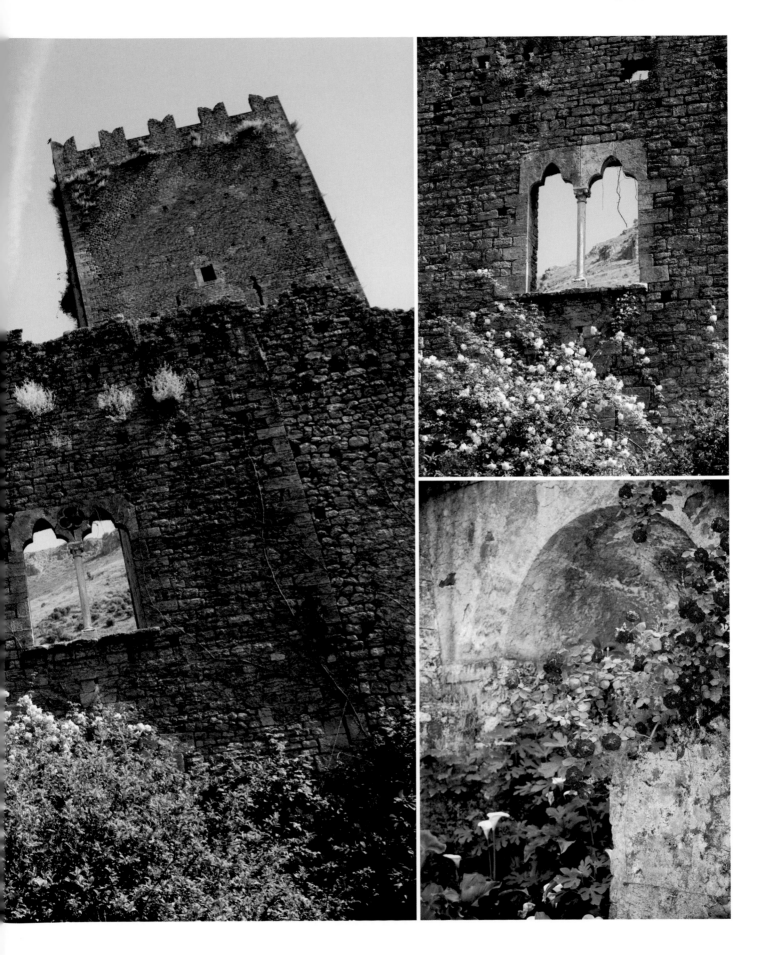

AFTER DARK *La Serata*

The Roman evening either keeps still or it sings. No one can behold it without growing dizzy and time has filled it with eternity.

— JORGE LUIS BORGES

As the daylight hours fade and the moon rises, Rome casts her magic spell over a captivated audience. This is Rome in her starring role – by night. Her timeless grandeur is glorified under spotlight.

Behold the evocative beauty of the Roman Forum at night. As the cool summer moon embraces the eternal Roman skyline, the city will captivate your imagination and quietly steal your heart.

Hidden away from the dazzling display of colourful lights and evening grandeur, Rome's backstreets, piazzas, bars, restaurants and clubs overflow with people and the buzz of excitement and energy fills the night air. Make your way to Rome's meatpacking district, Testaccio, for the best authentic Roman cuisine and late-night clubs.

Learn the local lingo, *Romanesco*, while hanging out with the fashionable Roman crowd in the *piazzette* (little squares) in the districts of Monti, Trastevere, San Lorenzo or Pigneto. Or, for a more romantic rendezvous, take a moonlit stroll along the charming Ponte Sisto pedestrian bridge and gaze at the evening reflections dancing along the winding River Tiber.

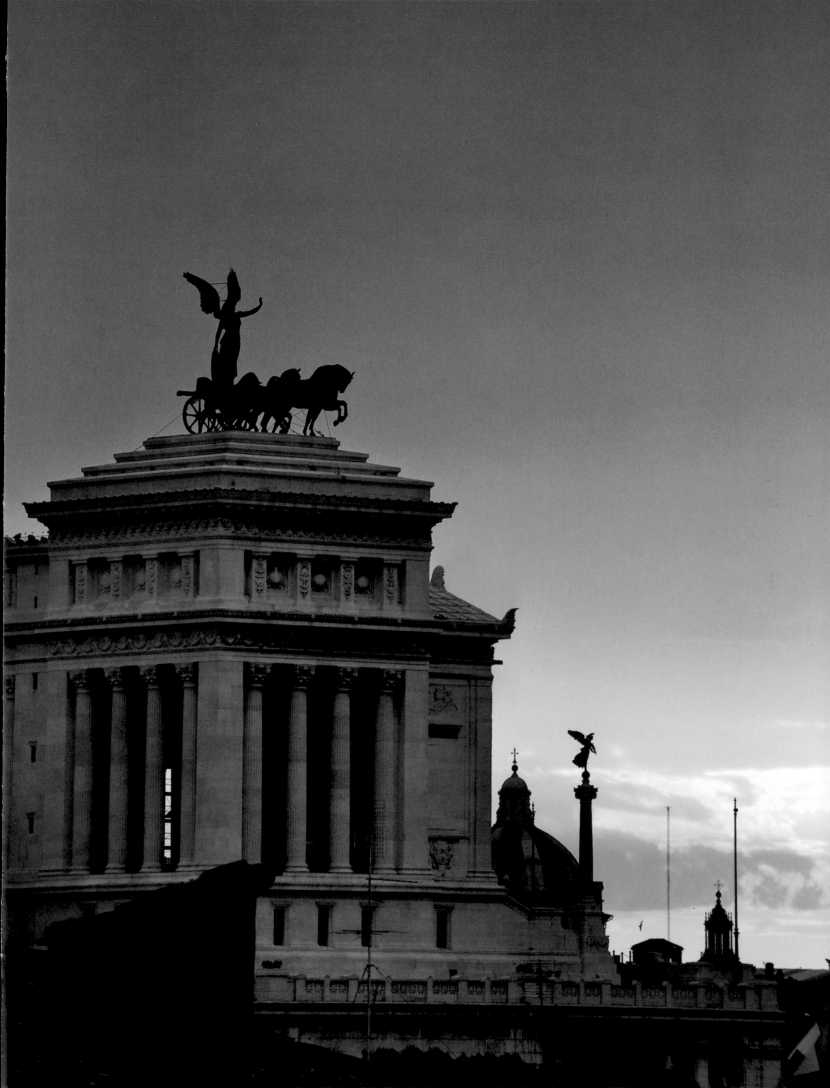

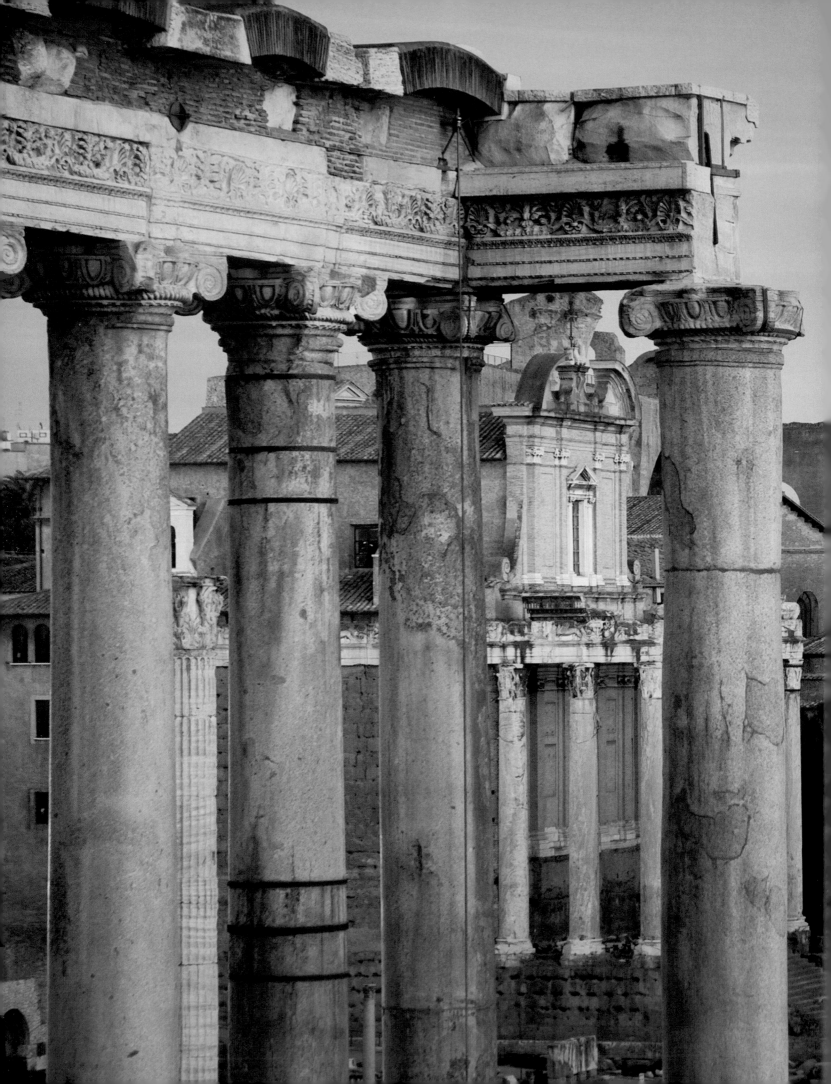

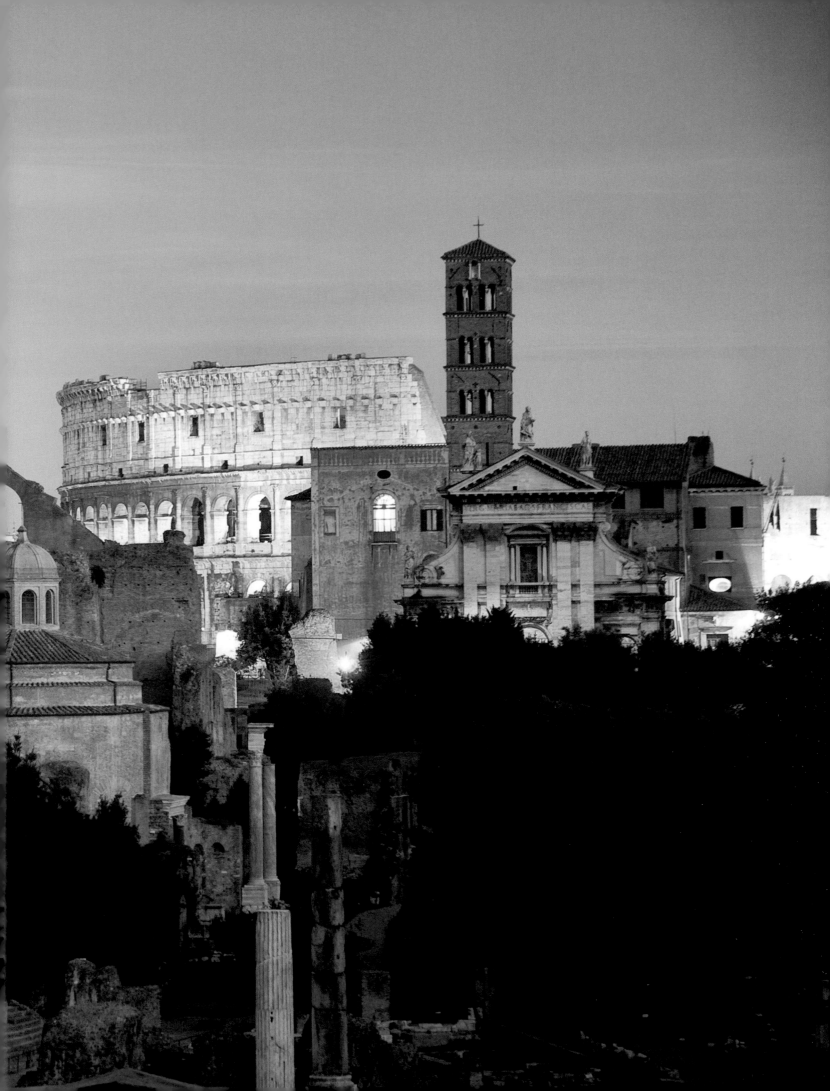

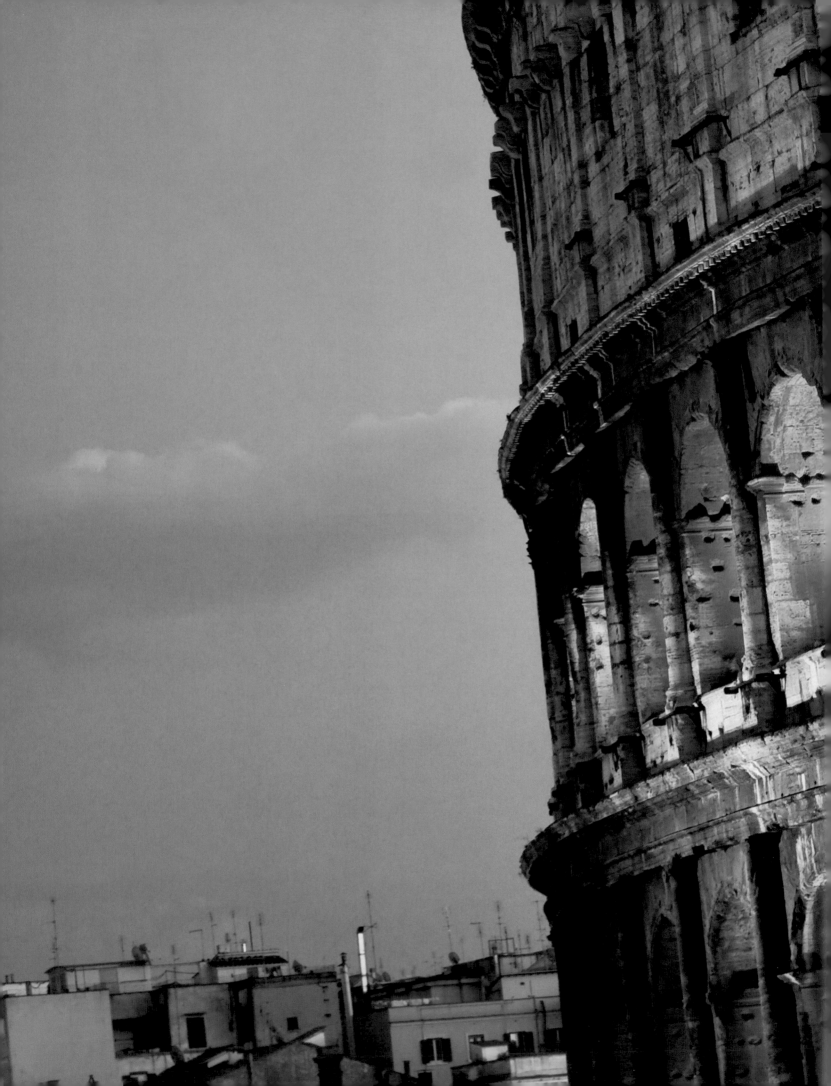

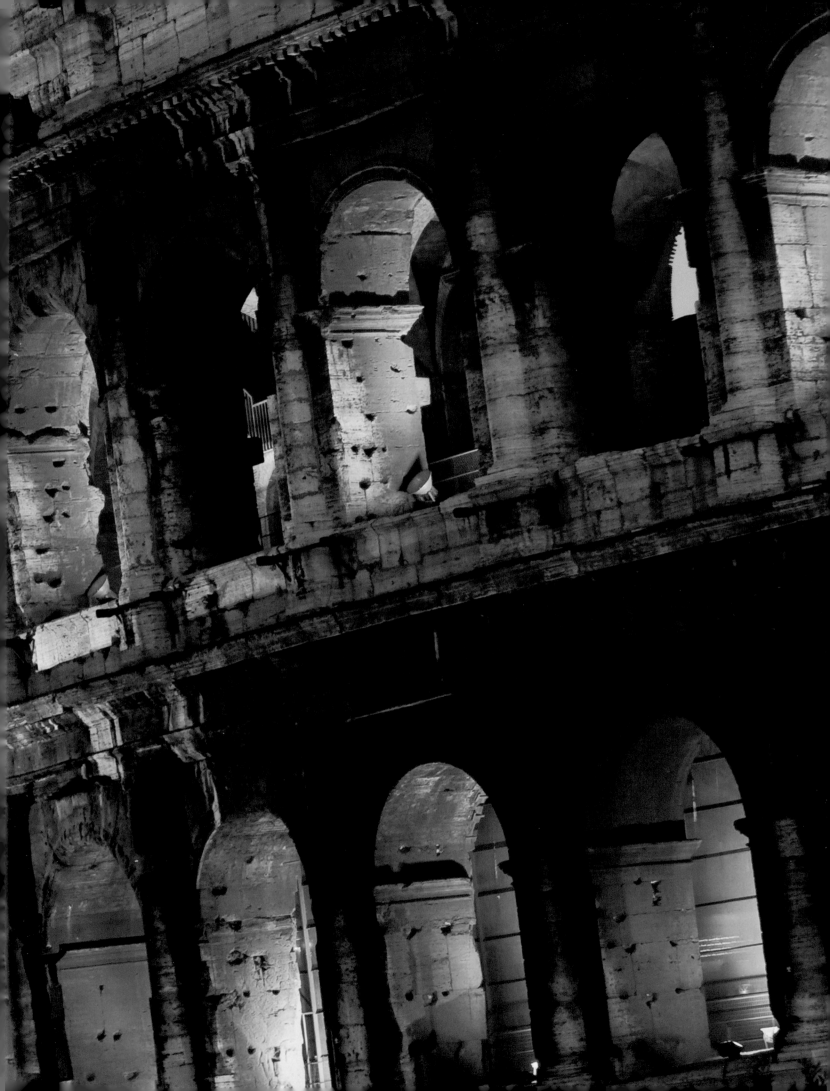

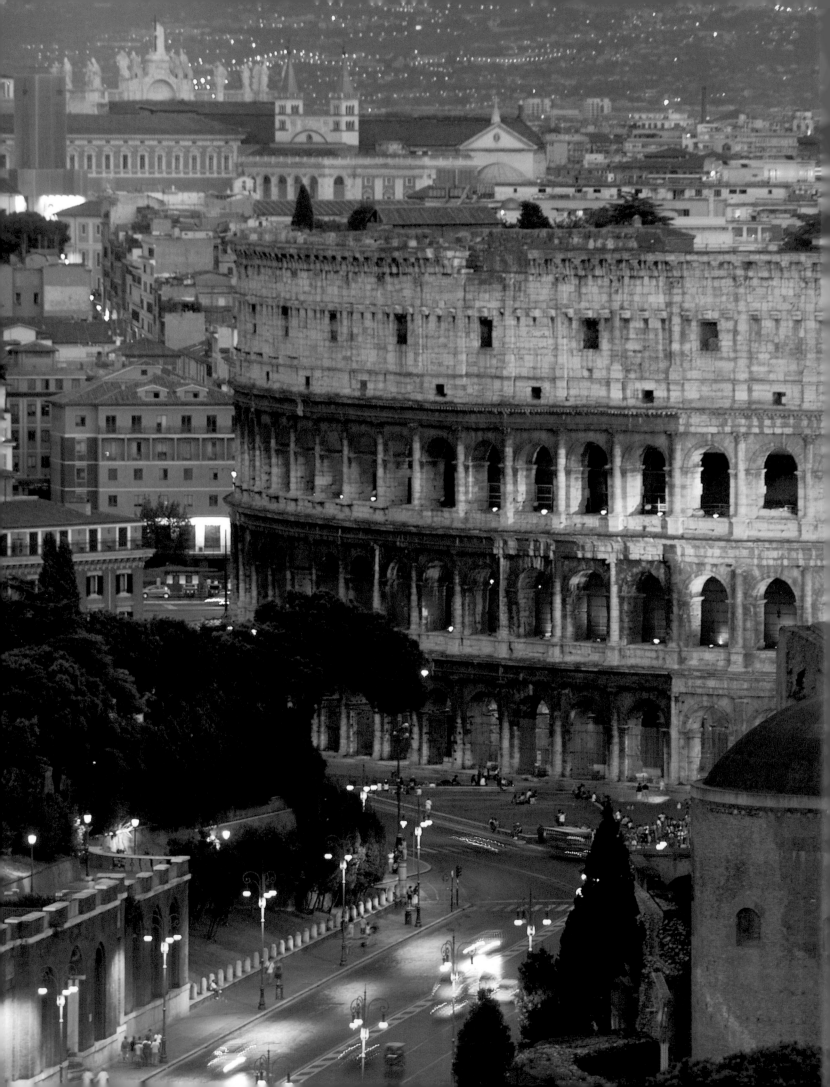

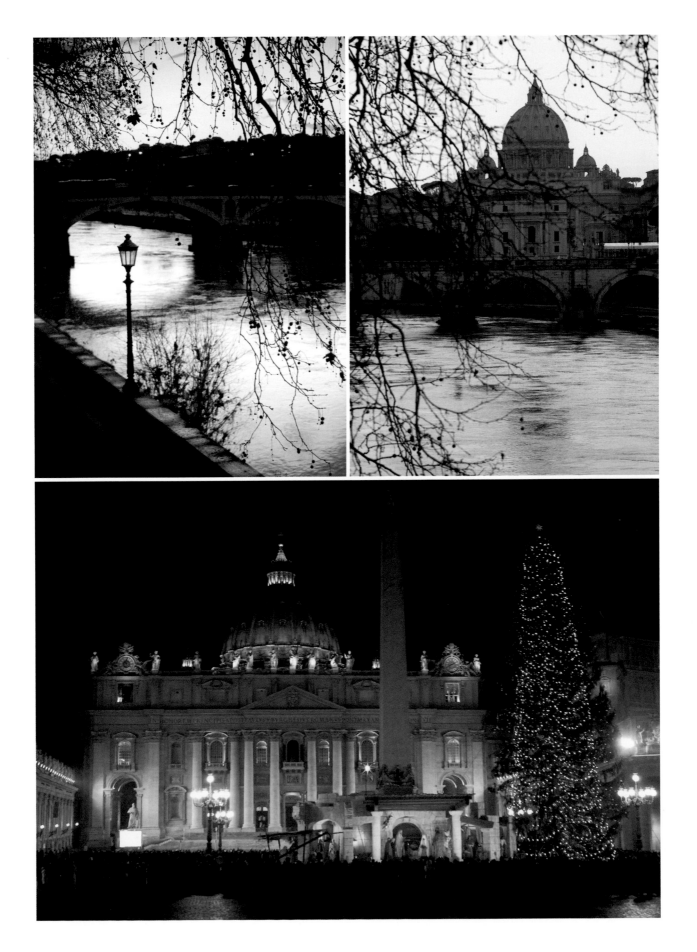

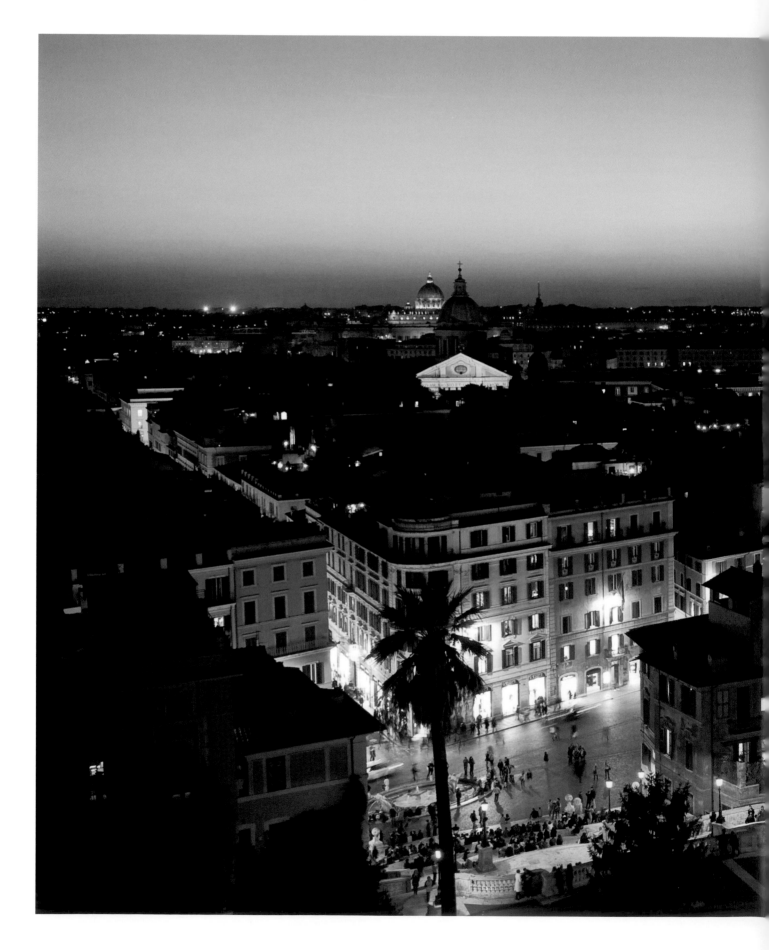

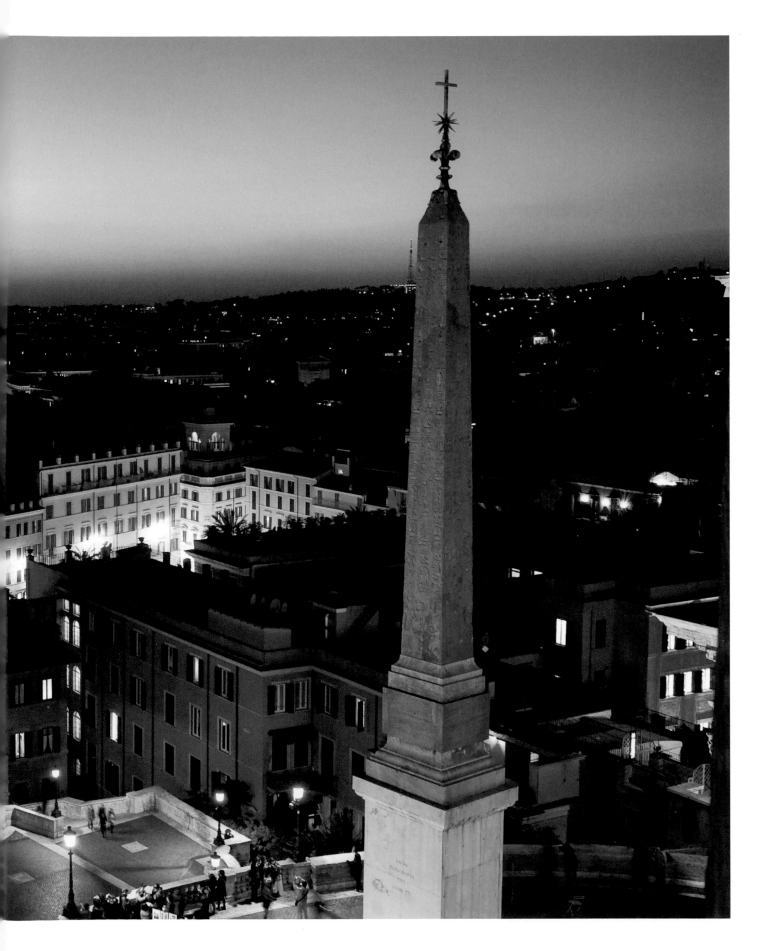

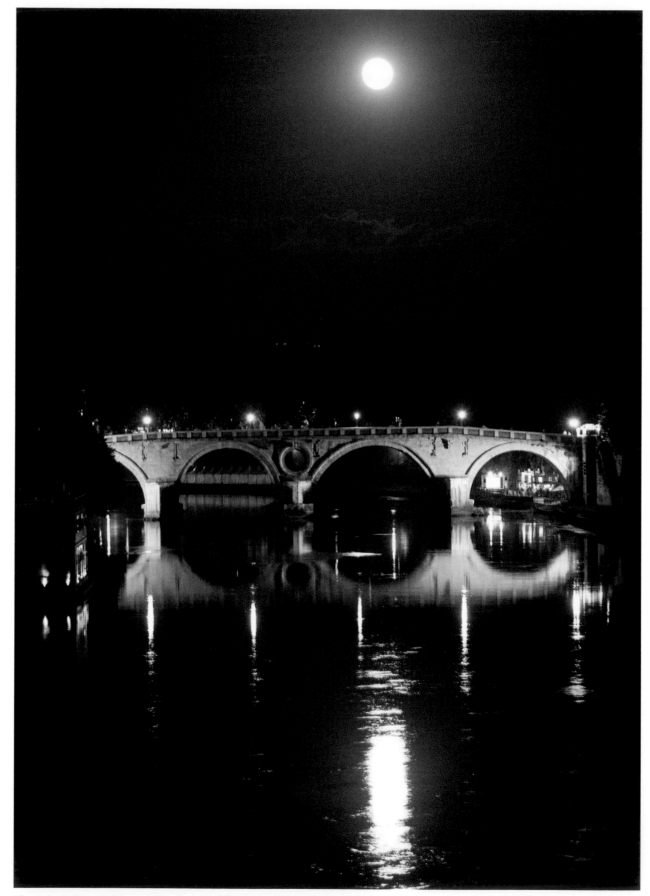

Above: Ponte Sisto, with its central oculus, is a pedestrian bridge connecting the lively
nightlife areas of Piazza Trilussa in Trastevere to Via Giulia and Campo dei Fiori.
Opposite: Street scene in the *rione* of Campo Marzio.

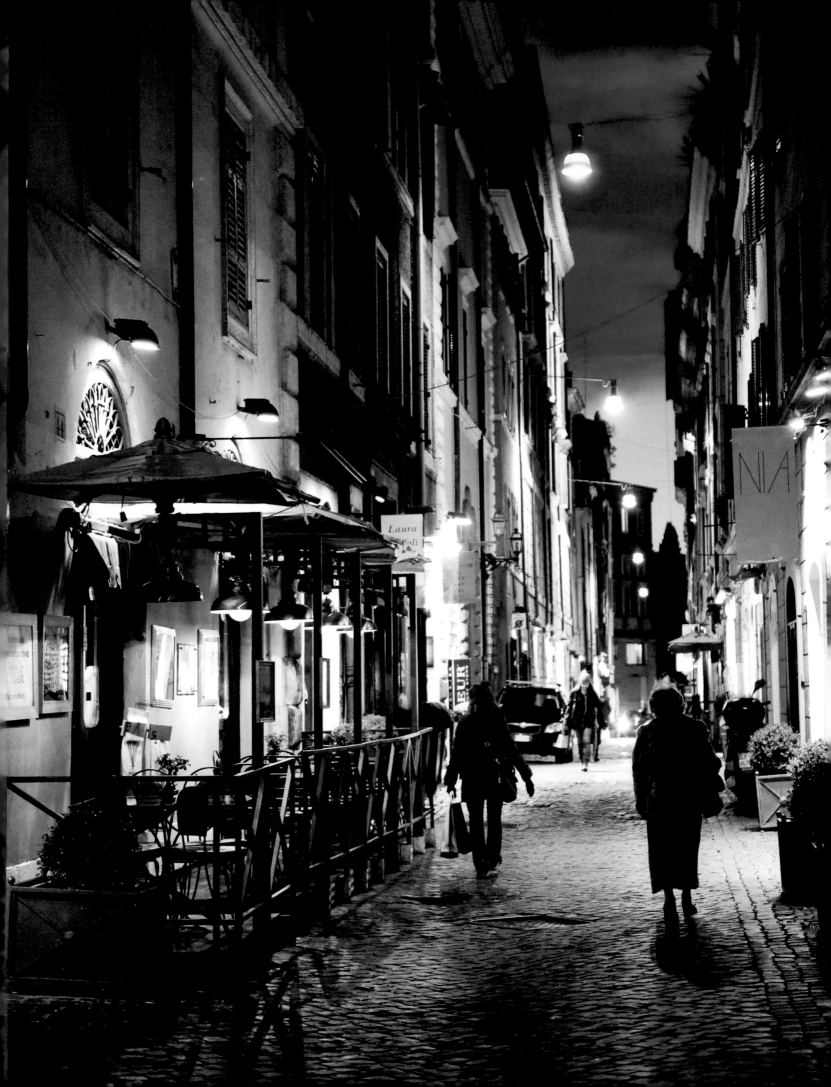

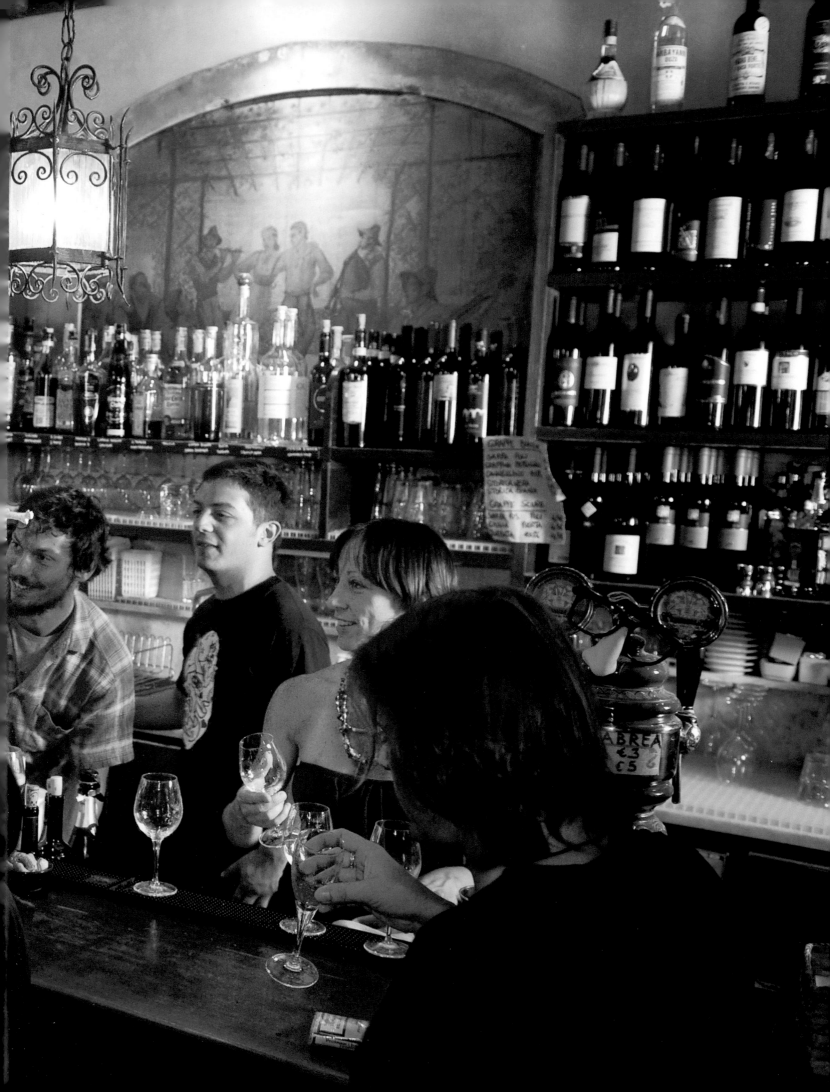

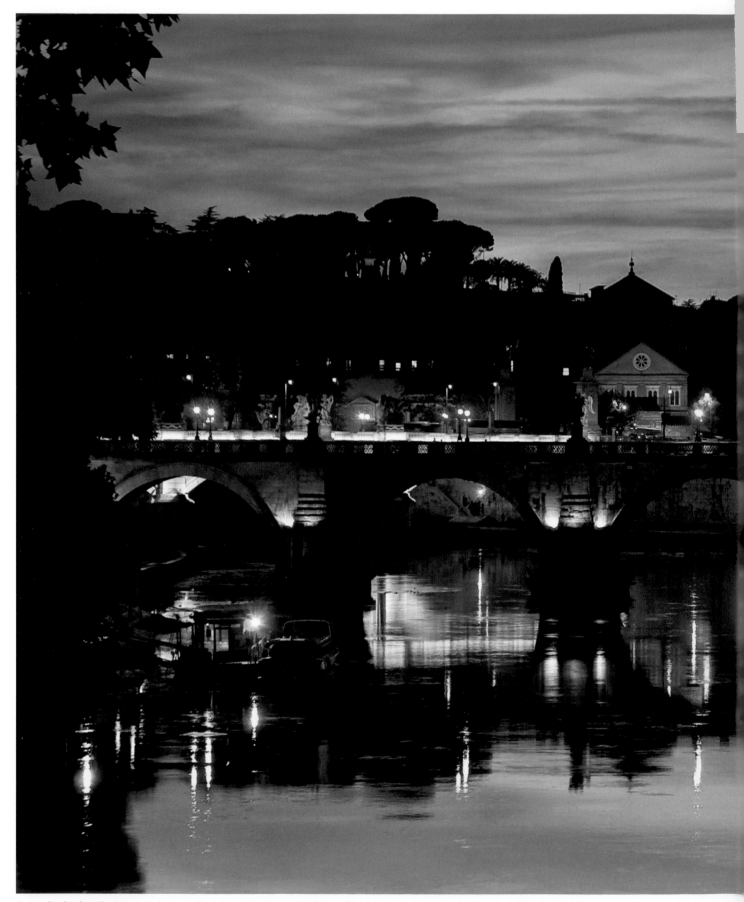

Cerise clouds adorn the Roman skyline over the dome of Saint Peter's Basilica and Bernini's enchanted Ponte Sant'Angelo, or Bridge of Angels.

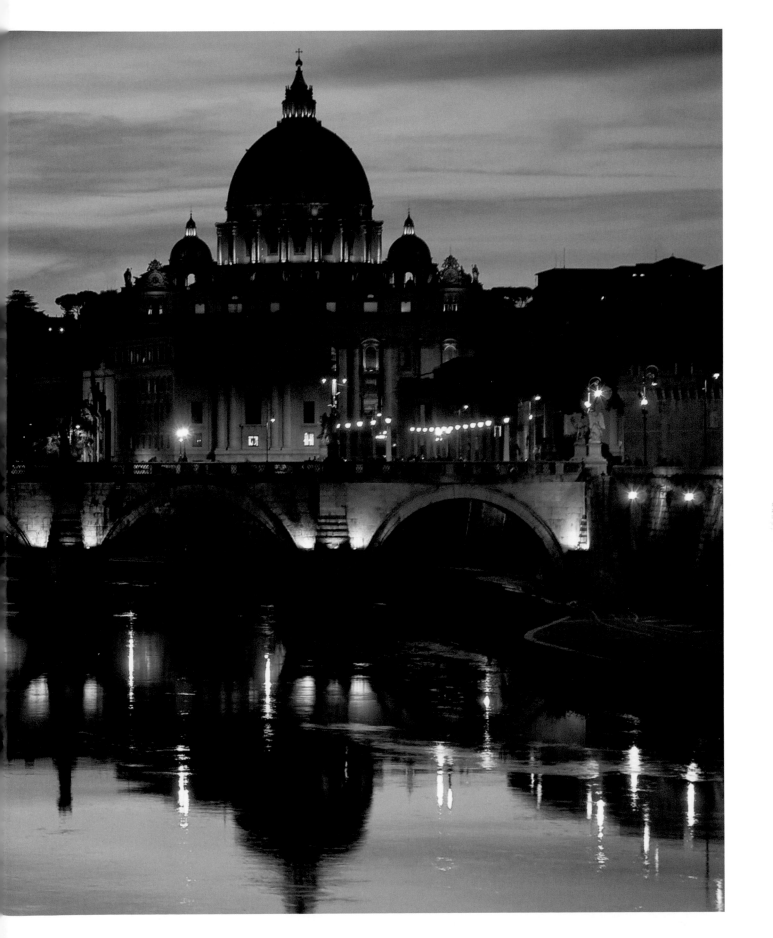

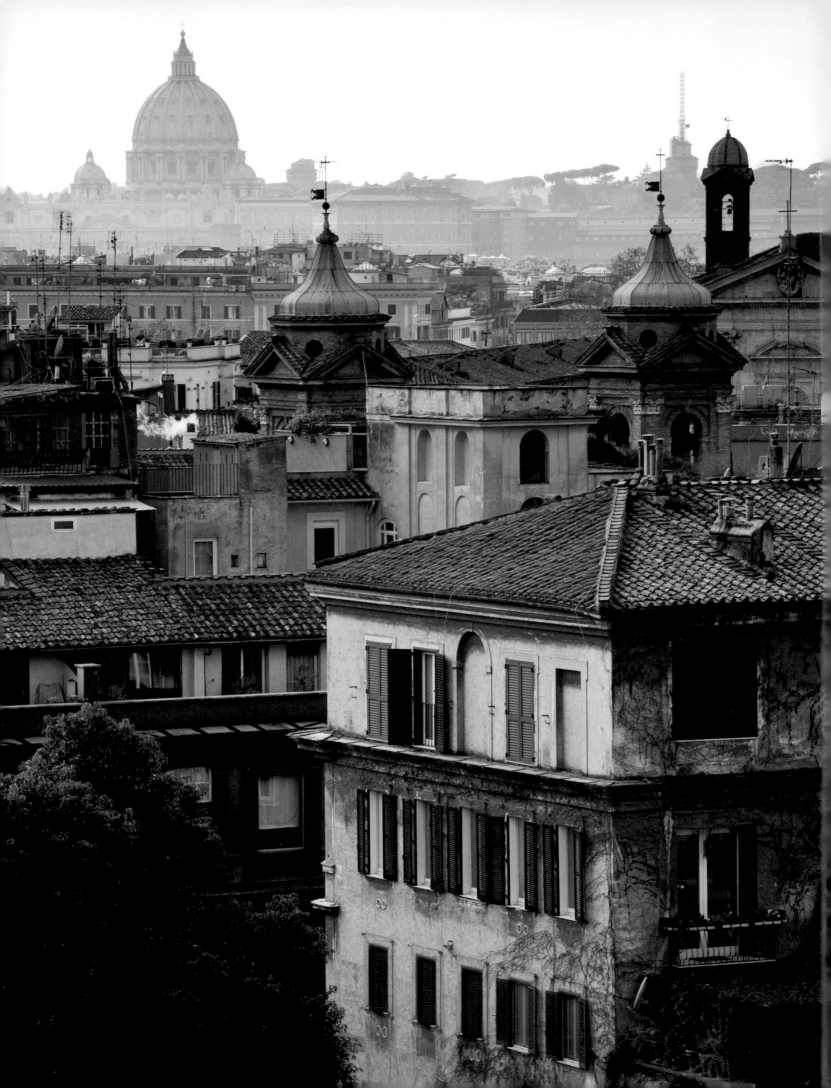

ACKNOWLEDGEMENTS

Special thanks to all of the people and organisations who assisted in the creation of this book:

Roma Capitale Sovrintendenza Beni Culturali

Su concessione del MiBAC – Soprintendenza per i Beni Archeologici del Lazio, Roma

Ministero dei Beni e delle Attività Culturali e del Turismo
Soprintendenza per i Beni Architettonici e del Paesaggio del Lazio
Soprintendente – Arch. Giorgio Palandri
Direttore di Villa d'Este – Arch. Marina Cogotti

Soprintendenza Speciale per il Patrimonio Storico,
Artistico ed Etnoantropologico e per il Polo Museale della città di Roma

Soprintendenza Speciale per i Beni Archeologici di Roma
Museo Nazionale Romano

Soprintendenza per Beni Architettonici e Paesaggistici per il comune di Roma

The French Embassy in Italy

Sovereign Order of Malta

Fondo Edifici di Culto

Pieux Etablissements de la France à Roma et à Lorette

Fondazione Roffredo Caetani – Giardino di Ninfa

Parco dei Mostri

Galleria Colonna

ENIT Italian Government Tourist Office, Sydney, Australia

Alice Adams, for her assistance in production for location and property releases, food styling and recipes.www.aliceadamsfoodstylist.com

Journalist Isobel Lee, for her initial edit and artistic input

Models: Tea Franich, Sara Pasetto, Vanessa Taranto, Petter Jern, Rados Cvetic

CONTACT DETAILS

FEATURED HOTELS, RESTAURANTS, BARS AND CAFES

HOTEL HASSLER ROMA AND
IMÀGO RESTAURANT
Piazza Trinita' dei Monti, 6, Roma
www.hotelhasslerroma.com
+39 06 699340

FIRST LUXURY ART HOTEL ROMA
Via del Vantaggio, 14, Roma
www.thefirsthotel.com
+39 06 45617070

HOTEL EDEN
Via Ludovisi, 49, Roma,
www.edenroma.com
+39 06 478121

OPEN COLONNA RESTAURANT
Via Milano, 9/a, Roma
www.opencolonna.it
+39 06 47822641

VOLPETTI DELICATESSEN
Via Marmorata 47, Roma
www.volpetti.com
+39 06 5742352

DA REMO PIZZERIA
Piazza Santa Maria Liberatrice 44, Roma
+39 06 5746270

OSTERIA DEL VELODROMO VECCHIO
Via Genzano 139, Roma
+39 06 7886793

ANTICO CAFFÈ GRECO
Via Condotti 86, Roma
www.anticocaffegreco.eu
+39 06 6791700

TAZZA D'ORO
Via degli Orfani 84, Roma
www.tazzadorocoffeeshop.com
+39 06 6789792

SANT'EUSTACHIO IL CAFFÈ
Piazza Sant'Eustachio 82, Roma
www.santeustachioilcaffe.it
+39 06 68802048

CASTRONI
Via Nazionale 71, Roma
www.castroni.it
+39 06 48987474

PARANÀ CAFFÈ
via Portuense, 351/b, Roma
www.caffeparana.it
+39 06 55389505

AI TRE SCALINI
Via Panisperna, 251, Roma
www.aitrescalini.org
+39 06 48907495

MA CHE SIETE VENUTI A FÀ
Via di Benedetta, 25, Roma
+39 06 64562046

GUSTO
Piazza Augusto Imperatore 9, Roma
www.gusto.it
+39 06 3226273

EATALY
Piazzale XII Ottobre 1492, Roma
www.roma.eataly.it
+39 06 90279201

FEATURED ARTISANS

CHECCHINO DAL 1887
Via di Monte Testaccio, 30, Roma
www.checchino-dal-1887.com
+39 06 5743816

CAFFÈ DELLA PACE
Via della Pace 3/7 Roma
www.caffedellapace.it
+39 06 6861216

CONFETTERIA MORIONDO E GARIGLIO
Via di Pie' di Marmo 21-22, Roma
+39 06 6990856

CRISTALLI DI ZUCCHERO
Via di San Teodoro, 88 Roma
www.cristallidizucchero.it
+39 06 69920945

ACQUA MADRE
Via di S. Ambrogio, 17 Roma
www.acquamadre.it
+39 06 6864272

AGROPELAGUS, organisers of the
biological market in Vicolo della Moretta

MERCATO DI CAMPAGNA AMICA DEL CIRCO
MASSIMO DI ROMA
Via San Teodoro 74, Roma
www.campagnamica.it

MIA MARKET
Via Panisperna 225, Roma
www.miamarket.blogspot.com
+39 06 47824611

CASA DELLA LUCE (THE CANDLE STORE)
Via Urbana 21, Roma
www.candlestore.it
+39 06 90273263

SILICE
Via Urbana 27, Roma
www.studiosilice.com
+39 06 4745552

AGENTIA
Via Urbana, 32, Roma
www.argentia-jewels.com
+39 06 6875488

STUDIO CASSIO ARTE DEL MOSAICO
Via Urbana 98 - 98a, Roma
www.studiocassio.com
+39 06 47 45356

LA BOTTEGA DELL' ARCO
Via del Pellegrino, 58, Roma
www.labottegadellarco.it
+39 339 8994584

FERSINI RESTAURO
Via Bocca di Leone, 45/B, Roma
+39 06 6794994